The London Charterhouse

ABOUT THE AUTHOR

Stephen Porter, until his recent retirement, worked for over seventeen years for the Survey of London, a century-old project devoted to the history of London's built environment. His other books include *The Great Fire of London*, *The Plagues of London* and *The Great Plague* (also published by Amberley Publishing). He is head archivist for the London Charterhouse, a Fellow of the Royal Historical Society, and has held research posts at the University of Oxford and Kings College, London. After twenty-five years living in the capital, he now lives in Stratford-Upon-Avon.

PRAISE FOR STEPHEN PORTER

The Plagues of London

'Breathes new life into the story of the plague in London'
STEPHEN INWOOD, author of *A History of London*

'A vivid and thorough history'
GILLIAN TINDALL, author *The Man Who Drew London*

'Tells the story of plague in Tudor and Stuart London with great clarity and command' PAUL SLACK, University of Oxford

'Startling' *TIMEOUT*

The Great Plague

'*An excellent introduction for the general reader*'
THE SUNDAY TELEGRAPH

The London Charterhouse

A History of Thomas Sutton's Charity

STEPHEN PORTER

AMBERLEY

First published 2009

Amberley Publishing
Cirencester Road, Chalford,
Stroud, Gloucestershire, GL6 8PE

www.amberley-books.com

ISBN 978-1-84868-090-6

Typesetting and origination by Amberley Publishing

CONTENTS

FOREWORD

BUCKINGHAM PALACE.

Anyone who is familiar with Charterhouse today will welcome this detailed history of a remarkable institution. It traces its origins to the munificent bequest by the immensely wealthy merchant Thomas Sutton in 1611. It records the opinions of the supporters and the critics of his intention to establish an almshouse and a school. The former still occupies the site of a pre-Reformation Carthusian Priory in Clerkenwell, while the latter migrated to Godalming in 1872.

Whatever the motives of the founder, the fact that both the school and the almshouse are still fulfilling their original purposes is testimony to the durability of a well-conceived charity. They are also examples of the lasting value of private charitable foundations at a time when governments are expected to provide for all the needs of society.

This is the first in-depth account of the history of this remarkable institution for almost a century. It traces the achievements, and the flaws, of those who have both maintained and benefited from this splendid charity over the past four hundred years.

THIS MASTERPIECE OF PROTESTANT CHARITY

Thomas Sutton was an extraordinarily wealthy financier who had the reputation of being the richest commoner in England when he died in 1611, at the age of seventy-nine. He bequeathed the bulk of his fortune to found an almshouse and school, thereby creating the most lavishly endowed charity established between the Reformation and the foundation of Guy's Hospital in the 1720s. Because of uncertainty and prevarication, he died before it could be set up in the Charterhouse. But the scale of the endowment and the setting which he had chosen, which influenced its character and the way in which it was perceived, combined to make it England's most prestigious charity, a status which attracted admiration, yet also drew disapproval.

The site of the Charterhouse was acquired by Sir Walter de Mauny, a prominent soldier and courtier, as a burial ground when the Black Death struck London in 1348. The chapel built there became the church of a Carthusian priory, which he founded in 1371. This was the largest and best endowed of the nine Carthusian priories in medieval England, attracting financial support from the crown, the aristocracy and leading citizens of London. In the 1530s the priory was at the forefront of opposition to the Henrician Reformation and sixteen members of the community were executed or died in prison.

After the Dissolution, parts of the buildings were destroyed, but others were incorporated in an impressive mansion built for Sir Edward North in 1545-6, and embellished and extended in the early 1570s by Thomas, fourth Duke of Norfolk, until he was executed in 1572 for his involvement in the Ridolfi Plot, which sought to place Mary Queen of Scots on the throne. It was here, in one of Tudor London's premier mansions, that Queen Elizabeth chose to stay when she first entered London following her accession in 1558, and she was imitated by her successor, James I, on his arrival in the capital from Scotland in 1603. These were the buildings which Thomas Sutton bought in 1611 for his almshouse and school.

The provision of almshouses for those who were unable to support themselves, through old age or infirmity, was one of the major forms of charitable giving,

both before and after the Reformation. Schools were another conventional outlet for large-scale philanthropic gifts, for the children of the poor were regarded as one of the most deserving sections of society. The motives for charitable giving were complex and, for many, persuasive, involving personal piety, duty, honour, emulation and social control, but the establishment of almshouses and schools was necessarily limited to the more affluent benefactors.[1] They formed only the tip of the pyramid of compassionate donors, for while many could afford to provide for annual gifts in money, clothing or food, a considerable sum was required to erect and endow almshouses and schools. Even so, more than 750 almshouses were founded in England before 1547, between 1541 and 1599 Londoners established 37 almshouses in the capital and elsewhere, and there were 219 new grammar school foundations in England between 1558 and 1625.[2]

Founders of almshouses in the late sixteenth and early seventeenth centuries included members of the aristocracy, statesmen and senior churchmen. Almshouses were also founded by successful men of business, including Sir Thomas Gresham, in Broad Street, London; William Goddard, a fishmonger, who endowed the Jesus Hospital at Bray in Berkshire for forty poor persons; and the wealthy mercer Sir Baptist Hicks, Viscount Campden, who founded almshouses at Chipping Campden in Gloucestershire. In 1612 Sir John Slaney, Treasurer of the Newfoundland Company, established a school at Barrow in Shropshire and also founded almshouses there in 1619. The inclusion of a school in a foundation was unusual, but there were a number of other examples, including the charity established by Archbishop John Whitgift at Croydon in 1596, which consisted of an almshouse and school, and the Emanuel Hospital for twenty poor people erected in Westminster in 1600, which also provided for up to twenty poor children to learn a trade.

Such an establishment conferred prestige on the founder and served both as a highly visible reminder of a successful career and charitable munificence, and as a spur to others to be generous.[3] This was reinforced by the inclusion of the benefactor's name in the title, and coat of arms on the building. It could even extend to an effigy, prominently displayed, such as William Goddard's statue above the entrance to the Jesus Hospital. The creation of a distinctive identity included the requirement that the alms-people and scholars should wear uniform gowns and cloaks carrying the charity's badge.

To establish and maintain the purpose and propriety of the institution, founders and their trustees exercised control over those who were to benefit from their generosity. Statutes regulated the administration of the charity and the conduct of the inmates, whose behaviour was expected to demonstrate that age and poverty could be accepted with dignity when they were provided for in a suitably regulated establishment. The statutes also specified the categories which distinguished between those deserving of a place, the worthy poor, and those to be

excluded. The able-bodied, for example, were considered as being able to care for themselves.[4] In practice, the distinction between the deserving and the unworthy poor was difficult to make, with some being admitted who brought an institution into disrepute, and so were disciplined or expelled.[5]

The scale of Thomas Sutton's foundation reflected the size of his fortune, for it consisted of an almshouse for 80 men and a school for 40 scholars. His intention, expressed in 1609, was for the number of almsmen to be increased to 140, as the revenues grew, but this was never realised. He held the post of Master of the Ordnance in the North Parts from 1569 until 1594, taking part in the campaign against the rebellion of the northern earls in 1569 and the siege of Edinburgh in 1573. The profits of office, his other ventures in the north, especially his lease of the Durham coalfields, and favourable leases of manors which he held from the bishopric of Ely, laid the basis of a considerable fortune. This was augmented in 1582 when he married Elizabeth Dudley, the wealthy widow of John Dudley of Stoke Newington. But it was through the expansion of his activities as a moneylender that he increased his assets to become one of the richest men in England.[6] By lending on recognizances, which carried a statutory annual rate of interest of ten per cent, and mortgages, he added enormously to his capital. In the last sixteen years of his life Sutton lent £220,000 in sums that ranged from £1 to £8,800, with £37,000 advanced in 1604 alone.[7] The borrowers came from a wide social spectrum and included members of the aristocracy, gentry, clergymen, husbandmen and shopkeepers. At his death, £46,848 was outstanding, his income from land was worth £4,836 per annum and there was £3,242 in his chest.[8] The charity received about £23,000 from Sutton's estate and an endowment which produced an annual income, initially, of £3,872.[9] Yet by drawing attention to the way that charitable funds were invested, the foundation attracted criticism as well as praise, and, despite the scale of the endowment, became vulnerable to administrative and financial problems.

Sutton anticipated that there would be difficulties and, to ensure the implementation of his plans, he obtained an Act of Parliament and Letters Patent, secured royal approval and, eschewing the use of his own name, honoured the king by giving his charity the title of 'The Hospital of King James, founded in Charterhouse within the County of Middlesex'. As governors, he appointed some of the most powerful men at the heart of the Jacobean establishment, high-ranking churchmen and lawyers with the knowledge and authority to carry out his intentions and protect his legacy. They included the Archbishop of Canterbury and Bishop of Ely, the Deans of Westminster and St Paul's, the Lord Chancellor, the Lord Treasurer, the Chief Justice and one other Justice of the Court of Common Pleas, the Attorney General, and a Master in Chancery. The Stuarts came to have a direct as well as an honorary involvement. In November 1613 the Queen nominated the first poor scholar, and two years later a pensioner was admitted on her nomination. It became customary for candidates for admission to

be nominated on behalf of the King, the Queen, the Prince of Wales and his sister Elizabeth, Queen of Bohemia.

The link with the crown and Sutton's other arrangements reinforced the charity's prominence, and emphasised the respect in which it should be held. His foundation had a considerable significance in the context of the collective need to demonstrate that England could provide poor relief as capably as its Roman Catholic neighbours, and to refute claims that charitable giving had been adversely affected by the Reformation. Those allegations had proved difficult to counter, even though they were partly nostalgic.[10] In 1598 John Stow complained of the way in which wealthy Londoners were spending money for show and pleasure, on such buildings as summer-houses:

> much unlike to the disposition of the ancient Citizens, who delighted in the building of Hospitals, and Alms houses for the poore, and therein both imployed their wits, and spent their wealthes in preferment of the common commoditie of this our Citie.

This kind of harking back to pre-Reformation times drew the suspicion of Catholicism, and Stow was indeed suspected of having Catholic sympathies.[11] But the point had to be addressed, and Sutton's foundation gave Protestant propagandists a formidable example to deploy in their response.

Henry Holland, Sutton's first biographer, declared that the Papists' boasts about their own good works would be for ever silenced by his charity, for there was not an almshouse in the world to match it. Indeed, William Laud, who was to become Archbishop of Canterbury and a governor of the hospital, extolled it as 'the greatest work' since the Reformation. The foundation provided strong evidence to support Andrew Willet's claim that post-Reformation charity exceeded that 'in the like time of popery' and so he described it, in similarly extravagant terms, as 'the greatest gift that ever was given in England, no abbey at the first foundation thereof excepted'.[12] Thomas Fuller extended its uniqueness even further with his description of the charity as a 'Master-piece of Protestant Charity ... Peerless in Christendom on an equal Standard, and Valuation of Revenue.'[13]

Others welcomed Sutton's munificence because it could be used as an example, to encourage further generous giving. Henry Farley, a scrivener, was busy from 1615, if not earlier, trying to promote the restoration of St Paul's Cathedral and the replacement of its spire, burnt down in 1561. Sutton provided an ideal model for him to point to, having 'turned Charter-house to charitie'. Farley implied that a half of the sum which had been invested in the hospital would suffice to fund the restoration of St Paul's, although he stressed that the scale of Sutton's charity was extraordinary:

But such a worthy Phoenix is so rare,

That hardly any will with him compare;

Nay would tenne thousand would now joyne in one,

To doe as much as he alone hath done.[14]

Yet, despite such accolades and the seniority of the governors, the charity attracted influential opposition and legal challenges aimed at preventing the implementation of Sutton's scheme, attributed by the lawyer Sir Edward Coke to 'some great Courtiers'.[15] The avariciousness of those who hung around the Court, hopeful of picking up rich plums such as this, together with envy and resentment, may have played a part in the resistance to the setting up of the charity, but the opposition went much deeper.

Sutton's nephew Simon Baxter mounted the strongest challenge to the execution of his will, claiming that as the heir by law, he should inherit the whole estate. This was such a high-profile case that the Privy Council appointed Sir Francis Bacon to report upon it, although he was also acting for Baxter. Bacon proved to be the most prominent and influential critic of the proposed foundation, but rather than being simply a justification of Baxter's claim, his advice to the King was a wide-ranging consideration of the scheme, and alternative applications of Sutton's wealth.[16]

Bacon summarised Sutton's intentions as providing for an almshouse, a school and a post for a preacher; that is, poor relief, advancement of education and the propagation of religion. He used the opportunity to present his views on these topics, while making suggestions for possible uses of Sutton's fortune. The first objective could be better secured by establishing a number of smaller almshouses, where they were most needed, rather than one of 'exorbitant greatness' that would bring in the poor. As there were too many grammar schools already, Bacon argued that part of Sutton's endowment, intended for education, should be used to increase the salaries of university lecturers and to encourage them to remain in their posts longer, for many of them left within a few years to take up a benefice or a post as chaplain in an aristocratic or gentry household. The advancement of religion, he suggested, could best be served by funding a college for religious debates, an establishment for converts to the Protestant faith, or to provide stipends for preachers in those areas where religion was neglected, following the example provided by Elizabeth I. But, if the scheme were to go ahead, an establishment on that scale and in those buildings ought to be designed to benefit maimed soldiers, clergymen, householders and merchants, who should not be mixed with 'the basest sort of poor'.[17]

In his advice Bacon was reiterating views that he had already expressed. He had put forward the case for the augmentation of the stipends of university staff a few years earlier, in *The Advancement of Learning* (1605). Moreover, his antipathy to almshouses was not confined to the proposed foundation at the Charterhouse, on

the basis of its size. When Edward Alleyn applied for a patent of incorporation for the College of God's Gift at Dulwich in 1618, Bacon also argued that 'hospitals abound, and beggars abound never a whit less'. He did not add that this was the inevitable result of the policy, which he had advocated, of excluding the indigent poor from such institutions.[18]

Baxter's challenge failed and Bacon's advice was not taken, although his social preference influenced the governors when they specified who should be almsmen. They were to be bachelors or widowers over fifty years old (but if they were maimed they could enter at forty), who had been servants to the King, 'either decrepit or old Captaynes either at Sea or Land Souldiers maymed or ympotent', merchants fallen on hard times, those ruined by shipwreck, fire or other calamity, or held prisoner by the Turks.[19] The Letters Patent obtained by Sutton from the King on 22 June 1611 to confirm the establishment of the almshouse and school in the Charterhouse, not at Little Hallingbury in Essex, as he had first intended, referred simply to 'poore, aged, maimed, needy, or impotent People', without further qualification.[20]

The categories of beneficiaries and terminology used by Sutton, Bacon and the governors were similar to those described in the Act of Charitable Uses of 1601 and its extension to include the Oxford and Cambridge colleges and cathedral and collegiate churches of 1605.[21] But the disparity between the definition in the Letters Patent and that specified by the governors was wide enough to create uncertainty regarding the extent to which the foundation was intended for the poor, or for those from other sections of society who had suffered misfortune. In 1642 the governors revoked the earlier orders, preferring the terminology of the Letters Patent, and the question was raised periodically during the next two hundred years.[22]

Bacon was not alone in questioning the value of such a large foundation with limited functions, or taking the view that the wealthy should not postpone their charitable gifts until death.[23] The clergyman and writer Robert Burton preferred hospitals of all kinds, for children, orphans, the elderly, the sick, the insane and soldiers, and pest-houses for those with infectious diseases. He was critical of those 'gowty benefactors' who extorted money by 'fraud and rapine' until, towards the end of their lives, they set aside funds for an almshouse, school or bridge, effectively having taken from a thousand people to provide assistance for ten.[24] In 1613, £10,000 from Sutton's estate was allocated by the overseers of his will – the Archbishop of Canterbury and the Bishop of Ely – to the King, for the rebuilding of the bridge at Berwick-upon-Tweed. Therefore, the mention of a bridge may be read as a thinly veiled reference to the Charterhouse and Sutton. They authorised the donation on 26 June and judgement in favour of the governors in Baxter's case was given on 1 July. The sceptical view of donors' motives expressed by Burton endured, and was echoed at the end of the century by the political economist Charles Davenant, with the comment that hospitals 'very often are but so many Monuments of ill-gotten riches, attended with late Repentance'.[25]

As well as doubts about motives, the use of the Charterhouse, which Bacon regarded as inappropriately grand for an almshouse and school, also attracted unfavourable comment. Sutton may have chosen it partly as a compliment to the King, recalling his first arrival in London, and partly out of a nostalgic preference for a building of the previous century, rather than the newer and more fashionable, symmetrical, style.[26] In this respect, as in others, his death at such an early stage in his project prevented him from overseeing its implementation, although he did appoint Francis Carter as surveyor. Carter was Clerk of Works to Henry, Prince of Wales (who died in 1612), when Inigo Jones was his Surveyor. By 1614 Jones was Surveyor of the King's Works, and Carter was Chief Clerk.

Carter was retained by the governors, and proved to be anything but conservative. As well as the conversion of the buildings, the enlargement of the chapel, and the rebuilding of the tennis court as the school, some new ranges were needed. One was built to connect the chapel with the courtyard house, and this incorporated an open arcade of six rusticated arches with architrave, frieze and cornice, a fashionable Italianate feature, echoing monastic cloisters. New ranges were also erected in the Great Court, to provide accommodation, and there, and indeed throughout the site, Carter erected Classical doorways, triangular pediments and decorative finials, which were incongruous additions to the Tudor Gothic buildings. The work was completed in time for the Brothers, Scholars and staff to move into their new accommodation in October 1614.

Sutton's decision was an expensive one; the Charterhouse cost him £13,000 and the governors spent more than £8,000 adapting it. The combined sum of £21,000 was far more than would have been required for wholly new buildings on a vacant site. Wadham College, Oxford, was built in 1610-12 to house roughly the same number of people as the Charterhouse and cost £10,918 to build, and almshouses were provided for much less: the outlay on Whitgift's hospital in Croydon, built in the late 1590s for twenty-eight **alms-people**, was £2,700.[27] Nor was there any advantage in terms of speed, for the conversion of the Charterhouse took as long as the erection of new buildings would have done. But Carter's work was successful enough to soften Bacon's disapproval, for he included it in the list of buildings 'which tend to publique use and ornament' erected since James I's accession in 1603, which he incorporated in the royal proclamation prohibiting any more new buildings in London, drafted in 1615.[28]

Within the buildings, Sutton's grandiose tomb may have been regarded as pretentious and inappropriate for someone of his rank. His father, Richard Sutton, was Steward of the Courts of the City of Lincoln and was described as a gentleman. Thomas Sutton's coat of arms was assigned only after his death, in time for his funeral. Despite his direction that this should be carried out 'with the least pomp and charge as may be', his executors arranged a grand affair that cost £1,673. It was directed by William Camden, Clarenceux King of Arms, with a long procession of old men, the governors and other

mourners, making its slow and solemn way from Sutton's house at Hackney to Christ Church, Newgate Street, watched by 'a Vast Crowd of Spectators'. On the completion of the Chapel his coffin was taken to the Charterhouse in a torchlight procession, on the third anniversary of his death. These obsequies conspicuously demonstrated the respect accorded to a man who had given so much to help the poor, yet their scale perhaps irritated those who looked with disfavour on ostentatious display at funerals.[29]

The tomb was by Nicholas Johnson (or Jansen), Edmund Kinsman and Nicholas Stone. It is surmounted by the figure of Charity with three small children and the relatively brief inscription states that the hospital was founded at Sutton's 'only costs and charges ... and endowed with large possessions'. Such references to his munificence could have been intended to assuage criticism of the monument's scale, emphasising that it commemorated Sutton's generous charity as well as his life. But minimal inscriptions were favoured by some, giving only the 'name, state and calling' of the deceased.[30] References in monumental inscriptions to the deceased's philanthropy were still far from common, and this may have been one of the examples that provoked the antiquarian John Weever to grumble, in his *Ancient Funeral Monuments* (1631), that in some epitaphs 'more honour is attributed to a rich quondam Tradesman, or griping usurer, than is given to the greatest Potentate entombed in Westminster'.[31] The inclusion of a usurer in this context does suggest that Sutton's epitaph was one of the examples that had annoyed Weever.

While there is a danger of interpreting all such comments as being directed against Sutton, undoubtedly some of them were. The foundation brought into sharp focus the question of how charitable funds should be invested, as well as making manifest the size of Sutton's fortune, hitherto a matter for speculation, but now apparent both from the scale of the establishment at the Charterhouse and the publication of his will.[32] Wealth begets envy and the contents of a will produce disappointment as well as gratitude, while such an overt demonstration of his wealth could be construed as vanity, even though applied to benefit the disadvantaged. Henry Arthington, in the 1590s, declared that the giving of alms should be done compassionately and without pride, and that the donor should not seek to gain merit from the gift.[33] Thomas Gainsford, in 1616, included 'gorgeous buildings, sumptuous tombes, large hospitalles' among those vanities 'wanting the substance of good deedes and true humilitie'.[34] While large funerary monuments were not uncommon in the early seventeenth century, no other hospital was on the scale of Sutton's foundation, and the date of Gainsford's work suggests that its recent establishment in the Charterhouse prompted him to include hospitals in this context.

Practicality as well as humility favoured the foundation of smaller societies of the kind which Bacon and Burton had in mind, and the wider distribution of charitable investments. This was the pattern intended by Alleyn, whose College

of God's Gift at Dulwich contained places for twelve old people and twelve scholars, and his almshouse at Cripplegate provided for ten alms-people. He left directions in his will for the erection of two more almshouses of the size of that at Cripplegate, although his estate proved to be too modest for his plans to be implemented.[35] Matthew Chubb of Dorchester, who was said to have been worth £15,000 at his death in 1617, founded three almshouses over a number of years, at Crewkerne, Shaftesbury and Dorchester, for eight, sixteen and nine poor people respectively.[36] Between 1607 and 1614 Henry Howard, Earl of Northampton, endowed almshouses at Clun in Shropshire, Castle Rising in Norfolk and the Trinity Hospital at Greenwich in Kent, providing a combined total of forty-four places at a cost of more than £9,000 for the buildings and endowment, which was proportionately a considerably lower investment per place than Sutton's had been.[37]

These were typical cases, since donors with the means to provide almshouses preferred a number of small establishments to one large institution. The average number of alms-people provided for in English almshouses during the period 1480-1660 was twelve, and a survey of returns from eighty-nine of them in 1665 showed that the actual number in residence averaged just seven.[38] This applied to both London and provincial cities. For example, the average number of places in almshouses in Exeter by 1640 was just under ten.[39]

No partisan conclusions could be drawn from this, for it was also the pattern in cities and towns on the near Continent, whether Protestant or Roman Catholic. Those in the Low Countries had numerous similar institutions, with thirty founded in Catholic Bruges during the seventeenth and eighteenth centuries, generally as small almshouses. In Counter-Reformation Antwerp, the twelve new almshouses for the elderly founded between 1594 and 1656 together provided places for 101 residents.[40] In Holland, too, the establishments were generally small. Just two new almshouses in Amsterdam were relatively large foundations. The Sint Andrishofje was founded in 1614 for poor Roman Catholics and accommodated sixty-six women, and the Huiszitten Weduwenhof, a non-religious institution, was established in 1650 for about 100 poor widows, their children and elderly spinsters.[41]

Sutton's Hospital was an unusually large foundation in the context of north-west Europe. But far larger charitable institutions had been established in the Italian cities, as was pointed out by Edward Knott, who drew attention to examples in Naples and Rome, while condemning English almshouses as 'mean Nurseries of idle Beggars and debauched People'. Supporters of Sutton's charity dismissed Knott as prejudiced because he was a Jesuit (he was the Society's Provincial in London). They claimed that the size of an institution was not in itself a virtue, and alleged that those he cited were the inevitable results of aspects of the societies which created them. Naples was commonly associated with syphilis, because it was thought that the disease had been introduced to Europe there in 1494, and

so it required large hospitals to treat the infected, while the number of orphans in Rome was attributed to the sexual lapses of the celibate priesthood. A less contentious point was that large institutions had grown through an accumulation of donations, while Sutton's charity was unique because of the size of a single legacy by one donor.[42]

Small establishments, separately administered, spread the risk of losses through corruption, a common and apparently justified fear. The Act of Parliament of 1601 for setting up commissions of charitable uses was passed because of concern that charitable endowments were misused through 'frauds, breaches of trust, and negligence'.[43] In general terms, Bacon favoured dividing an inheritance into a number of modest legacies, rather than making a single large bequest that would be a magnet for predators.[44] He applied this principle in his advice to the King regarding Sutton's charity, anticipating that it would attract those who intended to exploit it and that its wealth would be misused, chiefly to the advantage of the Master. The choice of governors was good, but they could not always be attentive to the hospital's business. Although they were to meet only twice a year, a standing committee was formed to deal with the charity's business at other times, meeting every six weeks. But his concern proved justified, for experience showed that in practice they were unable to 'neglecte their weightier affaires of the whole Common Wealth for lesser matters of our private house'.[45] And, though his anxiety about the integrity of the Masters proved to be exaggerated, some of the administrative and financial officers did take dishonest advantage of their positions. Thomas Hayward made the post of Registrar so profitable that, as he admitted, he was offered £1,000 for it 'many times', although the annual salary was only £30.[46]

A more positive feature of small institutions was the sense of fellowship which they could engender. Large ones, on the other hand, created the problem of magnifying the personal tensions that arose, among the alms-people and with the staff, producing a difficult atmosphere, and certainly not that which the founders and advocates of almshouses hoped for. In the aftermath of the turmoil of the civil wars in the 1640s, there was a preference in some circles for small Christian communities, resembling monasteries.[47]

Sutton's foundation anticipated such wishes in terms of organisation, although not of scale. The connections with the Carthusian priory were acknowledged, by reverting to the name Charterhouse (it had been known as Howard House during that family's ownership), the term Poor Brothers was adopted to describe the **almsmen**, and regulations were enforced which prohibited almsmen and officers from marrying, and ruled that women (including the Scholars' matrons) should not live within the precincts. While many early modern almshouses provided accommodation for both sexes, all-male and all-female institutions continued to be established, such as Thomas Seckford's almshouse for thirteen men at Woodbridge in Suffolk and, later in the seventeenth century, the Duchess of Somerset's hospital

for clergymen's widows at Froxfield in Wiltshire. Nevertheless, the arrangements at the Charterhouse provoked the allegation that it had been founded on Roman Catholic principles, with its members bound to Roman Catholic rules. Those who criticised the charity because they detected 'something of Popery' declared that it should not be imitated, for that reason.[48]

Given the Earl of Northampton's beliefs, his foundations should surely have been a more obvious target for anyone on the watch for Catholic practices in almshouses. In fact, the rule at Trinity Hospital was that those who were unable to recite from memory the Lord's Prayer, the Creed and the Ten Commandments were not to be admitted. A similar requirement applied at Lady Dacre's foundation at the Emanuel Hospital, where failure to attend services and sermons was punishable by expulsion, as was 'obstinate heresy' at Whitgift's Hospital. At Castle Rising, prayers were to be said three times a day and the alms-women were required to attend two services each day, the regulations of Trinity and Emanuel hospitals stated that those who were blind or too infirm to go to daily prayers were not to be admitted, and at the College of St George at Windsor the almsmen had to attend two services each day.[49] The college was thought to be one of the precedents followed by Sutton when he was considering the form that his foundation should take, since he had his own copy of its orders and rules.[50]

The regulations set out by the governors of the Charterhouse were chiefly concerned with practical arrangements and the orderly conduct of those within the community. The governors, officers and Brothers did have to take the Oaths of Allegiance and Supremacy when they were appointed or before they entered, although this was neglected at times and the other religious requirements were relatively simple. All members of the community had to attend chapel daily, with a weekly sermon on Sundays. They had to take communion at Christmas, Easter and Whitsuntide, but exceptions could be allowed with 'some lawful excuse and just cause'. Such comparatively undemanding requirements may have been interpreted as providing an opening for the admission of Roman Catholics.[51]

In this respect Sutton was not treated respectfully after his death, despite the encouragement which he had given to those anxious to emphasise the scale of Protestant charity. Indeed, rumours that he had been a Catholic were so persistent that Edward Cresset, the Master during the 1650s, made enquiries about his religious leanings, only to find that he had been a 'good, honest Protestant' who kept his own chaplain.[52] Even so, as late as the 1820s a local historian felt it necessary to stress that Sutton was a Protestant, even though in the 'Catholic times' the buildings had been a monastery.[53]

Sutton had become an isolated and withdrawn figure in later life, which may have contributed to the development of such rumours, in turn limiting the support for his charity. He had operated outside the political and merchant communities, in London and Newcastle-upon-Tyne, unlike other benefactors, who were able to entrust the administration of their charity to the appropriate city or borough

corporation, or livery company.[54] His patrons, Richard Cox, Bishop of Ely, and the brothers Robert and Ambrose Dudley, Earls of Leicester and Warwick, had died between 1581 and 1590, and he seems to have had little influence at court, being both elderly and reclusive. Nor did he seek it, giving a sharp refusal to Sir John Harington's attempt to promote a scheme whereby Sutton would make Charles, Duke of York, his legatee in exchange for a peerage.[55] He had already decided that an almshouse was a suitable use for his fortune, perhaps following the example of the Earl of Leicester, whose hospital for twelve elderly or disabled soldiers had been established at Warwick in 1571.[56]

As well as doubts about his religious loyalties, there was disquiet about the way in which Sutton had amassed his fortune, especially his activities as a moneylender. He was criticised for being a usurer, which by extension was perceived as being 'to the disparagement of the charity'.[57] Regarded as a livelihood that exploited the efforts of others, usury, although legalised by the Usury Act of 1571, was still not wholly respectable and continued to attract hostility, especially among those urging the need for charitable giving.[58] Sutton's contemporary Nicholas Breton described a usurer as 'a figure of misery' and, significantly in this context, complained that 'His eye is closed from pity, and his hand from charity.'[59] In 1608 Joseph Hall characterised a hypocrite as someone who, 'With the superfluity of his usury … builds an hospital, and harbours them whom his extortion hath spoiled; so while he makes many beggars he keeps some.' Yet there was an ambivalence about such opposition to usurers employing their wealth for charitable purposes, which was exemplified by Hall, for just three years earlier he had encouraged Sutton to pursue his plans to create an almshouse charity, and overcome the difficulties that he was then encountering.[60] Sutton's reputation as a usurer and property developer was so strong that his intentions were misunderstood, even after he had acquired the Charterhouse. Among the applications on behalf of those hoping for a place as a pensioner or a post on the staff was one from an Essex man, who sent his brother post-haste to London to ensure that he would obtain lodgings at the Charterhouse when it was divided into tenements.[61]

Sutton was also censured for his meanness. Edward Knott complained that he had, 'lived a wretched and penurious life, and drew that masse of wealth together by usury'.[62] An apology written shortly after his death admitted that the charity was denigrated by those who claimed that he had put to good use the wealth he had acquired by unlawful usury, but excused his earnings by this means, because of his charitable intentions and good character.[63] The charity sought to promote a positive image of him, as a loyal Protestant who was a successful administrator, soldier and a businessman of 'vertuous Frugality'.[64] While his fair dealing and the soundness of his credit were indeed acknowledged, his wealth aroused envy, and his parsimoniousness was resented. Even Henry Holland conceded that he 'lived sparingly and frugally' and his reputation was such that he was supposed to have been Ben Jonson's model for his miserly character Volpone, although Jonson denied this.[65]

Sutton was not alone in attracting such disapproval. Of his wealthy contemporaries, Sir Horatio Palavicino was described as an 'extreme miser' and Sir John Spencer was also an exceptionally thrifty man, who did not allocate any of his fortune for benevolent purposes.[66] To a certain extent, Sutton's charity drew the criticism that might have been directed at all three men, by presenting a target for those unhappy with the acquisition and the disposal of wealth on such a scale. Palavicino and Spencer provided no such mark for critics to aim at.

Sutton's background, the way in which he had amassed his wealth, the scale of the endowment, the size of the institution and the suspicion of corruption, had all generated adverse reactions, with even its Protestant credentials being questioned. Perhaps significantly, no other wealthy benefactor sought to emulate Sutton by establishing a foundation that resembled the Charterhouse in terms of scale, setting and character. Despite being hailed as a symbol of what English Protestant charity could achieve, it also gave substance to fears that large charitable institutions would be exploited, and donors continued to prefer smaller almshouses, rather than follow Sutton's example.

CHAPTER 2

MAGNIFICENCE, MUNIFICENCE, AND RELIGIOUS GOVERNMENT

Sutton's financial abilities and thriftiness were badly missed during the early years of the charity, which quickly got into difficulties, significantly reinforcing the reservations about the hospital. His death before the charity was established was surely unfortunate, for although he had appointed Francis Carter to convert the buildings and John Hutton as the first Master, and his general intentions were known, the practical and financial arrangements had not been determined. These were set in train by the governors in 1613, but the next few years saw a number of changes among the senior officers. The Master could not hold a benefice in addition to his post at the Charterhouse, and Hutton resigned in 1614 to take the charity's living of Dunsby. His successor, Andrew Perne, left in 1615 on being appointed Proctor of Cambridge University. Peter Hooker was then appointed, but died in September 1617. The resignations of the first two Masters and the death of the third, within a little over four years of the governors' first meeting in 1613, must have created difficulties. These were exacerbated by the dismissal in 1616 of Humphrey Hartneys, the first Preacher and Deputy Master, who had, 'brought a greate scandall upon himselfe and the hospitall'.[1]

It may have been realised that appointing young clergymen would lead to such a rapid turnover, for they would be likely to prefer a living, since it provided a better income and would allow them to advance their careers. Perhaps in an attempt to achieve greater stability, the King intervened to secure the appointment of Francis Beaumont following Hooker's death. He was a scholar and 'dramatic writer' (not to be confused with the dramatist of the same name).[2] The Beaumonts were connected by marriage with the Villiers family, also Leicestershire gentry, and George Villiers, successively Earl, Marquess and Duke of Buckingham. Villiers was at that time in the ascendancy at court, as James I's favourite, and almost certainly advanced Beaumont's candidature. The monarch had the right of appointment only if the post had been unfilled for two months, and the grant to Beaumont was made just a few days after the expiry of that period. The governors had met once since Hooker's death, to deal with routine matters. It seems possible

that they did not approve of Beaumont's appointment, for the first three Masters had been clergymen, and this was their preference. Significantly, there is no record of his appointment in the minutes of the governors' meeting, or the register of the charity's contracts and appointments, even though those documents were consulted to see what procedure should be followed.[3]

The winding up of Sutton's complex financial affairs had not been helped by the death in 1614 of John Law, one of the two executors appointed by him. The other was Sir Richard Sutton, who was not a relation of his, and who then had to carry out the task on his own. Money owing to Sutton was received for a number of years. Sir Richard's work as sole executor included the payment of £12,115 in legacies, the £10,000 for the bridge at Berwick-upon-Tweed, the costs of Sutton's funeral and monument, legal charges and various other outgoings, all of which totalled £26,840.[4] In addition, the governors granted the manor of Tarbocke near Liverpool to Simon Baxter, as Sutton's heir, which he sold in 1615 for £10,500.

Another deficiency came from the failure to obtain payment from Thomas, Earl of Suffolk, for the manors of Hadstock and Littlebury, in Essex. Sutton had granted them to him, on the condition of his payment of £10,000 to the executors within a year of Sutton's death. If he declined, the manors were to be sold. Yet the Earl neither paid the money nor relinquished the property before his death in 1626, despite the governors' attempts to take possession.[5] That non-payment and the donations to the King and Baxter effectively reduced the sum that would have come to the charity by £30,500, and so too the amount of property which could be bought to generate income. This was badly needed, for by 1620 recurrent costs, legal charges and the expense of adapting the buildings had increased expenditure beyond the anticipated amount. Despite some retrenchment, in 1624 the total loss was said to have been £8,000, roughly equivalent to two years' revenue. Rent arrears amounted to £1,414, while the hospital owed £1,297 in long-term debts.[6]

Costs were incurred in attempting to obtain an Act of Parliament to confirm the foundation. Even when the almshouse and school were established, some antagonism lingered on. The governors' first attempt, in 1614, failed, after questions were raised regarding their powers to grant leases at rents which were lower than the true value. This was an advantage for those who were able to secure such terms, but disadvantaged the charity. It was a significant point, for an analysis in 1629 showed that an extra £743 could be added to the annual income by raising rents from just seventeen tenants to their true economic level. But that could not be done until their current leases expired, and the statutes prohibited the granting of a new lease more than two years before the expiration of the existing one.[7] An anonymous historian of the charity, writing in 1669, explained this abuse of the endowment with the comment that, 'many of the tenants to the hospitall are descended from servants to the Founder – and usually plead in the behalfe of the good bargaines they hold, that they are Mr Suttons rewards to

their auncestors for what services they did – and indeed many of his tenements seemed to be rather rewards than bargaines'. In an attempt to curb sharp practices when property was let, the term of any lease was restricted to twenty-one years and no entry fine could be levied at the commencement of a lease.[8] Nevertheless, the reduction of the charity's potential income in this way gave its critics a strong argument.

The death of Francis Beaumont on 18 June 1624 provided the opportunity for change. The governors wished to return to the practice of appointing a clergyman, but Prince Charles swiftly intervened and recommended another literary figure and courtier, Robert Dallington, a member of his household who was ordained as a deacon, but not yet as a priest. On this occasion, Charles, as Prince of Wales, did not wait for the expiry of the stipulated two months, but acted within three weeks.[9] Although the governors acquiesced and confirmed the appointment on 9 July, they registered their disapproval by reiterating the qualifications for the Master in the minutes of their meeting. These were that he should be a clergyman who had been in holy orders for at least two years and was about forty years old. Dallington was sixty-three.[10] His appointment was followed a few months later by the award of a knighthood.

Charles's intervention signalled that the foundation had his support, and his promptness suggests that he was aware that it was needed. Charitable endowments were not secure. Sir Francis Bacon was aware that 'glorious gifts and foundations' were fragile, with their wealth liable to be swiftly dissipated, and predicted that Sutton's charity could prove to be 'a blaze of glory' that would 'quickly extinguish'.[11]

In October 1624, just a few months after Dallington became Master, the most serious threat since Baxter's claim had been dismissed now emerged, when the Duke of Buckingham proposed that the Charterhouse should be closed. He was promoting schemes for an aggressive foreign policy, and wanted the endowment to be diverted towards the cost of creating a standing army of 10,000 or 12,000 men, to be sent to Ireland, 'or upon any other necessary service'. He had mentioned the danger to Ireland in an address to Parliament in the spring, but a more immediate undertaking was an expedition under the Protestant commander Count Ernst von Mansfeld, to recover the Palatinate for the King's son-in-law. Buckingham made strenuous efforts to provide for the raising and maintenance of Mansfeld's troops.[12] The plan to appropriate the Charterhouse's revenues was partly justified on the grounds that 'this Hospital is abused', and the fact that Buckingham put it forward at all is indicative of the charity's continuing fragility, ten years after the Brothers and Scholars had taken up residence.[13] He would not have made such a proposal while Beaumont was Master, given their connection, that link had probably provided him with information about the true state of the charity, and he did act soon after Beaumont's death.

In practical terms, however, its income could have made no more than a minor

contribution to the expense of Mansfeld's expedition or any other military venture, a point which William Laud seized upon in a vigorous defence of the foundation. He objected that its dissolution would be, 'a great scandal to this State and Church, and give the Roman party just occasion to triumph', and argued that to close such an institution so soon after its foundation could only deter those with charitable intentions. He feared, too, that its abolition might be a precedent to be invoked later to convert the property of colleges or cathedrals to secular uses.[14] Although Laud was then high in Buckingham's favour and his influence at Court was rising despite the King's dislike of him, even his forceful advocacy of the charity may not have been enough to defeat the proposal if it had been pursued. Buckingham's failure to persist with his plan was perhaps due more to the continued royal support for the charity (signalled by Dallington's appointment) than it was to Laud's reaction. It was said that Charles described the hospital as his 'Protestant argument'.[15]

Dallington had been a schoolmaster in Norfolk before attracting attention through his writings, and the subsequent patronage of the Manners family, Earls of Rutland. His first book was a translation of a part of Francesco Colonna's *Hypnerotomachia Poliphili*, which he published as *Hypnerotomachia. The Strife of Love in a Dreame*, in 1592. Travels in France and Italy during the 1590s with members of the Manners family led to *The View of Fraunce* (1604) and *A Survey of The Great Dukes State of Tuscany* (1605). He was a witness and beneficiary of the will of Roger Manners, fifth Earl of Rutland, in 1612, and secretary to his brother Francis, the sixth earl.[16] From *c.* 1605 Dallington served as a Gentleman of the Privy Chamber in the household of Henry, Prince of Wales, and compiled his *Aphorismes civill and militarie: amplified with Authorities, and exemplified with Historie, out of the first Quaterne of Fr. Guiccardine* for his instruction. After Henry's death in 1612, he re-dedicated the book to his brother Charles, with the flattering inscription that 'men look upon your worthy brother in your princely self', and secured a post in his household.[17] Dallington was not someone to be trifled with, and when a pirated edition of *The View of Fraunce* appeared, he reissued the work, with a preface criticising the morality of publishers, as well as containing general remarks regarding travelling.[18]

Charles' judgement in securing Dallington's appointment as Master proved to be sound, and under his direction the charity's problems were speedily tackled. The debts were paid and rent arrears reduced to only £187 by September 1625. He visited the estates and examined the terms of the tenancies.[19] In 1633 a settlement was reached with Theophilus, second Earl of Suffolk, over the long-standing dispute regarding the manors of Hadstock and Littlebury. Like his father, he had contested the payment, but now agreed to pay the hospital £7,000, at £500 per annum.[20]

As well as more efficient collections of revenue, Dallington introduced economies to reduce outgoings. The size of the establishment was cut, legal

actions were settled, administrative procedures were tightened and a table of annual expenditure was compiled. No matter was too small for investigation and reform. The junior officers' and servants' clothing allowances were halved, the practice of paying the officers in lieu of their drink entitlement was stopped, the laundresses' charges were found to be twice what was reasonable, and the Brothers were required to provide their own bed linen.[21] With these changes the finances were not only sound enough to permit the debts to be settled, but generated a surplus which, by the mid-1630s, funded the purchase of properties in Essex and Wiltshire, raising the annual rental to £4,504, and still leaving a reserve of £1,500.[22]

The governors' attempts to obtain an Act for the 'establishing and confirming of the foundation of the Hospital of King James' had continued, but had met objections in Parliament. A Bill, regarded by Archbishop Abbot as 'very necessarie', was introduced in 1624, with the continued support of Sir Edward Coke – who described the charity as 'the bravest Foundation, that ever was in the Christian World' – but that, too, was unsuccessful.[23] Eventually the opposition was overcome, and a Bill passed both Houses in 1628, after scrutiny by a Commons' Committee which had a brief to consider past 'misdemeanours' at the Charterhouse.[24]

In 1627 a set of statutes regulating the charity was promulgated, which reiterated that no member of the foundation was to be a married man, and ruled that those admitted as Brothers were not to have an income of more than £24 a year or an estate worth more than £200 – a generous definition of poverty.[25] In addition to the Oaths of Supremacy and Allegiance, the governors, Master, officers and Brothers were required to take an oath that they had not paid money or given any other gratuity to secure their position. In 1634 a candidate for a Brother's place, nominated by the King, felt unable to take that oath, and so could not be admitted. The inclusion of the requirement in the statutes indicates that such venality was anticipated, and his very proper refusal suggests that it was practised.[26]

The statutes gave the Master the right to enforce discipline, and the Brothers were required both to obey his orders and treat him respectfully, with 'noe reviling speaches being to be used to his face or behinde his backe'. They were also expected to appear 'with all sobriety in their habit as become hospitall-men, wearing noe weapons, Long hair or any Ruffian-like or uncivill apparell'. They should not go to brothels, bowling alleys, alehouses or taverns; they were not to swear, take God's name in vain, complain about their fellow Brothers, or be 'given to any drunkenesse or any other notorious vice'. Drunkenness was a particular concern, with regard to both the Brothers and the staff. Dallington made an effort to enforce the rules. In 1626 the Registrar resigned, the Steward was dismissed in 1628, and was followed four years later by the Chapel Clerk, who was discharged for drunkenness. And the rules on females were reinforced, with

the instruction that 'no woman or woman kinde' should be buried in the chapel or burial ground.[27]

The Scholars' qualifications, as set out in 1613, were that they were to be more than nine years old, but not over fourteen, and the sons of poor parents. Poverty was specified as not having 'any Estate in Lands' to bequeath to the child. The charity did attempt to enforce this, at least during the early years, for in 1623 a boy was expelled when it was realised that his father, a surgeon, was rather well-off. The statutes also directed that a boy should be 'well entred in Learning answerable to his Age'. The Schoolmaster's duties included assessment of the candidates' suitability.[28]

The establishment of the new school created an exciting challenge. The governors entrusted the appointment of the first Schoolmaster and Usher to the Bishop of London, John King. As Schoolmaster he chose Nicholas Gray, a graduate of Christ Church, Oxford, with a reputation as a fine Classicist. Appointed to Charterhouse in 1614, he was a successful Headmaster, establishing the reputation of the school and creating the system for sending to university those who were, 'upon examination found to be good scholars'. The examinations were conducted by the episcopal governors' chaplains. Those who went to university were supported with an exhibition. The school had no connection with a particular college, or with either university. Gray had to relinquish the post in 1625 because he had married; the governors showed their appreciation by promising him the next benefice to become vacant, 'for the great good and faithful service hee hath performed and done in his sayd place'.[29] He was duly appointed rector of Castle Camps in Cambridgeshire and his brother Robert, Usher since 1619, replaced him as Schoolmaster.

The statutes specified that the Schoolmaster and Usher were to read to the pupils, 'none but approved authors, Greek and Latin, such are read in the best esteemed free schools' and to provide Greek testaments for those in the upper school for use in the Chapel. The Scholars undertook weekly exercises and, in addition, every Sunday, members of the highest form were to present to the Master, 'or any stranger', in the Great Hall, four Greek and four Latin verses on the second lesson for that day. The boys who were to be enrolled as apprentices, and not sent to university, were taught arithmetic and preparing accounts.[30]

The first boy to hold an exhibition was Thomas Croftes, in 1617. Initially the exhibitioners were paid £20 per annum, but, as part of the economy measures, in 1623 the sum was reduced to £16. A Scholar had to have been at the school for two-and-a-half years to qualify for an exhibition. By 1628 there were twenty-six exhibitioners at the two universities; the number fluctuated from time to time, depending on the charity's income.

An early beneficiary of the system was Roger Williams, who was nominated by Sir Edward Coke, for whom he had been, rather precociously, taking shorthand notes of sermons and of speeches in the Court of Star Chamber. His admission

was approved in June 1621, and he entered Pembroke College, Cambridge, two years later with an exhibition from Charterhouse which he held until 1629. He graduated in 1627 and declined two benefices before sailing to New England, where he arrived early in 1631. Uncomfortable with the rigid regime in Massachusetts, he left in 1636 and founded Providence, the first settlement of Rhode Island. The colony grew under his guidance, welcoming anyone, regardless of their faith. Civil government was conducted by a general assembly of inhabitants, which met monthly. Williams bought the land from the Native Americans and maintained friendly relations with them, studying their language and culture and publishing his findings in *A Key Into the Language of America* (1643). He returned to England in 1643 to obtain a charter for Rhode Island, which he achieved in 1644, and again in 1651 to secure its confirmation. His defence of toleration, and his argument that civil government did not have authority over religion were expounded in *The Bloudy Tenent of Persecution for Cause of Conscience*, which he published in London in 1644. Following the Restoration, another charter was granted, in 1663. Williams was an important figure in both the early history of the New England colonies and the Puritan revolution, for establishing not only the principle but the actual observance of freedom of worship, unhindered by state or Church.[31]

After Nicholas Gray's departure, Dallington's earlier experience as a schoolmaster probably benefited the school, which remained very popular during his Mastership. As well as the Scholars, day boys were also educated, and by the mid-1630s 'many Towne Boyes and Outcommers from divers parts of the Citty and Suburbs are received and taught in the hospitall Schoole'. The statutes restricted the number of non-foundationers to sixty each for the Schoolmaster and Usher, which, with the forty Scholars, implies a maximum of 160 pupils.[32] But success led to exploitation, with the practice of selling places attracting unfavourable comment, especially as the staff took £30 or £40 to accept a pupil. Parents who could afford such a sum could not have been poor. The governors were aware of some malpractice. Dallington was censured for trying to secure the admission of boys, by entering them as nominees of a governor who was absent.[33]

The number of pupils produced problems. Thomas Barrow paid Robert Brooke, Schoolmaster from 1628, £4 per year to look after his son Isaac – twice the accepted rate. But Brooke was negligent, and the senior pupil, who was a relative, not only kept an eye on Isaac but also taught him, and when he left recommended that Thomas should be withdrawn from the school. Brooke's negligence may have been due partly to the fact that he took so many of the 'town boys' himself. In doing so he deprived the Usher of pupils, and therefore income, prompting him to resign.[34]

Dallington continued to enjoy the governors' confidence despite such problems, and in 1629 he and John Donne, Dean of St Paul's and a governor, replaced Sir Richard Sutton as Thomas Sutton's executors, managing the income from his

estate that was due to the charity as the residuary legatee. After Donne's death in 1631 Thomas Winniffe, his successor as Dean, also replaced him as Sutton's executor.[35]

The administrative duties did not prevent Dallington from continuing with his literary work, or supervising the ornamentation of the Charterhouse. The second part of *Aphorismes civill and militarie* was published in 1629, and he improved the gardens and walks, with bay trees planted and the garden furniture finely decorated and coloured.[36] A more significant aesthetic contribution took place in 1626, with the removal of the central panel of the overmantel in the great chamber. It was replaced by one carrying the coat of arms of Charles I, and the initials C.R. in an oval, with the four evangelists in the spandrels.[37] The previous decoration of the panel is unknown, but it may have included the arms of Thomas, fourth Duke of Norfolk, who had installed the overmantel *c.* 1571. The new design emphasised Dallington's obligation to the King, in the appropriate setting of the ceremonial room, where the governors of the hospital met and both Elizabeth I and James I had held court.[38] In his own apartments, a fine plaster overmantel depicting Faith, Hope and Charity was installed, probably in 1626-7, when the 'Master's Chamber' was refurbished. It is based upon a drawing by Maarten de Vos engraved by Hieronymous Wierix as 'Les Vertues Théologales'. The imaginative modelling of the figures and details suggests the work of a master craftsman, perhaps one close to the court, although his identity is unknown.[39]

Changes in the Chapel during the 1620s and 1630s included the installation of an organ in a new gallery, in 1626. Benjamin Cosyn was appointed as organist. He had held a similar post at Alleyn's establishment at Dulwich, from 1622 until 1624.[40] The pilasters of the gallery screen have survived and carry motifs of musical instruments, trophies of war, and an array of edged weapons and firearms, symbolising peace and war, without any Christian iconography. The militaria include muskets, pistols, swords, halberd, partisan, drum, bandolier and apostles bags, helmet and guidons, while the musical instruments include cornetts, viols and lutes, shawms, a harp, recorder, trumpet and cittern.

The musical life of the Charterhouse was further enriched by the admission of the composer, and former soldier, Tobias Hume, who entered at Christmas 1629. In 1605 he wrote that: 'My Life hathe beene a Souldier, and my idleness addicted to Musicke.' He had served with the Swedish and Russian armies and was a composer of songs and pieces for the bass viol, which he favoured. *The First Part of Ayres*, which he published in 1605, was the first book devoted entirely to the viol, and two years later he published *Captain Hume's Poeticall Musick*. In a petition to the House of Lords in 1642 requesting the opportunity to undertake military service, he described himself as a Brother of 'that famous Foundation of the Charter House' and presented the hospital in an unflattering light, by claiming that he was living in misery, having being forced to pawn all his best clothes, and was so hungry that he was reduced to gathering snails in the fields and taking

them home to eat 'for want of other meate'. These claims are quite implausible, and there is no evidence to support them. His contemporary Ruben Seddon simply recorded, in his characteristically laconic manner, that Hume 'dyed on Wednesday 16 of Apr. 1645'.[41]

Christopher Gibbons may have been at the Charterhouse briefly while Cosyn and Hume were there. He was nominated to a Scholar's place in January 1627 and accepted by the governors in the following June, but if he did take up the place he would have relinquished it in 1628, after his mother's death. He had a distinguished career as organist and composer. Cosyn may have played a part in his musical education, for the organist's duties were 'to attend divine service every Sunday, holiday, and holiday Eve, and to bring up the Schollars to Musicke'.[42]

Other changes to the Chapel followed the installation of the organ. In 1636 John Colt, probably John Colt the younger, supplied a stone reredos of the Ten Commandments on two white marble tablets with an elaborate surround, flanked by figures of Moses and Aaron carved in alabaster. The whole was surmounted by a cornice with a semi-circular panel or compartment containing Jehovah in the clouds, and rested on a base ornamented by another cherub's head in the centre. The representation of Moses and Aaron in the context of a church or chapel had only one known precedent, a painted commandment-table at Whitgift's Hospital in Croydon, also in a private chapel, but in a less prominent institution than Sutton's Hospital. In 1637 Colt was paid for another panel, no part of which has survived, with the figures of the twelve Apostles. These were part of changes to the Chapel begun in 1635 with the creation of a raised sanctuary on which stood the communion table surrounded by wooden rails.[43] As Archbishop of Canterbury and so chairman of the governors, Laud, rather than Dallington, probably initiated those changes, and had carried out similar work in the chapel at Lambeth Palace.

By the beginning of 1637 Dallington's deteriorating health prevented him from carrying out his duties. The governors were aware that the administration would be adversely affected without his direction, with a risk of 'many disorders' that could disrupt the community and be 'to the scandall' of the hospital.[44] Such concerns show both their continued sensitivity for the charity's reputation, and their reliance on Dallington in curbing disruptive tendencies, especially among the Brothers. The junior officers and servants also treated him respectfully, if not warily, for although he had pledged to restore their clothing allowance to the former level when the house had cleared its debts, they did not complain of his failure to honour that promise until after his death.[45]

In his will Dallington left bequests to the Brothers and staff, and to the charity which he had founded at Geddington. He died on 22 February 1638 and was interred in the Chapel, having requested a modest funeral.[46] Unlike a number of those who served in the households of the early Stuarts, his predecessor Francis Beaumont and Sutton's executor John Law, no memorial was erected to him, despite the charity's considerable debt to his abilities.

Law's memorial was paid for by the charity, and was included by Johnson, Kinsman and Stone in their contract for Sutton's tomb. Stone noted that he made this 'letell monemont'.[47] It consists of a painted half-length figure of Law in an oval recess, flanked by elongated winged female figures characteristic of Stone's work. The figures support a deep cornice surmounted by a cherub blowing bubbles and sitting astride a skull. The tablet was placed at the east end of the south wall, and now stands above the arch leading to the ante-chapel.

Beaumont's monument, on the other hand, was made and installed quite independently of the charity, by his niece Elizabeth. She married, *c*. 1602, John Ashburnham, who died in 1620, and in 1626 the eminent lawyer Sir Thomas Richardson, who was recently appointed Lord Chief Justice of the Common Pleas and in 1631 advanced to Lord Chief Justice of the King's Bench. On 28 February 1629 she was created Baroness of Cramond in the Scottish peerage. The monument has Beaumont's effigy kneeling on a cushion at a prayer desk, flanked by pilasters formed from narrow bookcases. She included her name and status in the inscription, and incorporated the heraldry of the Beaumont family and those of her two husbands in the design, even though they had no association with Sutton's charity. This was one of four monuments that she placed in London churches, marking the advancement of her kindred from county gentry to a family with strong connections with the metropolis and the Stuart Court. The monument is unusual, as a private monument in the Chapel of the best-endowed charity of the period, the governors of which were, throughout the century, reluctant to permit the erection of any monuments at all, yet this one was commissioned by a woman and emphasises her own achievements and family genealogy. The extent of her achievement may be judged from the fact that no further monument to a Master was placed in the Chapel until that to Philip Fisher, who died in 1842.[48]

As successor to Dallington the governors appointed another middle-aged clergyman with strong connections at court. George Garrard had studied at both Oxford and Cambridge and was a successful barrister, before being ordained. He had shared lodgings with John Donne and remained one of his closest friends and a regular correspondent. Garrard was also a friend of William Laud, the Archbishop of Canterbury; Thomas Wentworth, Earl of Strafford (Lord Deputy of Ireland from 1631 and Lord Lieutenant in 1640); and Francis Cottington, first Baron Cottington (Chancellor of the Exchequer 1629-41), and was employed by the Earl of Northumberland from *c*. 1630, becoming his chaplain. His contacts with Donne and other powerful figures in the Carolean establishment would have given him a good knowledge of the Charterhouse's affairs.

Garrard canvassed assiduously for the post during Dallington's long final illness.[49] The King approved the governors' choice, although in making the appointment they failed to observe their own stipulations of fourteen years earlier, for he was a deacon but not yet ordained as a priest and was in his late fifties.[50]

Once appointed, Garrard divided his time and attention between the hospital and the court. Something of a gossip, in May 1639 he wrote that, 'I leave often the Charter-house to go to my Lord Admiral [the Earl of Northumberland], and to other of my Court Friends, to be rightly informed'.[51] Reforms were not needed, for the charity was now securely established and considered as the model against which similar charities could be compared. When John Evelyn visited the municipal orphanage in Amsterdam in 1641, he described it as 'a foundation like our Charter-house in designe, for the education of decay'd Persons, Orphans, and poore Children'.[52]

The clergyman and writer Donald Lupton included a section on the Charterhouse in his *London and the Countrey Carbonadoed and Quartred into severall Characters* (1632) and seemingly agreed.[53] He praised the charity for its 'magnificence, munificence, and religious government'. The first characteristic reflected the wealth of the founder, the second 'shows the means to make the good thing done, durable', while the third demonstrated the founder's intentions. The charity had sent 'many a famous member to the universities, and not a few to the wars'. Good government kept it secure and made it famous, and he shrewdly pointed out that 'had it been great without good government, it had long ere this time come to ruin', or it would have been 'laughed at and derided'. He regretted that it seemed unlikely that Sutton's endowment would be emulated, and commented that ''Tis to be pitied, that such religious, charitable houses, increase not in number'. But his praise was not without irony. He summarised the almshouse as 'A relief for decayed gentlemen, old soldiers, and ancient serving-men', the inclusion of serving men presumably being a reference to Bacon's well-known and disapproving prediction. And would gentlemen fallen on hard times be pleased to find themselves in the same almshouse as serving men? He also mentioned that 'many places here are sold for monies' and the suspicion of Popery, and asked that those who administered the charity should 'live religiously, govern civilly, avoid bribery, [and] keep their canons directly'. Was he hinting that they did not?

Despite such gentle ironies, Lupton's account fairly summarised the charity's condition around 1630. Dallington had put it on a firm footing, removing some of the grounds for the criticisms which had marked its early years, and helping to establish its reputation as England's foremost charity. However, the close association with the Church and political establishments that the founder had put in place was to attract hostile attention to the charity during the coming decade.

A NEST OF UNCLEAN BIRDS

George Garrard's time as Master was to be dominated not by internal concerns of the kind which Dallington had faced, but the problems caused by the Civil War, which erupted in 1642 after a period of rumbling discontent. The war had a major impact on Britain's society and economy, and few areas avoided its deleterious effects. London was not besieged and profited from supplying arms and equipment to the parliamentarian armies, and from being Parliament's headquarters. But it suffered from the absence of the court, interruptions of internal and overseas trade, heavy taxation, the absence of young men serving with the forces, an influx of refugees and an increase in the numbers requiring poor relief. Its charities were adversely affected through a reduction in incomes, as tenants of the properties providing their endowments suffered losses due directly to the troops or, less traumatically, taxation and other levies.

Sutton's Hospital could not escape from the war's political and economic effects, especially as its governors were high-ranking figures. This had been emphasised during the 1620s and 1630s, with senior churchmen holding offices of state. John Williams, Bishop of Lincoln, was Lord Keeper of the Great Seal from 1621 and William Juxon, Bishop of London, was appointed Lord High Treasurer in 1636. Williams was translated to the Archbishopric of York in 1641 and Thomas Winniffe, already a governor as Dean of St Paul's, was consecrated Bishop of Lincoln.

By 1641 the governors were aware that the designated balance of six clergy and six lawyers had not been maintained, and resolved that in future 'wee will observe our said former Orders made in that behalfe'. But the circumstances were changing and when Lord Finch was removed (following his impeachment by the Long Parliament and flight to Holland) the vacancy should have gone to a common lawyer. However, the Earl of Warwick was appointed 'for certen speciall reasons'.[1] The Earl of Essex, who was to be Parliament's Lord General, was chosen later in 1641, but this was following the death of Sir Henry Marten and was not as a result of an expulsion. Indeed, there was no purge of the clergy or the royalists among the governors for another four years. In January 1644 the Bishop of Lincoln resigned, as he was unable to attend the assemblies. But at the meeting

at which his resignation was accepted, the Archbishops of Canterbury and York, the Bishop of Ely, Lord Littleton, Sir Robert Heath and Sir John Bankes were still listed, as absent governors, even though they were royalists, either actively supporting the King or, in the case of Archbishop Laud, in prison.[2]

Problems arose from the absence of so many of the governors, who were with the King or commanding the parliamentarian forces. In October 1643 the House of Lords was told that, 'so few of the Governors are in Town, as there are not a Number to meet for the Settlement and Disposing' of the hospital's affairs. No governors' assembly was held between 21 April 1642 and 25 January 1644 – an unusually long interval of twenty-one months. The Lords' response was that the archbishops and bishops were no longer qualified to act as governors and were displaced. An ordinance was prepared to permit the governors to eject those who were royalists.[3] But this was not urgent, for the absent governors could not influence the management of the charity. Bankes, Laud and Littleton were not replaced until after their deaths, and not until December 1645 were the Archbishop of York, the Bishop of Ely and Heath removed, while William Juxon, Bishop of London, continued to attend the assemblies until he resigned in the same month, pleading ill health.[4] The parliamentarian governors did not act in a partisan manner to eject the royalists, nor did they respond promptly to enforce Parliament's directives, even though by October 1645 seven of them sat in the House of Lords.

The absence of some governors contributed to the long interval between their meetings, but the numbers attending those assemblies which were held were similar to the pre-war years, with an average of ten governors both during the 1630s and between 1641 and 1647. A significant change was the absence of Laud after his arrest in 1641, which broke a long period of continuity. He had missed only one of twenty-four assemblies since his election as a governor in 1628, and at fifteen of them had presided as chairman, after his translation to Canterbury in 1633. By contrast, five governors served as chairman at the next fourteen assemblies, although from June 1645 some stability was achieved, with the Earl of Northumberland chairing all but one of the next seven assemblies.

Parliament had intervened in the charity's affairs from an early stage, as the country slipped into war. In April 1642 the governors resisted the recommendation of the House of Commons to appoint, as Chapel Reader, a Fellow of Trinity College, Dublin, who could no longer hold his post because of the rebellion in Ireland. They preferred their own candidate, who not only had a clearer voice for speaking in the Chapel, but had been a Charterhouse Scholar and their policy was to 'support those that have ben poore Schollers of the foundacon before others'.[5]

A few months later the Charterhouse attracted the attention of the House of Lords, when one of the Brothers, Robert Davies, heckled a sergeant recruiting for the Earl of Essex's army in nearby Smithfield. He shouted that, 'all were Rogues that went with the Earl of Essex, and the Earl of Peterboroughe', that he 'wished

the Earl of Peterborough were hanged' and that it were no matter if all those who served with them were hanged. This rash behaviour reflected his character as well as allegiance. He had been disciplined earlier as, 'a great disturber of the generall quiett' of the hospital, and this new offence led to both his dismissal and imprisonment on the orders of the House of Lords. The involvement of the Lords in such an apparently minor incident, which may not have been an unusual one in the tense atmosphere in London at that time, seems disproportionate, and probably reflects the insults offered to two of its members, as well as providing an opportunity to make an example of someone from an institution that was a potential centre of royalist support. If so, this view was not shared by the House of Commons, to which Davies successfully appealed. It twice sent orders to the Master to readmit him, although they were resisted.[6] Only one other Brother was expelled for his loyalty during the war, and he was serving with the royalist forces.

As well as its close connections with the court, the charity attracted attention from Parliament's adherents because of its supposed religious leanings. Their suspicions would not have been allayed by the presence of Laud and two of his episcopal allies, Matthew Wren, Bishop of Ely, and William Juxon, Bishop of London, among the governors, nor by the changes to the arrangements in the Chapel during Dallington's time as Master.

In 1643 Daniel Touteville, the Preacher since 1631, was sequestered by the parliamentarian authorities, accused of telling his congregations that they were 'a happy people', having the figures of Moses and Aaron in front of them and the organ behind. It was also alleged that he had not observed the monthly fast, had procured, 'Scandalous and Malignant Ministers to preach there to corrupt his people' and had 'been often drunke, and that on the Lords day'.[7] The comment of one of the older Brothers was, 'How improbable is it that he should be really guilty'.[8] Touteville had been a lecturer at St Sepulchre's parish and then preacher at St Bartholomew's the Less until his appointment at the Charterhouse, when the Calvinist George Abbot was Archbishop of Canterbury and, as chairman of the governors, would have approved his selection. Touteville was then described as, 'well reputed for his honest life and conversation, and every way well qualified both in ability of learning and otherwise to be Preacher'.[9]

The reredos with the figures of Moses and Aaron, with the other changes at the east end, shocked Puritan sensibilities and could not be ignored; the Preacher being held responsible for them and, possibly, for the organ, too, even though it had been installed before his appointment. Both organ and reredos were removed; the organ was sold and the post of organist was abolished, following Parliament's ban on music in worship. Benjamin Cosyn was dismissed, but not otherwise penalised, and was paid his salary until his death in 1653, because of his 'poverty ould age and imperfections of body'.[10]

Thomas Foxley was nominated to replace Touteville, but when it was discovered that he was married this was rescinded, and the governors chose Peter

Clarke. This proved to be an error of judgement, for Clarke did not conform to the hospital's requirements. Not only was he married, but also he brought his wife and family 'consisting of Women Servants and Children into the House there, contrary to the Foundations and Statutes … [and] to the Disturbance of the Peace of the Place, and of the Government of it'. By January 1645 he had left London and was replaced by William Adderley.[11] Robert Brooke was dismissed from his post as Schoolmaster in January 1644 'for certen misdemeanours'. He did not conceal his royalist sympathies, refused to take the covenant and whipped some of the boys who did.[12]

These changes, and the absence for a time of the Preacher, may have contributed to the 'divers and several misdemeanours' committed by the Brothers and junior officers, which were bringing the charity into disrepute. Their offences (chiefly drunkenness and swearing) were so serious that the Master felt that he did not have the authority to impose the penalties that they merited. The maximum fine permitted was 8s 8d, the equivalent of two weeks' commons. The governors' response suggests that they regarded inebriation as the more serious transgression, and provided for a fine equivalent to a month's commons for a second offence and expulsion for a third. Swearing or taking God's name in vain could culminate in the miscreant being deprived of any benefit except his room, but harsher punishment had to be decided upon by the governors.[13] Dealing with such matters internally helped to protect the hospital from outside intervention, for they could be used as evidence to support allegations of its degenerate condition if not addressed.

The parliamentary authorities regarded the charity as a potential resource for their own cause. Following the opening battle of the war at Edgehill, in October 1642, the Commons appointed a Committee for Sick and Maimed Soldiers which investigated the Savoy, Sutton's Hospital and St Katherine's Hospital, as potential lodgings for wounded soldiers. The scale of the Charterhouse's accommodation was modest by comparison with that at the Savoy, which had 150 beds and only two residents and was duly selected as Parliament's military hospital. But the categories who should benefit from Sutton's charity, as set out by the governors in 1613, could be interpreted as allowing places to be allocated to parliamentarian soldiers.[14] The Earl of Essex was entitled, as a governor, to nominate a poor man for a Brother's place, in rotation, but in January 1644 he was also given permission to fill the vacancies with four soldiers, or poor men over forty years old.[15]

The influential army chaplain, Hugh Peter, revived the proposal that it could be used to lodge disabled soldiers in 1646. In a Thanksgiving Day sermon to the Houses of Parliament, the Lord Mayor and Aldermen and the Westminster Assembly of Divines, Peter drew attention to the Charterhouse. He pointed to the founder's intentions, and touched on the sense of disappointment with the charity's loyalties, when he commented that it was a 'pitty that so gallant a work should prove a nest of unclean Birds; methinks it was built for this time, and God

may be much honoured, by turning the givers intentions into the right chanell, many faithfull souls will blesse your care and tendernesse'. His congregation would have recognised the allusion to Babylon in the Book of Revelation: 'the habitation of devils, and the hold of every foul spirit, and a cage of every unclean and hateful bird'. In his eyes, the Charterhouse remained a bastion of royalism, and Sutton's wishes had not been carried out. His condemnatory statement, to such an influential congregation, may have contributed to the implementation of changes a few years later, and the admission of more soldiers. By 1652 the Brothers included thirty-one disabled soldiers, twenty of them officers, and some of the Scholars were the sons of soldiers killed in Parliament's service.[16]

As well as its potential accommodation, the charity's financial reserve attracted attention, as the war dragged on and the costs increased. The exhibitions paid to the school's former pupils at Oxford and Cambridge were continued. The royalists had occupied Oxford as their headquarters, and so the numbers at that university had declined, with estimated admissions during the 1640s amounting to only forty-one per cent of the numbers admitted in the 1630s.[17] But even in the Christmas quarter of 1643 the Charterhouse still paid six students there, when there were fifteen of its former Scholars at Cambridge. Those who had gone to Oxford had contrasting experiences. One petitioned for his outstanding allowances in 1646, claiming that he had continued his studies throughout the war, but another had left in the autumn of 1643 and returned to his mother's house, which was later plundered by royalist troops.[18]

The Commons committee responsible for supporting the garrison at the strategically important city of Gloucester investigated the charity in the autumn of 1643. One of its first actions was to halt all payments to those outside the school and hospital, suspecting that some exhibitioners or others from the Charterhouse were serving with the royalist forces. Three members of the committee visited the hospital, armed with an authority to break open its chests, trunks and other repositories where money might be stowed. In 1642 the reserve set aside to buy more lands contained £2,000, which the Commons resolved to appropriate as a loan, together with any other money lying 'useless in Sutton's Hospital'. When the Ordinance was sent to the Lords they referred it to a committee, which recommended that they should not proceed with it because the charity's finances were so seriously impaired already, that if its reserve was taken it might cease to function.[19] The committee's chairman was the Earl of Northumberland. Sutton's ploy of specifying governors who were prominent in the political establishment had proved its worth, even though he could not have anticipated a crisis of this kind.

The charity's finances were undermined, nevertheless, by an unforeseen calamity. Its revenues fell during the war and so the reserves were needed. They were thought to be in the custody of John Clarke, the Receiver (the chief financial officer). In April 1642 he had been allowed to retain £1,000 to cover forthcoming

expenditure, but when this was required to pay outstanding bills he was unable to provide it and in December 1643 he absconded. He took with him 'a great part' of the rents received at Michaelmas and subsequent investigation showed that he owed the charity £2,389, equivalent to almost half a year's revenue.[20] He had served the charity for more than twenty years as Receiver and occasionally as Steward, and evidently was a trusted member of the staff. Indeed, Sir Robert Dallington nominated him to carry out some of the terms of his will.[21]

Clarke's peculation came to light only because of the unforeseen need for the missing funds, due to a shortfall in income during the war years. When the governors discovered that he was living in Shropshire – within a royalist area and so beyond effective legal redress – and had bought an estate there worth £500 per annum, they concluded that 'he had and hath an evill intent'.[22] But his immediate action, in absconding, may have been determined not only by the financial predicament he found himself in, but also royalist sympathies, for one of the Brothers noted that he had refused to take the covenant.[23] Arrested in 1646, after the collapse of the royalist cause, and successfully sued, he repaid part of the loss and made over property in Shropshire, valued at £1,600, but in the meantime his actions left the house in considerable difficulties. Indeed, its financial affairs were in the hands of his servant and the cook, described as 'two insufficient men'.[24] Matters were not helped by the death of the Auditor in 1645 and the failure of the governors' standing committee to examine six successive sets of annual accounts, from 1642-3 through to 1648-9.[25]

Roughly ninety per cent of the charity's rental income came from its estates outside London, in areas under both royalist and parliamentarian control. This income declined as tenants in the royalist or disputed areas, who paid a third of all the rents, found it difficult to remit their payments, because of the dangers of travel and their losses from taxation, free quartering and plundering. But those securely within the parliamentarian zone, and so free from the direct effects of the war, were also subjected to high levels of taxation, which they offset against their rents.[26] By June 1645, the estates in parliamentarian areas, which generated £2,748 in annual rents, were paying £600 per annum in taxes and assessments, and four months later a tenant in Essex, whose rent was £200 per annum, claimed to have paid £95 to the parliamentary authorities.[27] But the rental for Michaelmas 1643 does not show a simple pattern of reduced rents received from the parliamentarian areas, and little or nothing from the royalist ones. All of the rent for Hartland, in Devon, had been received. Unpaid rents for the Wiltshire estates were only sixteen per cent of the total arrears, yet less than a tenth of the sum due from tenants in Lincolnshire had been paid. Meanwhile, for the estates under parliamentary control in Cambridgeshire, Huntingdonshire and Essex, arrears were more than twice the level of receipts. For all of the Charterhouse's properties, receipts totalled only £1,290, less than a half of the sum due, while the arrears stood at £2,088.[28]

The difficulties increased and in April 1644 the governors claimed that within the previous two years the hospital had received little or no rent from its tenants in Wiltshire, Devon and Yorkshire, and that income from those elsewhere had been reduced because of taxation.[29] As rental income declined, the reserve, depleted by Clarke, was drawn upon, and had been completely spent by March 1645, when the deficit over the previous year was £1,500.[30] Despite such difficulties, the governors did not sacrifice all of their assets to bolster their income or appease the parliamentarian commissioners, for some items of silverware made for the hospital before the war have survived.

The tenants at Dunsby, in Lincolnshire, complained that they had been affected by both parliamentarian and royalist levies, with high taxes, loss of cattle and free quartering that had absorbed not only their profits but also the money for their rents.[31] By the end of 1646 most of the tenants at Elcombe, in Wiltshire, who had made payments to both armies, owed rent for one-and-a-half years.[32] Even in the early 1660s, tenants in Wiltshire and Lincolnshire were still asking for abatements of their arrears because of losses in the Civil War.[33] Yet a tenant of a relatively small holding at Dunsby claimed to have paid his rent throughout 'the most dangerous times', without any deductions for taxes or assessments.[34]

The governors were not passive, suing the heirs of one of Clarke's sureties and sending the Receiver's clerk to collect rents from tenants in Cambridgeshire.[35] He was also directed to visit Audley End to apply to the Earl of Suffolk for the £500 yearly payment due to the Charterhouse. His visit was not a success, the Earl paid nothing throughout the war years and by 1647 owed the hospital £2,000.[36] The governors were also unfortunate in that Samuel Martin, the Registrar since 1627, resigned because of ill health and in July 1643 went to Wiltshire, where he died five months later. His knowledge of the tenants' rents and conditions would have been invaluable. Worse still, many of the papers which he had passed to his successor John Yeomans, who served as Registrar for only a short time, were retained by him when the governors appointed another man to the post. In February 1645 they brought a case in Chancery in an attempt to recover the papers.[37]

With revenue in decline, attempts had to be made to reduce expenditure, especially as problems of supply and the imposition of the excise were causing prices to rise. As early as May 1643 the Manciple reported that he could no longer undertake to supply beef at a fixed rate, as hitherto, but would have to charge the market prices.[38] In an attempt to economise, in 1644 a second meal was removed from the weekly diet, but by the autumn there were fears that the liabilities could not be met, and more drastic reductions were implemented. The budget for meals was cut by a quarter, together with the extra commons that were served on festival days. The annual Founder's Day dinner was the only exception, perhaps because it was a requirement of the statutes of 1627 that it should be observed.[39] The officers' and Brothers' tables were now to be supplied 'in the frugallest manner' possible and even the Scholars' diet was to be reduced. Wages and stipends, too, were

pared. The Brothers' weekly allowances were reduced by 1d and their quarterly pensions more drastically, from £1 15s 2d to £1. The university exhibitions were cut to £15 and the junior officers' income was reduced by one-quarter. But the stipends of the senior officers, the Master, Physician, Preacher, Registrar, Receiver, Schoolmaster and Usher, were not reduced.[40]

These economies did produce some reduction in consumption. The quantity of bread purchased fell by fourteen per cent between the Michaelmas quarter of 1640 and the equivalent period in 1644, although this was not an expensive item and its price remained fairly stable until 1646. Butter and beer prices were unchanged between 1641 and 1646, but those of beef rose, as the Manciple had feared, and by April 1647 he was paying a third more than in 1642.[41] With the parliamentarian blockade of the River Tyne between 1642 and 1644 coal, too, became expensive, reaching 'intolerable prices' by January 1643, and the Charterhouse bought Scottish coal.[42] The Manciple evidently struggled to keep within the specified allowances, and in June 1645 a small committee was deputed to check the accounts on a weekly basis, to avoid 'needless and excessive' expense. Six months later the governors acknowledged that new gowns for the Brothers could be provided only if the draper was prepared to allow the hospital credit 'untill the house bee in Condition to paye for the same'.[43]

The numbers provided for fluctuated slightly, with the deaths and absence of some Brothers. Such fluctuations were greater than in the pre-war years. Between 1615 and 1641 there was an average of 7.6 deaths per annum among the Brothers, but the annual average rose to 9.4 between 1642 and 1646, with seventeen in 1645, more than in any other year during the whole period. No special precautions were taken against plague, even though in a five-month period in 1644 three of the grooms died of the disease, and there is no evidence that any of the other staff, Brothers or Scholars, contracted it. The grooms were replaced and the Brothers' places continued to be filled as they became vacant, with no attempt to economise by leaving them empty until the finances improved.[44]

Following the cuts in the domestic budget, the governors encouraged the Brothers to petition the House of Lords for assistance, which they duly did in June 1645. Asking for the removal of taxes from the hospital's lands, they claimed that if this were not done their allowances would be further reduced and 'their gray hairs brought in sorrow to the grave'. An Ordinance to free the charity's estates from taxes and assessments was read and approved in the Lords, but the Commons did not even discuss it, although that concession had been allowed St Bartholomew's, St Thomas's, Bridewell and Bethlehem hospitals in November 1644.[45] It seems that the Charterhouse was still in bad odour with the Commons.

A year later the Brothers requested the reinstatement of their Tuesday dinners, a victim of the cuts.[46] By then their sufferings were almost over. Military victory for Parliament in the summer of 1646 was followed by a financial recovery, as contact with the tenants in the royalist areas was re-established and rents could again be

collected. In October 1646 the Brothers and Scholars had their diet and allowances restored in full, as were those of the inferior officers and servants in March 1647, and in December the full value of the student exhibitions was reinstated. By 1653 the governors were able to allow the Brothers compensation for their reduced allowances, despite the theft of roughly £1,000 from the Receiver in 1650, when one of the thieves inflicted a serious head wound on a servant.[47]

The income was sufficient to cover the increases in food prices in the late 1640s, and the reduction of rents had been a more serious problem than rising costs. The financial reserves provided a cushion during the early years of the war, and thereafter expedients were employed that limited the financial impact on the Brothers and Scholars. Perhaps the greatest disruption to the charity was caused by changes in personnel, not so much at the supervisory level of the governors, but among the officers. The Preacher, Registrar, Receiver, Auditor, Physician, Schoolmaster and Usher left, absconded, were expelled or died, contributing to a period of disorganisation in the supervision of the finances and the community. On the other hand, Garrard continued as Master and his connection with the Earl of Northumberland provided the stability that was needed.

A COLLEGE FOR DECAYED GENTLEMEN

The establishment of a republic in January 1649 was followed by a period of change at the Charterhouse, which reflected the shift in national affairs, following the victories of the New Model Army and the political ascendancy of the Independents. Sutton's Hospital was not immune from the effects of those changes, because of its status as the largest and wealthiest almshouse charity and its links with the court.

The first historian of the charity, writing in 1669, looked back on this period as a time when there had been a threat to close the hospital and turn the buildings into a garrison, not least because its organisation reflected Sutton's supposed Catholicism. The Charterhouse was not alone in attracting such criticism, according to Richard Carter, who in 1641 sarcastically mocked the iconoclasts' intentions: 'Down with churches, hospitals and alms-houses, they do but help the widows, fatherless, blind, sick and lame, these were most of them founded by papists.'[1]

Rather than close down the charity, the new regime set about to reform it. In March 1649 the Council of State, the executive body of the republic, appointed a committee to investigate the mismanagement of the Charterhouse, with the authority to examine its records and question the officers. Its members were too busy to act and so it was superseded two months later by a new committee, which produced its report on the 'great disorders' there in March 1650. The report was presented to Parliament.[2]

It had taken almost a year to complete, but Parliament then acted swiftly, as did the governors. By an order of Parliament of 17 April those governors who had not subscribed to the Oath of Engagement to the new republican regime were to be displaced. The governors held an assembly on the following day, the first of seven meetings during April and May. This was an unprecedented burst of activity that contrasted with the normal pattern of two each year, and there were two more in December. Northumberland resigned as a governor in May, on the grounds of ill health, and seven months later Garrard was asked to relinquish his

post, albeit on generous terms.[3] With Northumberland's resignation, the deaths of three governors and displacement of four more who had not subscribed to the Oath, eight new governors were appointed: Bulstrode Whitelocke, Phillip Lord Lisle, Sir William Armyn (who had presented the report to Parliament), Sir Henry Vane the younger, Thomas Lord Fairfax, Oliver Cromwell, John Gourdon and John Bradshaw (who refused to serve). In October 1651 Edward Lord Howard was removed and replaced by Charles Fleetwood.[4] The displacement of the clergy marked a significant alteration in the character of the governing body, yet eminent lawyers were still selected, as were those holding senior positions within the state.

Cromwell resigned in December 1653, when he became Lord Protector (Philip Skippon was appointed in his place). His right of nomination lapsed with his resignation, but, as Lord Protector, in 1655 he sent an instruction to the governors to admit a boy to the school, with an explanatory letter to John Thurloe, Secretary of State:

> You receive from me, this 28th instant, a Petition from Margery Beacham, desiring the admission of her Son into the Charterhouse; whose Husband was employed one day in an important secret service, which he did effectually, to our great benefit and the Commonwealth's. I have wrote under it a common Reference to the Commissioners [governors]; but I mean a great deal more: That it shall be done, without their debate or consideration of the matter.

Her petition explained that her husband had been a sailor in the navy, lost the use of an arm and was receiving a pension of just £2 per year. She specifically asked for a place at Charterhouse for their son Randolph, who was 'tractable to learn'. Despite her successful appeal to Cromwell and his peremptory order, for whatever reason Randolph did not enter the school.[5]

Cromwell's eldest son Richard became a governor in May 1658 and Lord Protector on his father's death on 23 September. He resigned as governor in the following January. The direct descendants of his brother Henry included Henry Cromwell Field, appointed the hospital's apothecary in 1830 and its first Medical Officer in 1835. He died suddenly in 1840.[6]

On the retirement of George Garrard, Edward Cressett was chosen as Master, having been appointed Registrar in May 1650. He was not a clergyman and he was married, but after consulting the Letters Patent obtained by Thomas Sutton from James I, and assembly orders of 1615 and 1617, the governors justified their choice on the grounds that they were not violating the founder's intentions in appointing the most suitable man for the post. Their requirement was for 'an able and active man' and Cressett qualified on those terms, as a successful and wealthy businessman, as well as a firm adherent of Parliament. His family came to live in the house in Charterhouse Square adjoining the hospital, which was owned by

the charity but was not within the curtilage. The governors were satisfied with their choice and in 1654 doubled his annual salary to £100, in acknowledgement of his efforts.[7]

Another important change during this burst of reforming activity was the removal of William Adderley as Preacher and the appointment of George Griffith, whose salary was also doubled, to £80 a year, on condition that he preached twice on Sundays, and he was allowed to serve as Reader and draw that salary as well. This dramatic increase in the Preacher's stipend was a measure of the importance which the new governors attached to the post. Griffith was around thirty years old when appointed.[8] He, too, was married and in 1651 his wife was permitted to live in the Preacher's lodgings within the hospital, which were suitably adapted by the conversion of the 'Preacher's Stable' as a kitchen. In the same assembly as the one in which the Preacher's domestic arrangements were approved, a new Registrar was appointed. He was given the post despite being married, although his wife was not allowed to live in the hospital. The governors considered offering the post of Schoolmaster to a married man, on the same condition. They were, indeed, inconsistent in the application of the rule concerning married officers, for the Manciple and head Pantler were required to leave because they were married.[9]

The changes among the officers included the replacement of the Usher and the dismissal of the Chapel Reader, Matron, Butler and Porter. The Butler was guilty of 'excessive drinking' and the Porter of not only being overcome with drink himself, but of conniving at the Brothers' tippling, when his duties included notifying the Master of 'any member of the house that keepes unseasonable houres, or is in an unbecoming condition'. The Brothers, too, attracted the governors' attention, with one dismissed and nine others suspended 'for the detestable sinne of Drunkenesse'. This was part of a concerted campaign by the governors and senior officers in the early 1650s to reform a prominent foundation that had been conspicuous for its connections with the Court and, as Hugh Peter had pointed out, its royalist sympathies. Indeed, the republican hierarchy evidently saw their control of the charity as an opportunity to create a Godly community in an institution that had been part of the Carolean establishment. To do this they had to improve the behaviour of the Brothers, who were breaking the orders of the house 'daily', with drunkenness and swearing being the offences which were noted. However, other practices had crept in that were against the orders and were now to be corrected, such as eating in their own rooms and not in the hall. The junior officers' conduct was also unsatisfactory, highlighted by an incident which could not be ignored when two of them were guilty of 'fighting one with the other in the Common Dyning Hall of the said hospitall whiles the Cheife officers and Brothers were at dinner'. The governors established a committee to investigate the conduct of the junior officers and Brothers, in order to discover if any were 'drunkards, unclean persons or swearers'.[10]

Some offenders were suspended, with expulsion being the ultimate deterrent, but that process was not always carried out efficiently. Three Brothers expelled in December 1650 were still there in the following April, refusing to leave until their allowances were paid. Such 'lingring and continewing' within the hospital by those who had been expelled was thought to set a bad example and cause 'the Drawing away of other of the poore Brethren into Vicious and idle Lives, and to the great Clamour of the Governors and Scandall of the hospitall'. One problem was that some Brothers were able to hold their drink better than others and so were not punishable. They brought the charity into disrepute by drinking in alehouses, and so 'their offence alltogether as sinfull and skandalous' as those who became inebriated.[11] A part of the solution was to give places only to those whose conduct was thought to make them worthy. In 1653 a petitioner for a place was to be investigated 'concerninge his manner of life & converse' to determine whether he would be a suitable member of the community.[12]

By 1654 the campaign for a Godly reformation was held to have been successful, despite some continuing problems with 'inordinate drinking' by two Brothers, the expulsion of another for the same offence and the embezzlement of fuel by the grooms.[13] Much of the credit for this success was given to the Preacher. When he was offered the living of St Bartholomew the Less, the Brothers, officers and servants asked if he could be encouraged to stay because of his positive influence, providing 'much incouragement ... to lead their lives according to Godliness'. The governors agreed and raised his salary to £100, the same as that of the Master, and he stayed.[14]

The governors before the Civil War had tried to create an orderly society at the Charterhouse, which reflected their ideals and assumptions, aware of the attention that it attracted as England's largest charity. They, too, had grappled with the problems of dishonest and incompetent officers, and both the inappropriate behaviour of the Brothers, and their solutions to this problem, had been similar to those taken after 1650. Yet the leading figures in the republican regime, who were appointed as governors in the early 1650s, applied themselves assiduously to achieving and maintaining the desired standards, in a concerted attempt to establish a model community of the kind that some contemporaries earnestly wished for. They had scarcely any problems with the Brothers' behaviour in the late 1650s.

Among the actions which the governors took in 1650 was a survey of the school and the number of Scholars. Three years later another investigation was ordered, prompted by suspicions that the parents of some Scholars could afford to pay for their sons' education elsewhere and, moreover, that some Brothers were able to maintain themselves from their own resources, which was clearly contrary to Sutton's intentions.[15] But such abuse of the charity's purpose was a long-standing problem that was difficult to overcome, and indeed was not confined to the Charterhouse. Another issue which was addressed was the practice of officers

taking fees for arranging the admission of a boy to a Scholar's place. This was forbidden, and anyone who was found to have done so was to lose his post.[16]

A new Schoolmaster was appointed in 1653, with a pay increase, and in 1654 a house was built for him, close to the southern end of the schoolhouse.[17] Perhaps because of the more spacious accommodation, at about this time it became the practice for the Schoolmaster to take some boys as boarders.[18] Two years later a new house was built for the Matron. Her accommodation in the Westgate of Charterhouse Square was inconvenient because it was too far from the school, especially if a pupil was ill. The new house was within the hospital and close to the school, which was a further break with the previous practice of not allowing women to live within the precincts.[19]

By 1650 the last surviving Brothers from the original intake had died. Five of them lived into the 1640s and the last two, Ruben Seddon and George Harrison, died within nine days of each other in September 1647. Seddon had kept a record of the governors, officers and Brothers and two days before his death directed that seven designated Brothers should continue to maintain it, one after the other. It may have been one of his designated successors who indexed the Brothers' names and tabulated their deaths by year, although the meticulous standard which Seddon had achieved gradually deteriorated. His register of Brothers was kept only until the late 1650s, although the lists of governors and senior officers were continued until the early years of the nineteenth century.[20]

The register shows that thirty-six per cent of the 333 Brothers, for whom full information on admission, death or departure is recorded, were in residence for under five years and a further thirty-one per cent for between five and ten years. Yet just nine Brothers remained for more than twenty-five years. Their ages are not recorded, nor, in most cases, is the cause of death. Seddon described only those deaths which were unusual. For example, in 1630 a pensioner fell down the stairs in a tavern in Goswell Street and died of his injuries, and, two years later, one died after flames ignited his shirt while he was warming himself in front of a fire. Two died after choking on their food and one committed suicide. Of the 384 Brothers who had entered by 1650, twenty-eight were expelled, including those who were found to be married or had married after their admission.

Information on the Brothers' occupations or economic status was not included in most cases. Seddon himself left bequests of £75 6s 8d in his will, which indicates a comfortable prosperity rather than poverty.[21] The first in the list of those Brothers admitted in 1614 was Captain George Fenner, a prominent seaman and ship-owner who had fought in the campaign against the Spanish armada in 1588. He occupied Room One until his death in 1618, when he was given the unusual honour, for a Brother, of being interred in the Chapel. Another thirty-two Brothers in Seddon's record were described as 'captain', although whether this rank applied to service in the army or the navy was not specified. A few went on campaign even after they were admitted and one was killed at the Île de Ré in 1627.

The playwright Richard Brome entered in March 1650 and died in the Charterhouse on 24 September 1652. He had attracted attention in the years before the Civil War for his criticism of aspects of Charles I's personal rule, especially in his *The Court Beggar*. For that reason he may now have been regarded favourably. But he was also a deserving beneficiary of the charity; according to his first editor 'Poor he came into th' world and poor went out'.[22] Among a later generation of Brothers were Richard Jencks and William Herbert, both of whom entered in 1658. Jencks had been Secretary to the Eastland Company but, 'Beeing fallen to decay in his estate, old and weake in body, he got (by means of some old friend) into the Charterhouse, or Suttons Hospitall, where hee died'. Herbert was a writer who continued to publish after he had come into the hospital. He was an opponent of Roman Catholicism, but also a persuasive advocate of toleration of foreigners and refugees.[23] These were typical of the men who Bacon and the governors had intended should benefit from the charity. When John Evelyn visited in 1657 he described the hospital as 'an old neate, fresh solitarie Colledge for decaied Gent.'[24]

Earlier in the day Evelyn had a consultation with Dr George Bate 'about taking preventive Physick'. Presumably, once he had dealt with Evelyn's medical anxieties, Bate suggested that he pay a visit to the Charterhouse, where he had been Physician until the previous year. Bate was one of the most distinguished physicians in mid-seventeenth century England, and became a fellow of the Royal College of Physicians in 1640. He had been appointed physician to Charles I when the Court settled in Oxford at the outset of the Civil War, before moving to London. In 1643 he was appointed as the hospital's Physician and later became physician to Oliver Cromwell. While he was the Charterhouse's Physician he collaborated with Dr Francis Glisson, Regius Professor of Physic at Cambridge, and Assuerus Regemorter in a pioneering study of rickets, which culminated in 1650 in a jointly-authored book on the subject, *De rachitide*. In 1656 he was succeeded at the Charterhouse by Dr Gabriel Beauvoir, also 'a learned Physician of the Colledge'. After Bate's death some of his prescriptions were published as *Pharmacopoeia Bateana* (1688), later judged to contain 'many good and many trifling recipes'.[25]

Bate was better remembered for his political publications and his nimble adjustment to the changing circumstances, being appointed as physician to Charles II. Both *The Royal Apologie* (1648) and *Elenchtus Motuum nuperorum in Anglia* (1649 and later editions) defend Charles I's actions during the crisis of the 1640s, and have been attributed to him. In his memoir of Cromwell, however, written after the Restoration, he praised the Lord Protector's policies, while commenting that he, 'had two attendant spirits, a good and a bad'. Yet Bate also allegedly confessed, on his deathbed, to poisoning Cromwell, who he did attend during his final illness in 1658, 'with the provocation of two that are now bishops, *viz.* [blank] and his majesty [Charles II] was privy to it'. This confession was noted by Anthony Wood, Oxford antiquary and gossip, who also wrote that

Bate 'died at London of French Pox', in 1668. Delusion is an effect of syphilis and little reliance can be placed on Wood's statement, although the possibility that Bate was responsible for the Lord Protector's death has received some support. It would have been ironic if the Charterhouse's syphilitic former Physician had administered poison to one of its former governors.[26]

The hospital's financial recovery after the Civil War had continued. Between 1651 and 1654, meetings were held with external auditors to disentangle the accounts and put the finances in order, after the losses and difficulties of the previous decade. In 1653 terms were agreed with the Earl of Suffolk, whose offer of £3,000 in full settlement of the outstanding sum for Hadstock and Littlebury was accepted, to avoid further costs. It had taken over forty years to obtain £8,000 of the £10,000 bequeathed by the founder.[27] The regular revenues were restored, but it proved impossible to clear the rent arrears, which stood at almost £6,000 in 1651 and were only a little lower in 1660.[28]

Nor had problems with the staff been overcome, for in 1654 the Receiver was dismissed, owing the charity £483, and in the same year the Under Steward 'confessed that he had deceived the house to the value of £60'.[29] Alexander Lawson was appointed Receiver, but after his death in 1659 it was discovered that he owed the hospital £1,110, very little of which could be recovered.[30] Despite such setbacks, the reserve fund was re-established, and in 1656 properties in Charterhouse Square and Charterhouse Lane were bought, and the governors were able to consider buying Rutland House and Dunsmore House in Charterhouse Square.[31] The purchase of Rutland House would have reunited the site of the inner precinct of the Carthusian priory, which had been divided in 1565 when Roger, Lord North, sold the mansion and garden to the Duke of Norfolk, but retained his own house. In 1630 North's house was bought by the Manners family, Earls of Rutland and patrons of Sir Robert Dallington.

In the event the governors did not buy Rutland House, nor any other major addition to the endowment, although the reserve contained £1,050 by 1661. Nevertheless, they pursued a policy of consolidating the existing holdings.[32] They considered selling the manor of Blacktoft, in Yorkshire, because it was too remote to be managed efficiently, although that was not done until 1757, and parcels of land at Little Wigborow in Essex were bought to unite the hospital's holdings there. But even that property, much closer to London, could not be supervised fully and in 1653 the Bailiff decamped with the rents for the previous four years.[33] Leases were still being granted at rents below the true value of the properties, although the governors ordered the implementation of the recommendation of 1629, that they should not be set at less than two-thirds of a property's annual value.[34]

As well as having sufficient funds to erect new houses for the Schoolmaster and the Matron, the governors could afford to carry out a thorough repair of the buildings in 1657.[35] They were also able to add four extra Scholars' places to the

original foundation, bringing the number to forty-four in 1658, and they decided that two more exhibitioners' places could be added when required, to support the school's former pupils at the universities.[36] The Brothers' pensions were increased by £1 per week. These additions were attributed to Cressett's efforts and his 'good husbandry'.[37]

The dignity of the hospital and its surroundings also concerned the governors. A portrait of the founder was commissioned, for the great chamber, and the charity's arms, which was set within a surround carrying the great seal of England. The governors' arms were also to be drawn and mounted over the Master's table in the Great Hall. A gallery in the Chapel, used by 'strangers', was reserved for the governors and their families, or those 'persons of Quality' approved by the Master and Preacher. Some 'superstitious inscriptions' on the Chapel roof were to be erased.[38] The reference was to the open-timbered roof over the south aisle, which had been the priory's chapter-house.[39] However, the Carthusian iconography on the bosses of the vault in the ante-chapel was not defaced, nor was the panel carrying the coat of arms of Charles I in the overmantel of the great chamber.

The governors were sensitive to the condition of Charterhouse Square, the former outer precinct of the priory, which still provided a buffer between the Charterhouse and the city. They paid for the enclosure of the open area with rails and approved the appointment of a porter, who was to prevent boys from playing and the riding of horses through the square. Brewers' drays and the 'drifts of cattle' that passed through it to and from Smithfield had also caused disturbances, and the householders' practice of piling rubbish and logs in front of their houses was disliked.[40] The narrowness of Charterhouse Street, which ran from the west side of the square to St John Street, caused problems because it became congested with carts and drays, and the governors who used it to get to the Charterhouse were subjected to 'uncivill and sordid behaviour'.[41]

Concerns of a different nature were caused by the performances in Rutland House of Sir William Davenant's 'Morall Representation' consisting of dialogues on various historical topics, with music by Henry Cooke, Henry Lawes, Charles Coleman and George Hudson. Entitled *The First Days Entertainment at Rutland-House*, this was performed over a ten-day period in May 1656 and in early June the governors became aware of 'strong endeavours' to obtain official sanction for more 'meetings' there. They objected, because of 'the greate inconveniencyes' that had been caused, and fears that these would be accentuated if further performances were permitted.[42] Their efforts were in vain and Davenant's *The Siege of Rhodes* was performed at Rutland House later in 1656, possibly in early September. Based upon the Ottoman defeat of the Knights of St John in 1522, it was described by Davenant as 'a representation by the Art of perspective in Scenes, And the Story sung in *Recitative Musick*'. Cooke, Lawes, Coleman and Hudson again supplied the music, with Matthew Locke. *The Siege of Rhodes*, which was in five acts, was long regarded as the first

English opera, but that distinction is now given to Richard Flecknoe's *Ariadne*, which had been performed in 1654.[43]

By the late 1650s the Charterhouse had lost its earlier reputation as a royalist stronghold and Oliver Cromwell's widow, Elizabeth, and their daughter Frances, widow of Robert Rich, took refuge there as the republican regime collapsed in 1660 and the monarchy was restored.[44] But the extent to which the charity was embedded within the political and religious system was emphasised by the speed with which the changes made over the previous ten years were then reversed. Charles II did not land at Dover until 26 May 1660, but ten days earlier the governors had ordered that the arms of the Commonwealth were to be taken down and the royal arms set up in the east window of the Chapel, in the Great Hall and above the hall porch in Master's Court, where they remain.[45]

There had already been changes among the governors and officers. At an assembly on 18 May, four of the governors supplanted ten years earlier were reinstated, beginning a process which, by the end of 1661, saw twelve governors restored or newly appointed. Of those who were now displaced, some had been attainted of high treason and others had 'fled out of this Kingdome fearing the just reward of theire rebellion'. Their replacements included the Archbishop of Canterbury and the Bishops of Ely and London, and when the Bishop of London was translated to Canterbury in 1663 the Bishop of Winchester was made a governor.[46]

Edward Cressett resigned on 12 July 1660; his support for Parliament and his adherence to the Baptists made him unacceptable to the returning royalists, despite his undoubted competence. A few years later the historian of the charity commented that Cressett 'deserved in many respects very well of that house and therefore Received publicke thankes from the Lords the Governors 1660 upon his dismission out of it'. This view was later echoed by Guy Miège.[47] The practice of appointing a clergyman as Master was not reintroduced, however. The post had been coveted during the Interregnum by Edward Hudson, a clergyman, who demanded it as a reward for assisting a group of royalists plotting to assassinate Cromwell and restore the monarchy.[48] The plot failed, and so Hudson could not claim his prize and Cressett's replacement was one of Charles I's courtiers, Sir Ralph Sydenham.

Despite these changes in the early summer of 1660, George Griffith continued as Preacher for a year after Cressett's departure. His reputation extended beyond the Charterhouse. In May 1661 the governors were told that on Sundays 'a Multitude of Strangers' who had no connection with the hospital came to the Chapel and waited for the prayers to be completed before 'thronging in with violence' to hear the sermon. This was a tribute to Griffith's effectiveness and popularity as a preacher. It also suggests an unfavourable reaction by some Londoners to the reinstatement of the Anglican service in their parish churches and, from the timing of their arrival, at the Charterhouse Chapel as well. Their attendance was

disliked because of the disturbance and crowding that was caused, and the heat that so many people generated, especially in the summer. As a consequence the porter was instructed not to admit these unwelcome worshippers.[49] Under the new arrangements, the sacrament was to be administered only on the first Sunday of each month, except for special occasions.[50]

Griffith was removed from his post in July 1661, on the grounds that his family was living in the hospital. The dispensation granted by the governors after his appointment was regarded as no longer valid, although that was clearly a pretext for the removal of someone whose religious beliefs were incompatible with those of the new Anglican establishment. He was followed later in the year by five of the Brothers, who refused to attend services and take the sacrament, and so were expelled for their nonconformity. All of the Brothers and officers had to take the Oaths of Allegiance and Supremacy, reiterating the requirement stipulated in the Act of 1628.[51]

A further reversal of the practices during the Interregnum, described as the 'late licentious times', was to again give precedence to the nominees for Brothers' and Scholars' places according to the governors' 'degree and dignity in the kingdom', not their seniority of appointment.[52] As another step to cleanse the system of vestiges of the former regime, in June 1662 the list of Scholars compiled in May 1660 was declared to be invalid. Only those boys who had been nominated by the four governors who still held their positions were to retain their places in the new list.[53]

Despite the scale of these changes, they did not mark a complete return to the situation before the Civil War. The balance between the clergy and lay governors had been changed, with the number of churchmen halved. Just three served as governors thereafter, and the Master was no longer a clergyman. But the connection with the Court was re-established, while the lives of the Brothers and the Scholars continued much as before.

CHAPTER 5

A HEALTHFUL, PLEASANT AND LARGE MANSION

In some respects the period between the Restoration and the end of the Stuart dynasty was similar to that before the Civil War. The crown continued to be involved with the charity's affairs, including the choice of Master. Among the Masters were Martin Clifford and Thomas Burnet, two of the most distinguished men to hold the post. The charity also experienced economic difficulties once again, with falling rents and rising costs. In 1686 it came to the centre of affairs, as a result of James II's attempt to place a Roman Catholic as a Brother, testing the efficacy of his dispensing powers. The governors' resistance was to be much admired by no less a figure than the nineteenth-century historian Lord Macaulay, in his magisterial *History of England*.

This lay in the future, as the Restoration regime began to establish itself and reward those who had remained loyal to the crown during the previous twenty years. The clamour of petitioners, asking for compensation for their service to Charles I and their losses, or pressing their claim for a post, was such that the King was hard pressed to provide for all of them. As an expedient, he used the Charterhouse as an outlet, by sending nominations for Brothers and Scholars to the governors. They bridled at this, disliking the tone of these royal letters, which were:

> all or most of them in a Mandatory style which wee conceive and hope his Majestie upon better information will be pleased to alter with respecte to the Rights belonging to the Governors of this hospitall by the Charter of the Foundation thereof.

Too many were being referred for the King's allowance, which, as now restated, was for no more than two Brothers or Scholars at once on the waiting list, with one place allowed to a nominee of the Queen Mother, Henrietta Maria, and the same allowance for each of the governors. The Privy Councillors among the governors were deputed to explain matters to the King, stressing that this had been the arrangement that had existed during his father's reign.[1]

The King also attempted to appoint a new Registrar and a Receiver, the posts having been vacant for more than two months, giving him the right of appointment. The governors were clear that the Letters Patent had not given him that right, for the Registrar and Receiver were not officers of the foundation but servants, and so 'of arbitrary election' by them. His nominees were not appointed.[2] Nevertheless, he persisted and in 1671 recommended George Seignior for the vacant post of Preacher, on the death of Timothy Thurscross, who had succeeded Griffith. However, the governors did not comply and subsequently appointed John Patrick. There was speculation that they would request that such royal mandates in favour of candidates should not be sent to them in future.[3]

The Restoration saw the revival of church music. In 1662 the governors appointed a new organist, Nicholas Love, and directed him to install an organ in the Chapel. He acquired one from John Hingeston, the 'Keeper and Repairer of his Majesties Organs, Harpsicalls and other Instruments of Musicke'. At that time Hingeston was engaged in installing a new organ in the Chapel Royal at Whitehall, and the conjunction of dates suggests that the instrument supplied to the Charterhouse was that which had been installed in the Chapel Royal in the 1630s and was now superfluous.[4] Love paid Hingeston £100 for the organ of six ranks of pipes; that which had been bought in 1626 had cost £40 5s.[5] The organ gallery erected in the Chapel in 1626 had not been removed, and the new instrument was installed there.

Love's duties included 'teaching the poor Scholars to Sing, and playing on the Organs at set times of Divine Service'.[6] He also oversaw the music for the festivities at May Day and Christmas and for the Founder's Day celebrations on the anniversary of Thomas Sutton's death. On May Day 1665 the entertainment was given by the 'Earl of Abergavenny's Musick', the band of George Nevill, the Earl, who died in the following year.[7] From the early 1660s the King's trumpeters were regularly paid 5s for Christmas, with a similar sum paid to the drummers. By the early 1670s the trumpeters were also paid for playing on Founder's Day, and in 1674 the Gentlemen of the Chapel Royal performed on that anniversary. The Gentlemen's attendance became a regular feature of the Founder's Day commemorations until at least 1687.[8]

Hingeston almost certainly brought Henry Purcell to the Charterhouse. Purcell was appointed his assistant in 1673 and assisted him in tuning and repairing the instruments of the Chapel Royal and, probably, the organ at the Charterhouse which Hingeston had supplied. He succeeded Hingeston in 1683.[9] Purcell's connection with the Charterhouse was a fruitful one. He set nine metrical psalms from John Patrick's *A Century of Select Psalms ... For the use of the Charter-House*, first published in 1679. The text of Purcell's anthem *Lord, who can tell how oft he offendeth?* is from a 'preparatory prayer before the Sacrament' at the Charterhouse and perhaps was composed during the mid-1670s for use in the Chapel.[10] His anthem, *Blessed is the Man* was specifically an 'Anthem for

ye Charter house sung upon ye Founders day by Mr Barincloe & Mr Bowman',
Gentlemen of the Chapel Royal. It was probably first performed in 1687, and as
it proved to be very popular, it was adopted as the Founder's Day anthem.[11]

Sir Ralph Sydenham remained Master until his death in 1671, when
the governors appointed Martin Clifford as his successor, on the King's
recommendation. In supporting Clifford the King disregarded his earlier promises
of the post to two other men, and overlooked the eager solicitations of a third.[12]
The Oxford antiquary Anthony Wood wrote of Clifford that he 'might have been
eminent had not the [civil] wars hindred his progress'.[13] He was secretary to the
Duke of Buckingham (a governor from 1670), and in 1661 collaborated with the
duke in a project to manufacture crystal glass at Rutland House, in the area later
known as Glasshouse Yard.[14]

He also assisted the Duke in his literary activities with Thomas Sprat,
Buckingham's chaplain. Their literary barbs provoked a description of them
as 'malicious Matt Clifford and Spiritual Spratt'. Together with Samuel Butler,
they were said to have co-operated with the Duke in preparing *The Rehearsal, a
Comedy*, which caricatured John Dryden as the pretentious poet Mr Bayes. While
Dryden did not respond directly, *The Rehearsal* was one of the provocations
that led to his devastating satire of Buckingham in *Absalom and Achitophel*
(1681). Clifford was a prominent literary critic of Dryden, and the last of his
Notes upon Dryden's Poems in Four Letters was dated at the Charterhouse, 1
July 1672.[15]

Clifford may have owed his appointment to Buckingham's patronage, but the
Earl of Shaftesbury was given the credit for having his salary doubled to £200,
which freed him from 'the iron hand of terrible necessity'.[16] In one respect,
Bacon's prediction seemed to be coming true, although Clifford's years at the
Charterhouse were indeed productive ones, and saw the publication of his major
work *A Treatise of Humane Reason* (1675), which cogently argues the case for
religious toleration. He contends that man is guided by his own reason, in religion
as in all else, and reason provides the basis for faith. Therefore, the freedom to
be governed by reason applies to everyone, and those who hold a contrary view
to one's own are not necessarily in the wrong and will not be eternally punished
for the error, for an individual's religious affiliation owes much to environment
and upbringing. Buckingham welcomed Clifford's work and advocated 'a true and
perfect liberty of conscience', while warning him that the book would be 'attacked
on all hands'. His expectation was borne out, not least by the reaction of Peter
Gunning, Bishop of Ely, who proved to be an insensitive guest when dining at the
Charterhouse, commenting that, 'It's no matter if all the copies are burnt and the
author with them because it makes every man's private fancy judge of religion.'
But Clifford also received some robust support, notably from Albert Warren,
whose riposte against the critics included the point that the Church depends upon
the state, not the state upon the Church.[17]

Clifford's literary achievement was considerable, although he may not have been a suitable choice as Master in other respects. He would sometimes 'drink to excess', the very habit which, over the years, the governors had been most concerned to eradicate from the Brothers' behaviour. He was not an easy person to deal with either, having a quick temper and being impatient with fools, treating them 'according to their folly'. Henry Spellman, the Registrar, complained to the governors that Clifford, 'haveing taken offence' against him, was trying to deprive him of the benefit of a lease of property in Charterhouse Square. Nor did he endear himself to the Brothers, for when he died at the Charterhouse, in 1677, he was 'not much lamented by the Pensioners'.[18]

While Clifford was Master, the first published history of the charity appeared, in 1677, as *Domus Carthusiana; or, an Account ... of the Charter-House near Smithfield in London*. The author was Samuel Herne, who had been nominated to a Scholar's place in 1656 and awarded an exhibition in 1663 to Clare College, Cambridge, where he was elected a fellow in 1671. His history, partly based upon an anonymous manuscript compiled in 1669, includes an account of the foundation and the life of Thomas Sutton, which is somewhat inaccurate as to his early life, and prints documents relevant to the establishment of the charity.[19] Not surprisingly, Herne's was a commendatory account, and contained the reassuring comment that 'the Revenues are no way embezel'd', perhaps included because of the awareness of financial abuse of residential charities.[20] In 1665 the King had initiated a survey of hospitals and almshouses, responding to 'many complaynts concerning the ill governing of Hospitalls and misemploying of their revenues'.[21]

Herne described the Charterhouse as a 'healthful, pleasant, and large Mansion' and the Dutch artist William Schellinks, who visited in 1662, was favourably impressed, describing it as: 'a very large building and grand in its conception, halls, chambers, kitchens, school, and many other rooms, besides galleries, a beautiful church, and a very fine, pleasant garden with attractive walks'.[22]

The community, which Herne numbered at 188, provided an attractive environment in which to live. The Brothers did have concerns, however, asking in 1662 for an increase in their pensions and the appointment of two women to nurse the sick and infirm. On his admission as a Brother in 1664, Captain Edward Swan wrote, 'I expect as much happiness in it as a thankfull poore man can wish'. He survived the Great Plague in the following year, as did the other residents who remained during the epidemic, having not left the buildings for seven months. The charity was indeed fortunate during the calamities which struck London in the mid-1660s, with 'hardly a head aking of above forty left in the house in the great sicknesse year 1665 and not a tenement belonging to it touched in the fire time 1666'.[23]

That good fortune was not to last however, and in 1671 a fire destroyed a section of the Brothers' lodgings, which had been built in 1614. The statutes required the hospital to keep a range of fire-fighting equipment and a fire-engine was bought from the London maker William Burroughs in 1655.[24] Nevertheless, it

could not be deployed effectively when the fire broke out, and the buildings along part of the west boundary wall and the adjoining range facing the Great Court were gutted, with the flames spreading to the rear of premises in St John Street.[25]

Christopher Wren prepared a design for the new buildings, which the governors accepted, appointing Edward Woodroffe as surveyor of the project. Wren's connections with the Court and senior churchmen probably explain this commission. Woodroffe was Surveyor to the Dean and Chapter of Westminster from 1662, and Assistant Surveyor of St Paul's cathedral, where he worked with Wren. He was one of three surveyors appointed to rebuild the City churches after the Great Fire.[26]

The buildings were erected for a length of sixty feet along the boundary wall, and the adjoining range, newly built on the previous alignment, was of fourteen bays. Of three storeys and attics, it had a plain façade relieved chiefly by prominent string-courses and Sutton's coat of arms cut in Portland stone.[27] It may have contained rooms for as many as thirty-four Brothers, whose furniture at this period consisted of no more than a bed, chair, table and shelves.[28] Herne noted that £1,000 was taken out of the reserve fund because of the fire, but the cost may have been more than £2,000, including the subsistence allowances paid to the Brothers who had to be lodged out of the hospital, while their accommodation was being rebuilt.[29] To reduce that cost, the governors suggested that each of the undamaged rooms could be shared by two Brothers.[30] The Wren building was demolished in 1826.

This unforeseen expenditure came at a time when the charity's prosperity was becoming increasingly fragile. The endowment consisted largely of properties in southern England, on land which had generated a rising income during the long period of agricultural price inflation in the late sixteenth and early seventeenth centuries. The rental income had risen by forty per cent since the establishment of the charity, while the cost of living had increased by twenty per cent. But the estates were becoming less remunerative, as prices for both arable produce and livestock fell. Falling prices created problems, as tenants found themselves in difficulties, and a growing number asked for their debts to be cancelled or their rents reduced, which they backed with threats not to renew their leases. In some cases the governors were considerate, especially if the problems caused by 'the fall of the price of all Countrey Comodities' were intensified by other difficulties, but could concede only so much, having a very small income from other sources. Receipts were lower than the rents due in twelve of the years between 1660 and 1679, and in ten of those years there was a deficit on the annual account.[31]

Rent arrears grew steadily, from £6,129 in 1675 to £6,815 in 1680 and £8,409 in 1683. In 1687 some were removed from the account, 'in regard of the poverty and indigency of the persons from whome for the most part they have many yeares since beene due they are now become altogether desperate'.[32] The gross rental in 1684 was £5,187, a fall of almost £300 since 1675, and the rents due

from rural properties, for which new leases were agreed between 1677 and 1689, showed a decline of ten per cent. A submission by one of the Brothers stressed that all rents set when leases were granted should be at the true annual value, indicating that the former practice of setting some below their potential level had continued.[33] Yet his objective was not now achievable, although the governors had taken determined action to prevent the officers from benefiting from leases of the hospital's property, when, in 1676, they forbade them from taking such leases.[34] Sales of land were not an attractive option since prices were low, reflecting the general decline in income from agricultural land.[35]

Some improvement came from the development of the charity's estate in Clerkenwell in the late 1660s. Within twenty years almost the whole area had been set out with streets and nearly 250 small houses.[36] This brought some benefit, for the lease granted in 1668 for twenty-one years, at a ground rent of £30 per annum, was renewed and extended in 1681 for a yearly rent of £100.[37] Even so, by 1713 the proportion of the charity's rental contributed by its London properties was still no more than seven per cent.[38] Irregular sources of revenue were estimated at only £150 per year. Perhaps because of the hospital's reputation as a wealthy establishment, it received few legacies. Those who did make bequests were generally the governors or senior officers, and the sums were not large. Among the governors, the Marquess of Halifax and the Earl of Craven each bequeathed £100 during the 1690s.[39]

An appraisal made in 1680 criticised the eccentric accounting methods. It was estimated that the true figure for rent arrears was approximately £11,000, rather than the £7,000 which appeared in the accounts, but also concluded that the finances were essentially sound, with a potential annual surplus of £500.[40] Some economies were recommended, chiefly the removal of additions to the original expenses, reducing the number of Scholars from forty-four to forty, and of university exhibitioners from twenty-nine to twenty-four, with the sum paid for placing a Scholar as an apprentice halved to £20. These were implemented in 1685. Salaries also seemed to offer scope for savings. The senior officers' stipends had increased from £140 to £396 13s 4d per annum since 1613, with the Master's salary having risen fourfold. But the governors decided that they should remain at their current levels until new appointments were made, when they would be reviewed, and proposals for modernising the accounting procedures were not adopted.[41] Other savings were possible; for example, by reducing the cost of food served at the Master's table, which attracted critical comment because of the cook's lavish use of such ingredients as butter, fruit, spices and suet.[42]

Some reductions were made, but expenditure continued to rise nevertheless. In 1684 it was estimated at almost £5,500, an increase of £2,000 over the previous sixty years, and it averaged £5,700 per annum during the first decade of the eighteenth century.[43] Because of the failure to significantly increase revenue or curb expenditure, the charity was occasionally so hard-pressed that it was unable

to pay its suppliers promptly.[44] In 1677 they were owed 'a very greate some' and by 1687 the debt was £2,000, which had 'blasted' the honour of the house.[45]

The doubtful ability and questionable honesty of some of the staff undoubtedly contributed to the charity's problems. In 1661 the Manciple was suspended, having squabbled with the Brothers, and on investigation the governors realised that the only option, for the peace of the community, was to remove him from his post. His successor was appointed at the Brothers' request, but was subsequently criticised because of the quality of the food. When this was first raised, four Brothers were reprimanded for their 'mutinous Action' and the ringleader was suspended for being 'a mover and promoter of faction and disorder in the house'. Yet within a year the complaint that both the food and the cloth bought for the Brothers' and Scholars' clothing were of inferior quality, was upheld, and the Manciple was dismissed, 'much indebted, to the greate dishonour of this hospitall'.[46] The next Manciple, Colonel Henry Hene, resigned in 1671 when it was realised that he was 'not well skilld in the nature of that Place', and he was admitted as a Brother because he wished 'to passe his time with more quiett'.[47] In 1686 the Butler was removed for failing to account for beer delivered to the hospital worth £40.[48]

The financial situation gave the Brothers the opportunity to make known their dissatisfaction with Hene's successor as Manciple and with the Housekeeper, and they did so in an uncompromisingly worded petition. Presenting themselves as 'humble poore men and Christians', the Brothers complained that the two officers were defrauding the hospital by concealing the prices they paid at market, supplying inferior meat, not supervising the preparation of the food and providing the Brothers with only a half of the rations to which they were entitled. Their behaviour was offensive too, for they swore and blasphemed, bringing their mothers, wives and children into the kitchen, so that the Charterhouse was likely to become a hospital for women and children as well as for men and boys.

The Manciple, who hardly ever attended Chapel and never received the sacrament, had been in a 'meane and low' condition when he had taken the post, but now was said to be worth £20,000. Both he and the Housekeeper displayed their new affluence in an offensive manner, treating the Brothers as 'Doggs and Vassalls' and threatening to cudgel them as they went 'swaggering and domineering up and downe the House and Kitchen with theire swords by their sides ... though neither of them was scarce worth a Sword when they first came to this Hospitall'.[49]

The investigation made in 1680 produced the more serious insinuation that the charity could be, 'brought to confusion ... by the negligence and misdealing of the Officers Combining together'. It was alleged that because the Registrar, William Lightfoot, was an attorney 'in great Employment', he neglected his duties, that he and the Receiver were investing the hospital's money and retaining the interest, and that the Auditor failed to inspect the books properly. A further question was the propriety of the Auditor's additional role as steward for ten of the hospital's

manor courts, using the fees to supplement his own income rather than the charity's revenues. Despite the allegations, the Registrar, Receiver and Auditor, held their posts for twenty-five, forty-two and forty-seven years respectively, and the governors did not separate the posts of Auditor and Steward of the Courts until after the Auditor's death.[50]

Some issues raised during this period of investigations in the late seventeenth century were indeed addressed. The governors ruled that in future the Matron was not to be a married woman, and the officers and servants who were married were given one year to leave their posts. But the allegations against the senior officers were not followed up and a later attack on the running of the hospital by Richard Clarke, a Brother, was condemned by the governors as 'a false and scandalous libell' and he was expelled.[51] This negligence was to have serious consequences that did not become apparent until after the death of the Auditor, Richard Spour, in 1717. He had held the post since 1670 and for most of his time in office Robert Payne had been Receiver. Payne's father had been appointed Receiver in 1660 and Robert, who had been a foundation Scholar, had succeeded him in 1676.

When the new Auditor drew up an account for 1715-16, Payne was instructed to co-operate by supplying receipts and his own account of income and expenditure. This created difficulties for him, and by November 1717 he was forced to admit that he owed the hospital £2,500. Upon investigation, it was found that the true figure was more than £6,000. The governors' reaction was first to suspend and then to dismiss him, 'for his notorious violation of his Duty' in refusing to make up his accounts or pay the hospital the money in his custody. In the immediate aftermath of his dismissal, the governors agreed to lend £100 each, to help overcome the problems that had been caused, and they later converted these loans to gifts. In 1719 a judgement was obtained against Payne for £6,244 and he also conveyed to the governors an estate near Leominster, in Herefordshire, and a laystall in Stepney that was let for £72 per annum.[52]

Payne died in 1723. The award made in 1719 was not received; by 1718 only £400 had been recovered from his sureties. The Herefordshire estate was sold in 1729 for just £1,094, and his assignment of the profits of houses in London to the governors led to litigation with a widow, who claimed part of the profits, with the case continuing into the mid-1720s.[53] It is unlikely that the accounts for the earlier years of his tenure could be checked as effectively as those for the later ones, and he may have continued fraudulent practices which his father had established. No figures were provided for funds which Lightfoot and Spour may have appropriated. The losses to the three officers may have been equivalent to approximately two years' revenue.

Scrutiny of the charity's affairs around 1680 had also brought to light allegations regarding the admissions procedure, similar to those made before the Civil War. The application of the oaths of Supremacy and Allegiance, which seem to have been applied with enthusiasm immediately after the Restoration, had

become neglected, as had the taking of an oath that no money had been given for a place. As a result, several Brothers had bought their places, and some had been admitted who were not qualified, according to the founder's intentions and the governors' orders. Presumably this implied that they were not poor or that they did not in any way need a place in the hospital. There is little evidence for the social background of the Brothers, although the example of Richard Lewis supports the allegation of comfortable circumstances rather than poverty. At his death in 1691 the contents of his chamber included thirty-two pieces of gold, eight gold rings worth £12, silver to the value of £100, and linen and clothing valued at £25 8s.[54] Francis Keymer's background also suggests prosperity, for he was a member of a gentry family in Somerset. For him the Charterhouse provided a refuge from determined litigants rather than the effects of poverty, and he entered through the patronage of the Earl of Shaftesbury 'not being able openly to appeare and shewe himself in the country'.[55]

Allegations continued to be made regarding the Scholars: that some were sons of wealthy parents, some were heirs to considerable estates, and some had gained their place by bribery. The evidence for the social status of the parents of foundation Scholars is incomplete. Nevertheless, it does show that many were gentry or clergymen, with London tradesmen also represented, and some yeomen and husbandmen. Of sixty fathers whose sons were nominated in the 1660s and 1670s, and for whom such information was recorded, twenty-nine were gentlemen, twelve clergymen, eight esquires, three doctors, two knights, two servants of the charity and the remainder were an innkeeper, a goldsmith, a clockmaker and a yeoman.[56] The evidence can be misleading. For example, when John Evelyn used his influence with the Lord President of the Council, a governor, to gain admission for a boy, he could justify this because his mother was a widow, 'formerly living plentifully, now falln to want'. Her social status and contacts masked her actual circumstances.[57]

The earlier procedure of examining Scholars who were to go to university may have lapsed, for in 1677 the governors ordered that the practice should be followed, and that those who were to be placed as apprentices required a certificate of their good behaviour at the school before they could be apprenticed. The governors' assembly which approved these measures also agreed to expel a Scholar for persistent bad behaviour, which would have a corrupting effect on the other boys.[58] Yet the school was evidently popular and the Schoolmaster gained the governors' agreement to take in boarders, sanctioning an existing practice.[59] During this period the Charterhouse emerged as one of England's leading grammar schools, together with St Paul's, Westminster, Winchester, Eton and Merchant Taylors'.[60]

The charity's connections with the Court remained strong, and William Erskine, a son of the Earl of Mar, succeeded Clifford as Master in 1677. He was one of the five Cupbearers to Charles II appointed in 1660, and a Fellow of the Royal

Society, described by John Evelyn as 'a Wise and learned Gent' who would have been better employed as 'a Privy Councelor and Minister of state than laied aside'.[61] He was uncle to Anne Scott, wife of the Duke of Monmouth, and she may have given him the full-length portraits of Charles II and five governors which now hang in the Charterhouse.[62]

Monmouth was elected a governor in 1675 and attended eight of the next twenty-four assemblies. He was the darling of those Protestants who wished to remove his Roman Catholic uncle, James, Duke of York, from the succession. But after he was convicted of high treason, for raising a rebellion against James after he had come to the throne, he was displaced as a governor in June 1685, just before his execution.

At their previous assembly in May, the governors had appointed Thomas Burnet as Master, to replace Erskine who had recently died.[63] With his appointment, the governors reverted to the choice of a clergyman, albeit one who wore a 'lay habit'. He was about fifty years old when he was appointed and was to hold the post for thirty years, until his death in 1715. The governors no longer insisted that no other positions could be held at the same time as the Mastership, and in 1689 Burnet was appointed Chaplain in Ordinary and Clerk of the Closet to William III.

Burnet had been educated at Cambridge, where he had come under the influence of the Platonists, among whom was Simon Patrick, brother of John Patrick the future Preacher at Charterhouse. In 1681 Burnet published the first two books of his major work, *Telluris theoria sacra*. This was in Latin, but, at Charles II's request, he prepared an English translation, *Sacred Theory of the Earth*, completing the work in 1689 with the publication of its two final books. By 1726 it had gone through six editions. Burnet's concern was to reconcile the world as he saw it with the scriptural account of the creation and the flood, as described in the first chapter of the Book of Genesis. His theory was that the earth had been a smooth and featureless sphere; indeed, literally 'without form', and that the waters beneath had broken through the crust as a divine punishment for a sinful world, creating the earth's varied landscapes before receding. Burnet was attracted to the grandeur of the landscape, especially the mountains and the seas. In the second part of the work he discussed how God would end the world through fire, creating a new heaven and earth where man would live without sin.

He developed his arguments in his *Archaelogiae Philosophicae: sive Doctrina antiqua de rerum originibus* (1692), which he dedicated to William III. However, his allegorical treatment of scripture and the thesis that God had created the world through natural causes, not miracles, were too controversial to gain acceptance by the Church, and he was forced to resign his post as Clerk of the Closet. His abilities were such that he had been considered a possible future Archbishop of Canterbury, but when the post became vacant in 1694, on the death of his friend John Tillotson, he was passed over because of his unorthodox interpretations of scripture. Two later works were not published until after his death.

Burnet was also drawn into controversy as Master because of his role in opposing James II's attempt to gain a Brother's place for a Roman Catholic, Andrew Popham.[64] Robert Spencer, Earl of Sunderland and one of the Secretaries of State, was appointed a governor in April 1686 and attended an assembly in the following November, but did not take the Oaths of Allegiance and Supremacy. He instigated the attempt to place Popham in the Charterhouse, supported by George Lord Jeffreys, who had been appointed a governor in October 1685, in his capacity as Lord High Chancellor. The King's letter to the governors regarding Popham was delivered in December 1686 to William Lightfoot, the Registrar, not to the Master, and Lightfoot then issued a certificate for Popham's admission. The attempt to circumvent the Master was inept, and when Popham presented his certificate to Burnet he was told that as it was addressed to the governors they should discuss it before he could enter, which they did at their assembly in the following January.

At that assembly, Burnet, as the most junior governor, was called upon to vote first, and he pointed out that the Act of Parliament of 1628 required that all governors, officers and Brothers had to take the Oaths of Allegiance and Supremacy prior to admission. When a governor questioned whether this was relevant, Burnet was supported by the Duke of Ormond, his patron, who commented that 'an Act of Parliament was not so slight a thing, but that it deserv'd to be consider'd'. After some discussion, the motion that Popham should be admitted was defeated, and Jeffreys and some others left abruptly. No letter could be sent to the King because the assembly was not then quorate, having fewer than nine governors.[65] Some other business was transacted at that assembly and at others without the requisite number of governors being present, but a quorum was doubtless thought necessary for such an important matter.

Before the next assembly at which the issue was discussed, in June 1687, the King granted Popham and five other men a 'Lycence Dispensation and Pardon' to hold places procured by Sunderland without conforming to the Church of England and taking the Oaths of Allegiance and Supremacy. Philip de Cardonel, another of his nominees, presented his letter at the Charterhouse, and the King sent a letter and his Letters Patent to the governors, requiring them to admit Popham, giving him precedence over de Cardonel.[66]

Nevertheless, they held to their earlier resolution, and a letter was prepared and signed by eight of the governors, including Burnet, informing the Earl of Middleton, one of the Secretaries of State, that the Charterhouse was a private hospital, and that the governors were required to act according to its constitution, referring to the Act of 1628. Lacking the signatures of a majority of the governors, the validity of the letter could have been questioned, but the King did not persist with his attempt, and Popham was not admitted. From his nineteenth-century Whig perspective, Lord Macaulay was appreciative of the governors' stance and wrote that the King, 'was daunted by the great names of Ormond, Halifax,

Danby, and Nottingham, the chiefs of all the sections of that great party to which he owed his crown', having successfully resisted the movement in the 1670s and early 1680s to exclude James from the throne, on account of his faith.[67] Popham's case at Charterhouse in fact coincided with James's bruising encounter with the fellows of Magdalen College, Oxford, where he intervened in the appointment of the college president.

The governors were indeed too senior to be censured over such a matter, and although it was suggested that Burnet might be called before the Ecclesiastical Commission, he did not face further action. He had previously made his position more secure. Although Sydenham had been appointed to the position of Master for life, Erskine, Clifford and Burnet had been appointed during, 'the wills and pleasures' of the governors. When Burnet challenged this in December 1686, his terms of appointment were changed, and he was given the post for life.[68]

In his account of the dispute, Burnet cast the Charterhouse in the heroic role of a small frontier garrison that had halted a great army, setting an example to the rest of the country so that it could prepare to defend itself. While this comparison may have been apt, the affair's significance was rather greater than his description of the Charterhouse as simply a 'private Hospital' would suggest, given the governors' seniority, and its role as England's foremost charity. Indeed, its standing made it a suitable place for the King to test his policy of using his supposed dispensing power. In doing so, he could secure the admission of Roman Catholics to positions from which they were excluded by the Test Acts, even though some governors could be expected to oppose his attempt. He had clashed already with William Sancroft, Archbishop of Canterbury, and Henry Compton, Bishop of London, on a separate matter, arising from his 'Directions to Preachers' of March 1686. Peter Mews, Bishop of Winchester, and the Marquess of Halifax could be expected to oppose any attempt to circumvent the taking of the oaths. Contemporaries believed that the Earl of Danby, who was present at the assemblies which discussed Popham's case, took a leading role in opposing the King over the dispensing power, and James did hold him responsible for the governors' opposition.[69] And so, it seems that at least five governors were likely to resist Popham's admission.

On the other hand, the court's calculations may not have been completely wide of the mark. The King had the support of Jeffreys and those who left the assembly with him and, in the event, only half of the governors signed the letter to Middleton explaining their position. The governors who had attended the assembly in January, but not in June, were the Duke of Beaufort and the Earls of Rochester and Mulgrave. They may have left when Jeffreys did, or at least supported the King. The Earl of Berkeley, who had not been present in January, but was at the June assembly, did not sign the letter. If Sunderland and Berkeley had attended the assembly in January 1687, the King may have had the support of up to six governors, at a time when attendance at assemblies was commonly at least eight, but no more than ten.

Moreover, Ormond and the Earl of Craven had been consistently loyal to the Stuart monarchy, and the Court may have counted on their support, although in the event they opposed Popham's admission. Daniel Finch, Earl of Nottingham, signed the letter to the King, but had been chosen as a governor since January, and so would not have figured in the court's initial calculations of support.[70]

Sunderland was to become the most prominent convert to Catholicism during James's reign, announcing his conversion after the birth of an heir to the throne in June 1688. He never did take the oaths, and yet not until May 1689, after he had fled the country, did the governors rule that his place was vacant. Jeffreys escaped abroad in the wake of the Glorious Revolution, but was not replaced as governor until after his death in April 1689, and there was no purge of the governors as there had been in the late 1640s and early 1660s.[71]

In choosing to present Popham as a Brother, the Court may also have been influenced by the earlier slackness in taking the Oaths of Allegiance and Supremacy, and perhaps by the charity's reputation for being indulgent to Catholics. Condemned by the Puritans earlier in the century, this could now be interpreted as the toleration which James was endeavouring to promote, which relieved both Dissenters and Catholics from discrimination.

The case of Erasmus-Henry Dryden suggests that there was some leniency in applying the religious requirements to the Scholars. He was the third son of John Dryden, the Poet Laureate, and his two older brothers had been sent to Westminster School, under Dr Busby. But Charles II nominated Erasmus-Henry to a Scholar's place at the Charterhouse, and he entered in February 1683. When he left in November 1685, he did not join Oxford or Cambridge, but went instead to the Catholic college at Douai, and later became a Roman Catholic priest. His brother John may have become a Catholic by 1685 and, although their father apparently had not converted by then, their mother Elizabeth (daughter of Thomas Howard, Earl of Berkshire, and Elizabeth Cecil Howard) was, like some other members of her family, at least sympathetic to Catholicism. She felt the need to assure Dr Busby in 1682 that John would 'duely go to church heare' before entering Westminster, perhaps to assure him of John's religious orthodoxy, for this was an undertaking which most parents would not have needed to give. Busby could have had concerns about the family's religious leanings after teaching Erasmus-Henry's brothers, and so his parents preferred to send him to the Charterhouse because it was supposedly less rigorous in such matters.[72]

Dryden left at the beginning of a long period of stability at the school. Burnet's thirty years as Master were far surpassed by Thomas Walker's service as Schoolmaster, from 1679 until his death in 1728 at the age of eighty-one. John Stacy held the post of Usher for ten years and when he left in 1695, he was succeeded by Andrew Tooke, who retained the post until 1728, when, following Walker's death, he was appointed Schoolmaster. Tooke was permitted to hold the post of Professor of Geometry at Gresham College from 1704.

Among the boys during Walker's long tenure were Sir Richard Steele and his contemporary Joseph Addison, both of whom pursued political and literary careers (they were leading members of the Whig Kit-Kat Club), forming a celebrated and influential literary partnership; John Davies, who became President of Queen's College, Cambridge, in 1717; and Martin Benson, appointed Chaplain to George II in 1727, and Bishop of Gloucester in 1735. Benson later recalled that he was 'educated in grammar learning' at the Charterhouse, and remembered the place with affection. Despite his successful career in the Church, he was said to have coveted the Mastership of the Charterhouse, beyond all else.[73]

On Burnet's death Steele wanted the post, and canvassed for it.[74] He petitioned the King, but as he was married and held the post of Surveyor of the Stables at Hampton Court, he was disqualified from being appointed to the position. Steele was knighted in 1715, although to reward his political career rather than his literary achievements. The Preacher, Dr John King, was appointed Master of the Charterhouse.

CHAPTER 6

A SCENE OF HORROR AND WRETCHEDNESS

The appointment of John King broke with the previous practice of appointing someone from outside the charity to the post of Master. Only in the case of Cressett in 1650 had an officer been promoted to the post, and that was after he had been Registrar for just a few months. King, however, had entered the Charterhouse as a Scholar, and, after taking a BA at Christ Church in 1682 and an MA three years later, he had returned in 1696 as Preacher. When he succeeded Burnet, he was the first pupil from the school to be appointed Preacher and Master, and was very proud of his achievement.

The governors' choice probably reflected their awareness that King possessed the level of knowledge of its affairs that was required. He took a BD and DD, but was an able administrator, rather than a scholar or theologian, as his immediate predecessors had been. King used the experience which he had gained of the establishment over the previous twenty years to restore the financial situation and tackle other problems, missing only eight of the sixty governors' assemblies held during his Mastership.

Many aspects of the administration continued unchanged. Applicants for the officers' posts and Brothers' and Scholars' places approached the governors or their contacts at court, in the government or the Church to gain support.[1] In 1730 two governors who were expert manipulators of the political network, Sir Robert Walpole and the Duke of Newcastle, were both canvassed before an election for places at the Charterhouse, partly because the Duke of Somerset was thought to be gaining a disproportionate influence over such elections. Political and personal rivalries were not set aside when places at the Charterhouse were to be filled, nor were elections simply endorsements of agreements made in advance of an assembly.[2] In 1734 three candidates were considered for the rectory of Little Hallingbury, one of whom received two votes and the others five each, and the governors had to meet again a week later to resolve the matter.[3] A much longer delay followed a tied vote, when two applicants for the post of Physician were being considered in March 1751. It was not until an assembly in June of

the following year that one of them was selected.[4] In many cases, the governors consulted the records to confirm existing rules and check precedents. Even so, they broke with previous practices on occasion, as in 1737 when they appointed as Usher the applicant who had not been to the school in preference to one who had been a foundation Scholar.[5]

The Brothers during the period included John Bagford, collector of books and broadsides, who died at the Charterhouse in 1716, and Elkanah Settle, who, like Martin Clifford, had been among Dryden's literary adversaries and was satirised by him as the 'heroically mad' Doeg in *Absalom and Achitophel*. Settle was first fiercely Whig and then strongly Tory during the Exclusion Crisis of the early 1680s, but secured the appointment of City Poet in 1691. His many dramatic works included *Distressed Innocence, or The Princess of Persia*, for which Henry Purcell provided the overture and act tunes, and he has also been suggested as the librettist of Purcell's semi-opera *The Fairy Queen* (1692), adapted from Shakespeare's *A Midsummer Night's Dream*. His city and literary connections and collaborations with Purcell would have given him contacts at the Charterhouse, where he spent the last six years of his life until his death in 1724. Samuel Johnson did not dignify the almshouse with a name, commenting only that Settle, 'died forgotten in an hospital', allegedly so poor that he owned only one suit of clothes.[6]

Two royal governors were entitled to nominate candidates: Queen Anne and her consort, Prince George, during her reign and, after the accession of George I, with Queen Sophia remaining in Hanover, the King and the Prince of Wales. In 1716 the Prince was chosen as one of the sixteen governors, although the assembly at which he was elected was the only one that he attended. He relinquished that position when he came to the throne in 1727 and thereafter he, Queen Caroline and Frederick, Prince of Wales, each had the right of nomination.[7]

The board of governors during the early eighteenth century contained no more than three clergymen, including the Master, while the majority were members of the House of Lords. No Bishop of Ely was appointed after the death of John Moore in 1714, breaking a practice that had been initiated by Thomas Sutton. Following the death of William Talbot, Bishop of Durham, in 1730, the pattern that was established was for the Archbishop of Canterbury and the Bishop of London to serve as the ecclesiastical governors.

So far as the financial administration was concerned, John King certainly wielded a new broom. He exposed the Receiver's peculation and revised his muddled accounts, which were expressively described as 'intricate and brangled'.[8] He made four circuits of the hospital's properties and familiarised himself with the tenants' problems, supervised repair of the sea walls in Essex and the addition of a chancel to St Leonard's church at Southminster, one of eleven benefices bequeathed to the charity by Thomas Sutton. He was the first Master to visit Elcombe, in Wiltshire, for more than ninety years, and was able to increase the revenue from the farms

there. At Lady Day 1715, the hospital owed its suppliers more than £1,160, but he recovered £4,500 of rent arrears, which allowed him to clear all outstanding bills and debts by 1719, 'a thing not known in the memory of man'.[9]

Following the discovery of the scale of the mismanagement, the reform of accounting procedures suggested earlier was implemented. In an attempt to limit future misappropriation of revenue, the governors ruled that none of the four offices of Registrar, Receiver, Auditor and Steward of the Courts, should be combined, another change that had been recommended more than thirty-five years earlier.[10] Many governors' assemblies were held at Whitehall and it was now agreed that at least one each year should be at the Charterhouse, which allowed closer oversight of the charity's affairs, as well as an awareness of the condition of the buildings.[11]

An Act of Parliament was obtained in 1721 that reduced the quorum from nine governors to five, to allow business to be dealt with more quickly. In the following year the governors decided that the Master could hold any office or benefice, in Church or State, so long as he still resided in the hospital and continued to supervise the life of the community.[12] Evidently this was done to permit King to be appointed Archdeacon of Colchester, and may reflect his careful observance of the rules in such matters; the question had not been raised in the case of Burnet. In 1728 King was also appointed a Canon of Bristol, and thereafter the Master and Preacher commonly were pluralists.

The changes made in the years after King's appointment and his careful oversight of the administration saw the charity's rental income increase, from a little over £5,500 in the early 1720s to £6,200 by the late 1730s, when the surplus on the current account averaged £400.[13] In 1736 it was recommended that this figure should be allowed for repairs each year, 'The Buildings growing now very Old'.[14] The reserve was no longer large enough to allow property to be bought, as income could be increased only by raising rents, and the period of low agricultural prices in the first half of the eighteenth century restricted the scope for such rises. By 1748 arrears had increased again, although owing to a further fall in farmers' incomes, rather than neglectful administration. The prices of agricultural produce over the period 1743-7 were ten per cent below those during the previous five years.[15]

The improvement in the charity's finances permitted repairs to the buildings. The Physician's house adjoining the gatehouse was demolished and in 1716 a new one was built, the cost of £800 being shared equally between the charity and the Physician, Henry Levett.[16] (This is now the Master's lodge.) King was concerned about the condition of the Chapel, and in 1726 he and the Bishop of London oversaw its renovation, an expensive undertaking that was possible because the reserve fund contained £1,400.[17] The ceiling over the north aisle was boarded, to match that over the south aisle, and two of the tall windows on the south side were made to conform to those opposite by filling in their lower sections, and

the easternmost window on that wall was completely filled in.[18] The windows were re-glazed with clear glass. The upper part of the south wall was rebuilt, in brick, and the roof over the south aisle, which probably dated from the early sixteenth century, was replaced. Internal alterations included re-paving the floor with stone slabs, the restoration of the east window, and the panel above the altar with the Ten Commandments, with the direction that they should be 'beautified with proper ornaments', and the addition of a decorative cartouche to the organ gallery.[19] The work was characteristic of the period, especially in the treatment of the ceilings and windows, to create greater uniformity. But King's more elaborate plans for a monument to himself would have required considerable changes to the south aisle, and so were not implemented. Furthermore, because the conditions that he stipulated for other bequests from his estate were not met, none of them came to the charity.[20]

The principal benefactor during the period was Dame Elizabeth Holford, whose bequest of £4,700, in her will of 1717, provided for eleven exhibitions for Scholars at Christ Church, Pembroke and Worcester colleges and Hart Hall, Oxford.[21] The arrangements were implemented in 1728 and in 1745 the exhibitions at Hart Hall were transferred to University College.[22]

On King's death in 1737 the governors appointed Nicholas Mann as Master, reverting to the earlier practice of choosing someone from outside the charity. Mann was a scholar and antiquary, who had attended Eton and King's College, Cambridge, and he held the posts of King's Waiter at the Custom House and Keeper of the Standing Wardrobe at Windsor. His scholarly connections may explain why the Royal Society carried out some experiments with artillery in the Master's garden during his tenure of the post. By 1750 he had caused a tablet to be placed above the door into the ante-chapel, with an inscription that informs those approaching the Chapel that he had been Master and enjoins them to do good for their community; the marble slab over his grave outside that door is plain. He died in 1753 and bequeathed to the hospital a 'brass horizontal dial' set in the wall of Chapel Cloister, his copy of John Rocque's map of London and its surroundings, which was 13ft long, and a portrait of Spencer Compton, Earl of Wilmington, briefly Prime Minister in 1727 and again in 1742-3.[23]

John King had a strong and positive influence on John Wesley, the founder of Methodism, who came to the school in 1714. A nominee for a Scholar's place could wait for five or six years before being admitted and so, to ensure that he was not then too old, it was advisable to nominate a candidate when he was six or seven. The upper age for admission, originally set at fourteen, had been raised to fifteen in 1669. When a governor died before his nominee had been admitted, the boy nevertheless was entitled to enter, if he was not too old.[24] Wesley's father was chaplain to the Duke of Buckingham, a governor, who nominated him to the Scholar's place in May 1711, so his wait of three years was shorter than that of many applicants.[25]

Wesley was fortunate, for eleven Scholars were admitted in 1714, but the average number was just eight each year, and so some boys failed to gain admission, even though they had influential support. Walter Leightonhouse, rector of Washingborough, near Lincoln, gave two sermons in one day and later that day died, suddenly and unexpectedly. His widow inherited barely enough money to settle his debts, and was concerned that she would be too poor to bring up their eight children satisfactorily. But one of their sons had 'a good proficiency in learning' and so she petitioned the Queen for a nomination to the Charterhouse. Although her application was supported by a number of people, including the Bishop of Lincoln, she was not successful.[26]

The school building was the tennis court erected by the Duke of Norfolk *c.* 1571, enlarged and adapted in 1614. By the eighteenth century its condition had deteriorated considerably, and the practical arrangements were unsuitable. In 1701 a boy drowned in the pond close to the Scholars' privy, and to prevent another similar tragedy a new privy was constructed, in a more convenient place.[27] A survey in the middle of the century showed that the school building had many defects. The structural timbers were sound, but the boarding of the floors and stairs needed renewal, the roof required repairs and, alarmingly, six or eight more pillars were necessary to provide additional support for the upper floor.[28]

The problems were noted in a letter to the Duke of Bedford, one of the governors, in October 1749. The writer criticised the condition of the Scholars' lodgings in the strongest terms, describing them as having the appearance of cells for condemned malefactors rather than those in an institution with an annual revenue of £6,000.[29] The school building was 'a Scene of horror and wretchedness', the result, so the writer alleged, of neglect that contrasted with the care given to the Brothers' lodgings. The small rooms or 'cabins', each of which was occupied by two boys, who shared a bed, were ranged on either side of the long gallery. Little light or air entered the gallery because the window at the end had been bricked up, and ventilation was provided by holes in the walls. The rooms on the east side were badly lit and ventilated, and the lath-and-plaster walls between them were so badly broken that in places a boy could squeeze through. The doors had been removed and the windows were so cracked and damaged that the Scholars were 'miserably exposed to cold'. The Master admitted that the rooms were 'generally ruinous', with walls 'full of gaps and breaches and very nasty'. He was also aware that they 'served sometimes for wickedness, and always for nastiness'.[30] But the provision of a window for each room on the east side would require the rebuilding of the wall.[31]

The boys roamed freely around the buildings at all hours, contrary to the rules, and the Schoolmaster wished to put a stop to the Brothers encouraging the Scholars to visit them in their rooms.[32] But the solution introduced in 1741, of locking the boys in overnight, was a dangerous one.[33] The servant who held the key lodged in another building some distance away, and the danger of that

arrangement if there should be a fire was all too obvious. Furthermore, the lavatory provided so that the boys did not have to leave the building at night was a room which opened directly off the Scholars' hall, where they ate, 'as one Room into another'.[34] Mann's response was to order that holes should be made in its walls 'to emit bad vapours'.[35]

The physical conditions may not have been quite so bad in Wesley's time, but the diet was woeful. He later recalled that the older boys snatched the younger ones' meat, and so he lived mainly on dry bread, 'and not great plenty of that'. Even so, Wesley thought that the sparse diet had contributed to his excellent health in later life, and he followed his father's advice to take regular exercise by running round the green three times every morning.[36] The beer supplies were plentiful, though. Over a two-year period during Wesley's time an average of 700 pints a week were delivered to the Scholars' hall, but it had to wash down some dreadful food.[37] The school staff complained that the boys were not receiving salads and other produce from the garden, and that successive manciples had supplied them with less than the stipulated quantities of meat. What is more, the meat was often 'unmarketable, unwholesome and stinking'. Cold food was served in the winter and the boys had to wait until the servants had taken their food. Furthermore, although the serving of salted fish had been discontinued some time before, partly because it produced 'ill humours and itchy indispositions', it had been reintroduced, and the Manciple was supplying a 'rotten and corrupt sort of it'.[38] The itchiness may not have been entirely due to the quality of the fish, for the Schoolmaster asked for a budget from which powder and soap could be provided for the boys, to help keep them 'Sweet and clean'. The Matron was responsible for washing the Scholars and combing their hair, but he suggested that a groom should be appointed for those tasks. The original arrangements, in 1614, had included such a post, but that had been allowed to lapse.[39]

Food and drink were the largest category in the budget, costing an annual average of £2,211 in the mid-1720s, equivalent to thirty-seven per cent of the charity's expenditure. Yet their quality and quantity frequently annoyed the Brothers, and provoked them into making complaints. In 1714 these were upheld and the Manciple was dismissed for providing unwholesome food and engaging in such dubious practices as reducing the size of the loaves, by 'chipping' them, and taking slices of meat and quantities of beer, claiming them as his allowance. The governors ordered an enquiry, recognising that the number of Brothers who failed to attend meals reflected the unsuitability of the food; some of them just could not 'bear with the usual Diet of the Hospitall'.[40]

Whatever changes were made did not entirely relieve the Brothers' distress, and in 1718 they petitioned the governors regarding the food, but the complaints were found to be unjustified, and the governors took exception to the continuing 'clandestine insinuations'.[41] But the intervention of Thomas Walker on the Scholars' behalf was effective, and in 1724 the Manciple was dismissed. The

governors confirmed the existing system by which two Brothers accompanied the Manciple to market, to examine the quality of the food and as a check on the accuracy of his accounts. But the food remained less than satisfactory and in 1737 a committee was instructed to consider altering the diet, especially the ingredients of the salads and the vegetables.[42]

Problems had arisen because of the gardener's increasing problems meeting his responsibility to supply fruit for the Master's table, vegetables and salad plants for the kitchen, and medicinal herbs, to reduce the apothecary's bills.[43] In 1731 he reported that, despite his efforts to prepare the kitchen garden for planting, he was unable to produce the crops that had been grown in the past. This he attributed to air pollution caused by 'the smoke from so many neighbouring Brew-houses, Distillers and Pipe-makers lately set up'. Because of its effects, he was forced to buy herbs and roots at market, although some vegetable and salad crops continued to be grown there throughout the eighteenth century.[44]

The Brothers won a victory in 1730 when they protested that they had to fast from six o'clock in the evening until midday the following day. They were now permitted to take broth from their evening meal to their rooms to keep overnight as a breakfast. The time of the morning meal had been moved from eleven o'clock to midday at the officers' request, prolonging the Brothers' fast, and in 1731 morning service was accordingly moved on an hour, to eleven o'clock.[45]

Whether driven away by the shortcomings of the diet or for other reasons, it had become common for a number of Brothers to be absent for several years, while drawing their pensions. In 1727 the governors ordered that two months in one year was to be the limit; any longer absence without permission would be punished by expulsion.[46] The governors were sympathetic in the case of Brothers who joined the Royal Navy or the army, despite their age, and those who genuinely needed to be cared for in the country because of poor health. But some Brothers were punished for their absence, refusing to eat in hall, or insolent behaviour and swearing. One was expelled for a range of offences, including not removing a woman 'that had kept him company for several years in his Chamber night and day'. In 1731 the governors repeated the rule that Brothers should not be married men, and that no women were to be allowed to live in the hospital, except for the two matrons, their families and servants.[47]

That order was cited in 1742 to justify the expulsion of Anna Williams, who was living in the Charterhouse nursing her elderly and infirm father, Zachariah Williams. He complained that he had never heard of the order and that, 'it is well known, that there are Numbers of Women and Girls, who commonly reside and lodge within the Gates of that Hospital, who appertain not to the Matrons or their Families'. After some bickering, the governors eventually expelled him in 1748, for disobedience; the servants ensured his compliance by removing the doors, casements and window shutters from his room, and carried away his furniture, leaving him, as he complained, upon the floor. He also protested that some of his

papers and scientific instruments had been lost and muddled when his room was dismantled. One of his research interests had been the problem of time-keeping at sea, but the Commissioners of Longitude had rejected his apparatus. Williams' criticisms of life in the Charterhouse were no doubt coloured by his wretched experience, but he did comment that the staff would not care for a sick Brother who was not prepared to hire them privately, and that there was no 'regular good Nurse belonging to the Place, though much wanted', a point which had been made in 1662.[48]

The boys, too, could be expelled for misbehaviour, although the preferred punishment was a 'solemn and publick Recantation' for such offences as 'beating and misusing the younger scholars'. Clearly, life there was not entirely peaceful, and there were many enticements and distractions, some of them outside the hospital, which led some 'unruly scholars' to escape by climbing the walls.[49] Wesley later recalled that while he was at the school, 'outward restraints being removed, I was much more negligent than before, even of outward duties, and almost continually guilty of outward sins, which I knew to be such, though they were not scandalous in the eye of the world'.[50] A few months after he had left in 1720 to go to Christ Church, Oxford, nine boys in the top two forms were reported to the governors for unspecified 'great misdemeanours and disorders', for which they had to make 'humble submission'.[51] They were not incorrigible miscreants, however, for five of them subsequently made their careers in the Church (one became Bishop of Down in 1752 and of Raphoe in 1753), and another was apprenticed in the Six Clerks' Office in Chancery. About ten years later the situation had arisen whereby a group of pupils, who were boarders but not on the foundation, did not have seating in the Chapel. They were supposed to attend a nearby church, but were found to have 'wholly absented themselves from Divine service', which was undesirable because of 'the great hazard of corrupting their Morals and the manifest diminution of the reputation of the school'.[52]

Although discipline may have been a problem, the academic abilities of the staff could not be doubted. Thomas Walker was noted for his scholarship – the inscription on his tomb describes him as an exact scholar in Greek, Latin and Hebrew – and Tooke was a Mathematician and a Fellow of the Royal Society. Wesley's brother Samuel was proud of John's achievements at the school, writing to their father that he was learning Hebrew 'as fast as he can'.[53]

Following Tooke's death in 1731, James Hotchkis became Schoolmaster, having been a Scholar and exhibitioner, returning as an assistant for almost seven years, before being appointed Usher and later Schoolmaster. Described as 'a very good natured man', he had a close knowledge of the conditions at the school and was solicitous for the pupils' welfare.[54] But he did have problems maintaining discipline and within three years of his appointment had to appeal to the governors for help in the case of a Scholar who he accused of 'confronting one of the Pensioners and of his refusing to submit to the correction of the School'.

Because of the intervention of relatives, the boy was not expelled, but had to admit his wrongdoing and was sent to All Souls, Oxford, despite his 'general neglect of his studies and learning'. Other problems followed and soon afterwards a boy was withdrawn from the school 'in order to brake him of some bad habits, which he had here contracted'.[55]

The boys' misconduct included 'Assaulting and beating of the Servants of the House', which culminated in 1741 with a serious breakdown of discipline when, following complaints about the behaviour of the Captain of the school, a rebellion erupted which involved the siege of the Matron's house, and the dousing of her maid by the boys.[56] The governors asked Hotchkis to resign, but he refused and was vindicated by a committee of the governors, appointed to consider the state of the school, which, somewhat surprisingly, found that discipline was 'in an orderly State'. Following their report, examinations were extended to all pupils, not just those who were to go to university.[57] Nevertheless, in the following year a father withdrew his son, complaining to Lord Dartmouth, the governor who had nominated him, that the standard of education was too low.[58] Hotchkis did resign in 1748 and shortly afterwards was presented by the governors to the living of Balsham, which he had applied for ten years earlier.[59]

Hotchkis' successor, Lewis Crusius, was fined by the Master, soon after taking up his appointment, for his mismanagement of the school and for not maintaining discipline. Crusius appealed to the governors, who supported him and cancelled the fine. Nevertheless, they were concerned about the school and following Mann's death in 1753 Crusius presented them with a report. He had found that some Scholars came to the school unable to read and write and lacking knowledge of religion and decent manners. The boarders and day-boys were not so badly prepared, but it was thought necessary to reinstate subjects dropped by his predecessors and to add English and Geography. Crusius stressed that he and the Usher had too many pupils to look after and the governors, impressed by his 'care and abilities', allowed him an extra £40 per annum to employ an Assistant Usher.[60]

In his first year, Crusius insisted that the current sixth formers remain at school for an extra year and would not allow any of them to go to university, but generally, despite the problems, the number of exhibitioners at the universities was maintained. Crusius remained as Schoolmaster until 1769, and he adapted the building facing Charterhouse Square on the south side of Chapel Court for up to twenty-three boarders.[61] There was insufficient accommodation in the school dormitories and by the early 1760s, when there were more than 100 pupils, four boarding houses were used, including the Schoolmaster's house.[62] In 1754 plans were drawn up for a new school building, but they were not executed, although a number of the officers' apartments were renovated during this phase of work on the buildings.

Wesley returned to the Charterhouse in 1727 to act as a steward at the annual

Founder's Day dinner. This had become a rather grand affair, with so many staff to attend to the diners that the invitation stated that 'Gentlemens servants will not be admitted to wait at dinner'. The fare was in marked contrast to that provided at the school, and included rabbit, chicken, various fowl, lobsters, whiting, flounder, eel, shrimps and venison pasties, followed by pear and almond tarts, at a cost of £34 in all. Port, claret and a sweet fermented juice known as arrack added £30 5s 6d to the bill, and the ten musicians were hired for twelve guineas. The dinner was commonly held elsewhere, at livery company halls in 1720 and 1728, and more often at inns: the Crown behind the Royal Exchange from 1721 to 1726 and at the Crown & Anchor, near St Clement Danes church, throughout the 1730s.[63]

More than ten years later the Charterhouse provided a more tranquil haven for Wesley. On his return from Germany in 1738 he met Jonathan Agutter, who had entered as a Brother in 1733, and began to visit him regularly. Agutter was a member of the Religious Society in Fetter Lane, and arranged for Wesley to have a room at the Charterhouse to study in. He was there frequently during the early months of 1739, and the time which he was able to spend in quiet reflection was important in the crystallisation of his beliefs.

Wesley also visited the charity's organist, Johann Christoph Pepusch. Nicholas Love had held the post for fifty-one years, despite some 'indecent behaviour' at the Master's table in 1688, which caused him to be threatened with demotion to the Manciple's table.[64] Love's petition for a Scholars' place for one of his sons because he had 'a great charge of Children' and by misfortunes had been 'reduced to great poverty' met with a frosty response, but his request in 1710 that, as he was elderly, his son Thomas should be his assistant was approved.[65] He died in 1713, and Thomas succeeded him, and he, in turn, held the post until his death in 1737, which brought to an end a period of three-quarters of a century, during which he and his father were the organists at the Charterhouse. The governors then appointed Pepusch, a distinguished composer and musical theorist, who had come to England as a political refugee, establishing himself so successfully in London's musical world that he was employed by the Duke of Chandos at Cannons as Master of the Music. Chandos became a governor of Charterhouse in 1721 and it is almost certainly through that connection that Pepusch was appointed organist.[66]

Although he was no longer active as a composer, Pepusch continued with his theoretical work, and remained a major figure in the capital's musical establishment. He was visited at the Charterhouse 'as an oracle' by both students and senior figures in the profession. He was a founder of the Academy of Ancient Music, and in 1746 was elected a Fellow of the Royal Society.[67] A composer of masques, odes, sonatas and anthems, he is now best known for the overture and other music he arranged for John Gay's, *The Beggar's Opera*. Pepusch died at the Charterhouse in 1752 and was buried there. In 1767 a wall monument to him was erected by the Academy of Ancient Music.[68]

A few years after Pepusch's death, Wesley again wandered around the site, reflecting on his schooldays rather than his later visits: 'I wondered that all the squares and buildings, and especially the schoolboys, looked so little.' This, of course, was easily explained:

> I was little myself when I was at school, and measured all about me by myself. Accordingly, the upper boys being then bigger than myself seemed to me very big and tall, quite contrary to what they appear now, when I am taller and bigger than they.[69]

By the time of Wesley's reflective visit, the Master was Dr Philip Bearcroft who, like John King, had progressed from being a Scholar, to an exhibitioner, then Preacher in 1724, and finally the Master, on Mann's death in 1753. In 1735 the governors suggested that he produce a new history of the charity. This was published in 1737 as *An Historical Account of Thomas Sutton Esq.; And of His Foundation in Charter-House*. Bearcroft explained that he preferred the form 'Charterhouse' to the more common usage of 'The Charterhouse' because that was the style in the Letters Patent and Act of Parliament, which set up the charity. He justified producing another history on the grounds that Herne's study was 'somewhat confused' and 'full of mistakes' regarding Thomas Sutton's life, which Bearcroft corrected, having identified his father's will and investigated the claims for his university education.

In his dedication Bearcroft pointed out that the Charterhouse had the unique distinction among charities, schools and colleges to be 'governed always by the Chief Personages of the State', and described Sutton's charity as 'the rich Gift of this Great Hospital'. His forthright tone may reflect an awareness that, although active opposition to Sutton's charity had dwindled away, some hostility to almshouses generally remained.

Bernard Mandeville, in 1723, asserted that 'Pride and Vanity have built more Hospitals than all the Virtues together' and he was critical of the rich miser who refuses to help his close relatives while he is alive, but applies his money for charitable purposes at his death. He did not mention Thomas Sutton, and it is not clear that he had Sutton in mind. In any case, Mandeville's comments would not have been out of place at any time during the previous hundred years or more, and notions of how the poor could be provided for had changed by the eighteenth century, with residential charity losing favour. The preference was for investments to be more productive by supporting trade and manufacture, to help the poor to work, rather than to maintain them in almshouses. All of the poor that can work should be found work, according to Mandeville, for when charity is too extensive it produces, 'Sloth and Idleness, and is good for little in the Common Wealth but to breed Drones and destroy Industry'.[70]

Even so, his contemporary Daniel Defoe, a powerful advocate of English industry and commercial enterprise, was greatly impressed by Sutton's charity,

which he described as 'the greatest and noblest gift that ever was given for charity, by any one man, public or private, in this nation, since history gives us any account of things'.[71] Defoe may have been following his fellow Whig writer Guy Miège, who, in 1691, had described the charity in similarly glowing terms as 'This noble Foundation not to be parallelled by any Subject in Europe'. He added that Sutton had been a Protestant, explaining that he mentioned this 'to silence all Papists that boast so much of their Charity, as if no Protestant were capable of that Virtue'.[72] Miège's comment harked back to the points that had been made in the early days of the charity, more than seventy years earlier.

A few years later the satirical observer of the London scene, Ned Ward, gave more recent issues an airing. He did not refer to the Charterhouse by name, although his device of an imaginary conversation between two grumbling almsmen was set in an alehouse in Charterhouse Lane. It included a reference to the Master's salary being increased from £50 to £200, which were the actual figures, and another to an almsman who had asked for an allowance for his food and drink when he was away, which was an allusion to the case of John More, a Brother, in 1696. As a result, the Master, at that time Thomas Burnet, 'now keeps his coach and lives as great as the Governor of a town, instead of a master of a hospital'. The almsmen bemoan a reduction in their allowances, the amount and quality of the food, and their inability to obtain redress. Ward also alluded to the allegation that the governors nominated their own former servants as pensioners, both to reward their services and to avoid the expense of maintaining them when they were old. His criticisms were pertinent and directed not only at the Charterhouse, for he commented that at 'any considerable hospital' the complaint could be heard that the pensioners were kept on short rations, while the officers 'grow fat at a plentiful table'.[73]

Bearcroft was aware of such allegations and the objections which Sir Francis Bacon had raised in his advice to James I.[74] He asserted that the regulations had prevented the house from becoming corrupt and that the Master's salary and allowances were a reasonable remuneration. Rules had been set out to prevent inappropriate behaviour, with penalties for those who broke them, culminating in dismissal from the house. Bearcroft singled out 'that odious and filthy Sin of Drunkenness', a significant choice in view of the problems which it had caused and which he was aware of from his perusal of the assembly minutes. But only 'a few unworthy Persons' had entered among the Brothers, of which there had been more than a thousand. The governors were careful to admit only those men who met the qualifications defined in 1613. They were right to provide for the 'penitent Prodigal' who had spent his wealth and needed a refuge; after all, 'the Prudent and most Careful sometimes Miscarry, and fall into Poverty, as well as the Dissolute and Vain'. His example of a deserving case among the Brothers was a gentleman impoverished by 'the imprudent spending of a very considerable Estate' who, at the Charterhouse, was able 'to reflect and recollect himself', not only behaving

'chearfully under the most acute Distempers', but providing an example to the others by his 'good Life, and good Manners'. The school, too, had been a success, with some former pupils 'raised to high Stations, and great Credit in the World'.

Bacon had objected that the Charterhouse buildings were 'fit for a Prince's habitation' and so inappropriately grand for a charity that to use them for that purpose 'is all one as if one should give in Alms a rich embroider'd Cloak to a Beggar'. Bearcroft's response was that, with the passage of time, 'whatever Embroidery there was in this rich Cloak, it is long since worn out, and the Charter-house in its present Buildings is by no Means fit for the Habitation of a Prince'. Repair of the buildings was one aspect that Bearcroft addressed, and it was well under way when he died in 1761.[75]

Despite the repairs, the Charterhouse was beginning to look distinctly old fashioned, without yet being picturesque, for the buildings were not attractive in an age which preferred the Classical style, with symmetrical façades and regular fenestration. The aristocracy had moved away from Charterhouse Square by the 1690s, and their mansions were gradually replaced by town houses for the gentry and professional classes. Only parts of Rutland House and the Charterhouse itself remained from the sixteenth- and seventeenth-century mansions that had stood around the square. Both in the style of the buildings and the social context, the Charterhouse had lost much of the dignity which had characterised it in the seventeenth century.

THE APPEARANCE OF MELANCHOLY POVERTY

To succeed Bearcroft as Master, the governors again made an internal appointment by choosing Samuel Salter, the Preacher. Salter was a Classical scholar, from an ecclesiastical background, who held a number of positions within the Church and was granted a Lambeth Doctorate of Divinity by Archbishop Herring in 1750. On his death in 1778, the Preacher, Thomas Sainsbury, was in his early thirties, and probably thought to be too young to succeed him as Master, and that may also have applied to Samuel Berdmore, the Schoolmaster, who was thirty-nine. The governors turned to William Ramsden, who, having been Usher since 1748, had long experience of the charity. They had not previously promoted the holder of such a junior post to serve as Master, and yet preferred to do so rather than appoint someone from outside. Ramsden was to be Master for twenty-six years and was eighty-six years old when he died in 1804.[1]

Salter and Ramsden presided over a relatively prosperous period in the charity's history. Rental income was increasing during the 1760s and '70s, reflecting rising prices for agricultural produce, which translated into higher rents and farm improvements, especially enclosure and drainage. When the enclosure of the upland and the drainage of the fen at Dunsby were proposed in 1750, the governors were informed that the charity's property there could provide an extra £350 per year.[2] The enclosure of the common fields at Colerne in Wiltshire was expected to double the value of the charity's farms at Thickwood.[3] The average annual income for the period 1761-71 was £7,239 and for 1771-5 it was £8,903.[4] But improvements required investment, rising prices produced higher costs for the hospital's supplies, as well as greater income, and rent arrears were still relatively high. They stood, nominally, at £5,582 by the end of 1773, when the Master showed that the true sum was roughly £8,500, almost the equivalent of the revenue for one year, and he estimated the liabilities to be £5,442.[5]

Some of the hospital's regular suppliers had not been paid for two years, some had received only a part of their account, and even the Brothers' pensions and officers' stipends were in arrears. His investigations had revealed negligence on the

part of the Receiver, John Colepepper, both in the maintenance of his books and in recovering arrears. Had he collected the sums that were due, the charity would not have to delay settling its debts, and so receive complaints of 'the shamefully tardy and defective payment of Bills'. The Master also censured the other officers for not carrying out their duties as specified.

Whatever their shortcomings may have been, Colepepper bore most of the responsibility, yet was not removed from his post until after a further investigation, carried out by the Auditor in 1778. He complained of the idiosyncratic way in which Colepepper kept his accounts, so that to anyone not familiar with his method they were 'unintelligible'. Bills were still not being settled promptly and the debt had risen and could not be paid out of the reserve because the Receiver did not transfer the surplus into it at the end of the year. Colepepper owed the hospital £2,107 when he finally left his post in 1779.[6]

The reserves had been augmented with the £5,521 received in 1757 from the sale of Blacktoft and the other lands in Yorkshire. The initiative came from the purchaser, and the governors agreed to sell because the properties were so far from London, they were expensive to maintain due to flood prevention works, and the sub-tenancies were creating difficulties.[7] The Act of Parliament authorising the disposal of Blacktoft specified that the receipts were to be used to buy properties closer to London, but they were invested in Bank of England stock, and by 1795 just £306 of that money had been spent in acquiring new property.[8]

The governors had come to prefer investment in securities, and in 1780 chose to retain the stock rather than sell it and buy an estate in Cold Norton, Essex, adjoining their existing holdings.[9] A few years later they did take the opportunity to buy land at Hartland, but financed the purchase by selling some of the charity's holdings in Lincolnshire.[10] The only other property purchased in the late eighteenth century was close to the hospital, in Charterhouse Square, Charterhouse Lane and Rutland Court, and a row of houses in Carthusian Street that was acquired from the Earl of Dartmouth in 1800 for £4,328.[11] The governors' intention may have been to retain as much control as possible over the immediate environs of the hospital. The square's value as a protective barrier had been demonstrated during the Gordon Riots in 1780, when soldiers were hired to protect it, to keep rioters away from the Charterhouse.[12]

The charity's property to the north, in Clerkenwell, was much less salubrious. The restriction on granting leases no longer than twenty-one years limited its ability to improve the area satisfactorily, for no developer would invest the sums needed to produce a worthwhile development with such limited tenure. Some poor buildings had been erected there since the first development of the district in the late seventeenth century, and there was no incentive to put up substantial houses. Ambrose Eyre resigned the post of Receiver in 1739 so that he could take a lease from the hospital of houses in Clerkenwell, but failed to profit from the

venture. He was admitted as a Brother in 1755 and died in the following year 'in Low Circumstances', leaving the houses in disrepair.[13]

A part of the area had been considered by the Commission for Building Fifty New Churches, as a possible site for a new church, and a survey was submitted to them in 1714.[14] The governors saw the possibility of creating a respectable development in conjunction with the new church, and commissioned an assessment of the potential value of the property, but neither the scheme for the church nor the Charterhouse's development went ahead.[15]

To resolve the tenurial difficulty, in 1763 the governors obtained an Act of Parliament which permitted them to grant their property in Clerkenwell on leases for ninety-nine years. Even so, there was no great interest from would-be developers, and a lease for that period was eventually granted to a local wheelwright, John Pullin, at a yearly rent of £674.[16] This was a disappointing return, and the length of the term prevented the charity from fully exploiting a potentially valuable part of its holdings.

No major financial bequest was received to bolster the finances, and the most important donation to the charity during the second half of the century was the book collection donated to the Charterhouse by Daniel Wray's widow Mary after his death in 1783. He had been a day-boy at the school between 1714 and 1718 and, in addition to holding the post of Deputy-Teller of the Exchequer, was a distinguished antiquary. A library for the collection was created out of the former ante-chamber to the great chamber, and contained Wray's portrait.[17]

Some of the financial difficulties may have been related to the fact that the officers' salaries were not competitive. When Henry Sayer, the Registrar, asked for a pay rise in 1771, he had a long supporting letter from his predecessor, Thomas Melmoth, who admitted, 'I know what Temptations an indigent man in your place must lie under of availing himself by bribes for the smallness and insufficiency of his pay'. Surely no prudent man would take the post, knowing that the remuneration was to be only the 'bare profits', and that they were much less than those for the clerks of the other hospitals and the city companies, although it was far superior to those jobs in importance and dignity?[18] Whether this was a self-justificatory statement to excuse the fact that he had taken bribes is unclear, but Melmoth had applied for the post of Master ten years earlier, and would scarcely have done so had he been suspected of such malpractice. Nor would the charity have placed a commemorative tablet to him in Chapel Cloister, which it did after his death in 1783. In any event, the governors recognised the justice of Sayer's claim, and increased the Registrar's salary by £120. In 1785 the Receiver applied for a rise, because the duties of his post were such that he needed to give them constant attention throughout the year, and his request was also met.[19]

A saving in salaries was made in 1790, when Thomas Ryder was appointed Steward of the Courts, a post he was to hold simultaneously with his existing position as Registrar. The justification for overruling the order of 1719 (which

stated that none of the four senior administrative posts could be combined) was that the statutes of 1627 allowed the governors to make appointments at their discretion. That was indeed correct, but did not address the reason for the separation of the posts, which was to reduce the opportunities for fraud.[20]

The officers complained about their accommodation as well as their pay. Sayer described his as being wholly unsatisfactory, lacking most of the conveniences necessary for a family and 'a Man of Business'. It had neither kitchen nor cellars, lacked offices for himself and his clerk, and was approached by a steep staircase.[21] He was an attorney of Lincoln's Inn and had recently fitted up offices in Red Lion Square, where he would have preferred to be based. The governors had to instruct him to use the apartment at the Charterhouse, which was considerably enlarged, but in 1782 Sayer claimed that once more it was 'generally out of repair' and further substantial alterations were carried out in 1789.[22]

The response to such complaints was to enlarge the officers' accommodation, to meet their requirements. By 1788 the apartments of the Receiver and Schoolmaster, as well as those of the Registrar, had been 'rendered commodious and enlarged', and those of the Preacher and Usher were extended in the next few years.[23] This was done by expanding into adjacent areas and rebuilding attic storeys. Even then the space was found to be insufficient, with some officers accommodated outside of the hospital, a trend which the governors struggled to stem. On the appointment of a new Auditor in 1783, the governors insisted that he live in or near the hospital and they took the lease of a house in Charterhouse Square for him.[24]

The Organist's apartment, too, was improved. From 1753 the Organist was John Jones, who was organist of the Middle Temple from 1749 and of St Paul's Cathedral from 1755. In 1776 he told the governors that although he had spent his own money on his apartment in the Charterhouse, he still lacked 'a Common Convenient Habitation' and they allowed him to enlarge it by adding another room.[25] He died in 1796 and a few years later his successor, R.J.S. Stevens, was said to have hosted large music parties in that apartment, which consisted of a sitting room, a library (described as 'a narrow and dark Room') and five bedrooms, one of which Stevens used as an occasional sitting room. The appearance of the apartment and the scale of his parties probably reflected Jones' investment and Stevens' own comfortable circumstances. He had been organist of the Inner Temple since 1786, was appointed as the Gresham Professor of Music in 1801 and then music master at Christ's Hospital in 1808. He also taught well-to-do pupils. In 1805 his income was £1,286 and in 1817 he received a large bequest, so that he was able to give up all his posts except the one at the Charterhouse, as well as the Gresham Professorship. Even so, he was aware that his stipend at the Charterhouse was relatively small, and had increased comparatively little since the appointment of Cosyns in 1626. His many activities, which included the composition of glees and anthems, may explain the allegation that he did not attend to his duties at the Charterhouse, except on Sunday evenings. He objected

that the Organist had to attend the Chapel on at least 240 occasions a year, and when the Master suggested to him that 'You are too eminent for us', he replied that the post had always been held by 'men of acknowledged abilities'.[26] Like Pepusch and Jones, Stevens was buried in Chapel Cloister.

By the early nineteenth century the financial position was much improved, and owing to increasing rural prosperity, problems with recalcitrant tenants were now solved relatively easily. When the Registrar wrote to those whose rents were more than a year overdue, most of them paid their arrears without further action being needed.[27] By the first decade of the century, the charity's rental income had risen to £15,000 per year, with Southminster, Elcombe and Dunsby together contributing forty-five per cent of this, but the London properties still providing less than ten per cent. Other investments and incidental receipts added more than £1,000 in some years.[28] Income had outstripped prices since the middle of the eighteenth century, so that the charity had gained a real addition to its revenue.

The changing economic context was reflected in the choice of employment for the boys who did not go to university. An increasing number now entered the professions or the public service, or joined the East India Company. As so many openings did not require a formal apprenticeship, the sum allocated to those not going to university became an allowance rather than an apprentice's fee, and was increased to £40 in 1772 and £60 in 1795.[29] In 1788 the age of admission for Scholars was set at fourteen, as specified in the orders of 1619, 1622 and 1627, and not fifteen, as decreed by the governors in 1669. This simply confirmed current practice, for boys over fourteen had not been admitted for many years.[30]

The qualifying age for Brothers was maintained, and in 1772 one of the King's nominees was refused admission, because he could not prove that he was fifty years old, although he cannot have been much younger than that.[31] The Brothers' pension was increased by £3 in 1755 and £4 in 1783, raising it to £14 per annum, and there were some improvements to their living conditions.[32]

The Brothers during this period included Alexander Macbean, a writer and indexer, and one of Samuel Johnson's amanuenses for his *Dictionary*, who was admitted in 1780 and died in the Charterhouse in 1784. John Doharty, a surveyor from Worcestershire, entered in 1760, and while his jottings suggest unhappiness with the establishment - containing a reference to the hospital as 'this most uncharitable Charter house' - he also produced sketches of an idealised almshouse. He evidently felt that the accommodation could have been arranged more satisfactorily, and in his design the buildings were placed around rectangular courtyards with formal gardens. Two of the three principal ranges in his layout contained the school and the Chapel and were connected by buildings, which housed the Brothers' accommodation. He called this the Charterhouse, although it did not bear any relation to the actual disposition of the buildings, and noted that if it had been laid out in this form, 'it might have been more Convenient'. This was a case of a Brother's professional life stimulating his activities while in the

hospital.[33] Others continued to practise their trades and supplement their incomes. Robert Dunkarton was a watchmaker, and when his apartment was robbed in 1785, twelve newly made watches were stolen.[34]

The charity and its founder still attracted positive comments. In his *Songs from an Island in the Moon* (1784), William Blake favourably contrasted the practical benefactor Thomas Sutton – described as 'a good man' – with the scientist Sir Isaac Newton, the philosopher John Locke, and two high-Anglican theologians, both chaplains to James II, William Sherlock and Robert South, who had clashed over some of the spiritual aspects of Christianity.[35]

A few years later, in 1802, James Peller Malcolm painted a very favourable picture of 'this most excellent charity'.[36] He found it a grand and affecting sight to watch the Brothers dining in the Great Hall, where they were served with 'the best of plain provisions', which consisted of 'a large loaf to each plate' and 'dishes smoking with excellent viands, excellently cooked'. Seated around the tables were eighty 'antient, respectable, venerable men … partaking of the bounties of the immortal Sutton'. Not only were their appetites attended to, but also their domestic and spiritual needs, with apartments containing 'every necessary to make them comfortable' and services held in the Chapel twice each day. Their age was 'such as to preclude a wish for excesses, nor', he added somewhat darkly, 'are such permitted', and their minds were kept as quiet as possible 'by every discouragement of dissention'.

But while Malcolm conveyed an impression of an idyllic little world, he also raised some pertinent points about the nature of the care in the almshouse. He felt that the Brothers did not live as long as they should, with few of them living for more than ten years after their admission. Malcolm blamed the separation of the elderly from their families, and he favoured life outside the almshouse over that within the community, where a Brother, who was 'old, unmarried, and desolate' before he could be admitted, then found himself 'solitary in the midst of numbers', not having a friend to converse with. This produced 'regret among plenty' and sad reflections that lowered morale, which was the fate of 'man without the society of his relatives'. Yet, for all that, the Charterhouse provided shelter and protection.

Shortly afterwards, in 1808, Robert Smythe wrote a history of the Charterhouse, based on the earlier accounts by Herne and Bearcroft. Smythe had been a Scholar and was a sympathetic observer of 'this Sanctuary, provided against the frowns of the world', where each of the Brothers had 'a neat room to himself' and was 'most excellently dieted'. He set out to refute Malcolm's comments, and questioned his statistics, which he claimed were very misleading, for almost a half of the Brothers were alive for more than ten years from their admission – during the 1790s the proportion had been forty-six per cent – and more than a fifth lived to be eighty or older. His figures showed that the average age at death was seventy-three.[37]

Smythe insisted that the Charterhouse was not 'a place of solitary confinement for delinquents', for although the Brothers may be desolate and friendless when

they arrived, with food, care and clothing, and the company of others in similar circumstances, they could go to bed and rise again in the morning 'without an anxiety for the future'. A Brother's relatives may call on him in the Charterhouse and he could get the Master's permission to visit them, and he was allowed to take walks out of the hospital. All that a Brother had to do was to observe the rules governing the hours of worship, the times of meals and bedtime. But Smythe, like Malcolm, hinted that a certain degree of discipline was imposed, commenting that it would be 'tedious' to detail the orders that the Brothers had to observe, which were hung in a frame in the Great Hall.

To support his argument, Smythe mentioned some of the distinguished Brothers. They included the 'very ingenious' student of medicine Edward Hooker and Stephen Gray, whose pioneering experiments with electrical conduction followed observations he had made within his room at the Charterhouse; he was awarded the Copley Medal by the Royal Society in 1731, and was admitted to the Society in 1732, four years before his death. Smythe felt that the merits of the Charterhouse were exemplified by Sir Henry Mackworth, a Brother from 1786 until his death in 1803, who lived 'in great comfort in this peaceful spot'.[38]

The provision of the Royal Hospital at Chelsea and the Royal Naval Hospital at Greenwich had reduced the need to accommodate soldiers and sailors at the Charterhouse who had served in the Army and the Royal Navy. Those who had been imprisoned by the Turks formed a group no longer in need of charitable care. But the practice which had developed since the early seventeenth century was that of the governors placing their tenants or servants as Brothers. Ned Ward mentioned this in 1699. The Duke of Marlborough nominated 'an old Waterman of mine' in 1765, and the place of origin of some Brothers suggests a direct connection with the nominating governor.[39] The decision in 1807 not to admit anyone who had been a 'menial servant' within the previous five years was intended to restrict this practice.[40] The order, advocated by the future Earl of Liverpool, was made only after the statutes and minute books of the governors' assemblies had been consulted, for precedents specifying 'the quality and condition of Persons to be appointed Pensioners'.[41]

The restriction was directed at those whose employment by the aristocracy was found to have made them unsuitable for life at the Charterhouse, having been 'strangers to more severe and useful labour; and who with frames ennervated by the luxuries, and minds contaminated with the vices of their superiors, have contracted habits ill suited to this calm and retired scene of religious meditation'. By the early nineteenth century, the Brothers were drawn from those men who could be described as 'between the middle and the lowest' social classes; in contemporary terms mechanics and tradesmen, vulnerable to the fluctuations of fortune, and so deserving beneficiaries of Sutton's charity. The Master explained that those admitted had to demonstrate 'a well-founded claim of poverty undebased by vice, and originating from inevitable misfortune'. Once they had been admitted, the hospital provided them with all their needs.[42]

Despite such care, the Brothers continued to have some complaints. They delivered a wide-ranging petition to the governors in 1777 which encapsulated criticisms that successive generations of Brothers had been making intermittently since the foundation of the charity. The Manciple and Cook were vulnerable to sniping about the quality of the provisions: the beer was 'bad pernicious and undrinkable'; the loaves had been 'deficient in Weight for years past'; the meat was 'for the most part very indifferent'; unsuitable food was served at supper; some of their rooms and beds were 'in exceeding bad condition'; they were not allowed fires in their rooms and the space around the fireplaces in the two halls was enough for only twenty-six Brothers; no 'proper nurses' were allowed to look after them when they were ill; and their pensions were inadequate. The governors dealt with the complaints point by point, and even tasted the bread and sampled the beer at one of their assemblies, and declared them to be good.[43]

The Cook would have welcomed their verdict, but she would not have been surprised by it. A traveller who shared a coach with her on a journey from Leeds to London in 1778 recalled that she 'turned up her nose at every dish like the mouse in the fable and told us they *ate* no such stuff at the Charter House'.[44]

The assembly at which the governors sampled the Brothers' fare was held on 6 June 1778. The Archbishop of Canterbury took the chair, Earl Bathurst, the Lord Chancellor, also attended, as did the Earl of Sandwich, able to spare time from his duties as First Lord of the Admiralty for such a task, although the American War of Independence was at its height. Affairs of state no longer touched the Charterhouse directly, as they had done in the seventeenth century, and tasting the Brothers' dishes could not match the drama of the confrontation with Lord Jeffreys, but it does emphasise that senior figures continued to serve as governors and discharge their responsibilities conscientiously. And not all of the old issues had gone away. In 1757 a tenant of one of the charity's farms in Lincolnshire asked for permission to sublet it, but when the governors were told that the prospective sub-tenant was a Roman Catholic they refused to grant the necessary licence.[45]

Some of the other staff came in for criticism also, including the 'basket-women', who carried out the Brothers' chores. The governors evidently had low expectations of their commitment to their work, and in 1779 commented that 'the present set seem to be as good as can be expected from such laborious Offices so poorly requited'.[46] A few years later one of the women who attended the Brothers was 'of a most abusive Tongue, and so obscene in her Discourse, that she is fitter for a Wapping landlady, or Mistress of a Brothel in Old Drury, than for a Post in Charterhouse'.[47] In 1794 the governors ordered that the twelve basket-women should in future be appointed by the Physician, that they should be between thirty-five and fifty years old, decent, clean, healthy, sober and well-behaved.[48]

Around the turn of the century one of the Brothers described them as 'dirty wretches' and accused them of charging for helping a sick or infirm Brother,

although it had earlier been a part of their duties. His summary of the state of the hospital was sent anonymously to Beilby Porteous, Bishop of London, and was also harshly critical of the Manciple, Cook, Butler and Gardener, for their 'Rapacity and plunder'.[49] The Butler was especially criticised, not only for selling some of the beer supplies, but because the beer which he sold was better than that which he was serving to the Brothers, who were sensitive to the quality of 'this very necessary comfort to an Old Man'. The Gardener was estranged from his wife, and had fathered the child of his niece. He had many gates through the garden wall, and was using these to enrich himself, 'by rapacity on the property of others', although whether this was by growing vegetables on others' ground, or by looting their crops, was not clear.

The writer did not spare his fellow Brothers. He was particularly upset by the agreement which one of them had made with the Master that entitled him to take the day's rations of any Brother who did not appear at dinner. Thus, a Brother who failed to turn up at dinner, for whatever reason, not only missed that meal, but also forfeited his supper and breakfast, which the bishop's informant thought 'should be remedied by all means'. He also criticised a number of Brothers for drunkenness, carrying on a trade outside the hospital, not attending chapel, not living in the hospital, cohabiting with 'a bad woman', or a combination of those transgressions. One of the Brothers had his daughter, her husband and child living with him, and another allowed his nephew to live in his room. Among those who had jobs, one worked for a chemist, which made him so smelly that 'his presence [was] very offensive'. The Brothers also included a hack writer, a baker, an enameller, and a drunken political activist, who had lost an eye during a recent election campaign.

William Hale Hale later recalled that when he was appointed Preacher in 1823 the Brothers were 'for the most part, low in appearance, and many of them disreputable in conduct'. This he explained by the fact that the hospital was unappealing to any but 'the meanest persons'. The domestic arrangements made two centuries earlier had been continued; the buildings displayed 'the appearance of melancholy poverty'; and the Brothers' rooms were 'with few exceptions offensive', as they were cleaned by the Brothers themselves, if at all. His account was, to some extent, self-serving, contrasting the unsatisfactory and unpleasant conditions before he became involved in its administration with those after reforms, which he had instigated or supported, had been implemented, and to answer criticisms that were being made in the 1850s, when he was Master. But he had been a Scholar from 1808 until 1811 and so had a long-standing knowledge of the Charterhouse.[50] Hale's contemporary Charles Dacres Bevan also recalled that when he was at the school, in the 1810s, the Brothers 'were not remarkable, as a body, for cleanliness, sobriety, or regularity either of conduct or temper'. In 1806 two of them were expelled for drinking too freely of the communion wine and, in one case, enticing girls to his room and treating them 'with the greatest

indecency', and in the other for having a woman sleeping with him every night. They had been transferred to workhouses.[51] Hale's point about the Brothers' rooms was borne out by the standing committee's realisation, in 1813, that the buildings were in such a bad state of repair that it might be cheaper to build new ones than to renovate the existing accommodation.[52]

Hale and Bevan knew the charity over many years from within, but what was the impression of an outsider making a brief visit? The American novelist Washington Irving gave a short account of the Charterhouse in *The Sketch Book of Geoffrey Crayon, Gent* (1819-20). Including it in a section headed 'London Antiques', he described it as 'one of those noble charities set on foot by individual munificence, and kept up with the quaintness and sanctity of ancient times amidst the modern changes and innovations of London'. Like so many visitors, Irving was struck by the fact that the 'whole establishment had an air of monastic quiet and seclusion ... [with] a mysterious charm', housed in buildings that consisted of 'a labyrinth of interior courts, and corridors, and dilapidated cloisters, for the main edifice had many additions and dependencies, built at various times and in various styles'. This was an appropriate dwelling for the Brothers, for their 'black cloaks and antiquated air comported with the style of this most venerable and mysterious pile'. He gave the school only a cursory mention, concentrating on the Brothers, who he described as 'superannuated tradesmen and decayed householders'. They included a collector of curiosities, a blind man fluent in Latin and Greek, and a gentleman who had spent both his inheritance of £40,000 and his wife's portion of £10,000. While his account of the charity was generally approving rather than critical, he summarised it as a 'picturesque remnant of old times' and does not entirely dispel the impression conveyed by those critics familiar with the charity.

Nor had this been done by Philip Fisher, who succeeded Ramsden as Master in 1804, when he delivered the sermon at the Founder's Day service in the Chapel in 1811, commemorating the two hundredth anniversary of Thomas Sutton's death. He looked back and expressed relief that the foundation had not only survived intact (even through the difficult years of the mid-seventeenth century) but had prospered. This, he thought, was because charity should be directed to specific ends if it were to be effective, and the founder had achieved this by bestowing his gift on those at the two extremities of life: youth and old age. Perhaps aware of the debates of the early seventeenth century, he asserted that Englishmen could justly boast that there was some charitable provision for almost every kind of calamity and need. Although criticisms had been directed at charities such as Sutton's, this was because of their flawed administration, not the principles on which they had been established.[53]

Fisher's sermon showed just how long a shadow had been cast by Sir Francis Bacon's sceptical paper presented to James I. Like Bearcroft, he was aware of its contents and felt the need to rebut them, justifying the management of the charity since its foundation, not by any wider considerations, but because it had

not succumbed to the corruption anticipated by Bacon. It had adapted to the changing times and now admitted somewhat different categories of men than had been specified at the outset, 'but at no time has that disgraceful misapplication of our means, which was so gloomily predicted by the great Philosopher … been permitted to prevail, that these walls should become the avowed receptacle only of the outcasts of the professions, the idle, the drunken, and the dissolute'. Such care had been taken to check the characters of those who sought admission that, over the years, only 'a few instances of depravity may have inadvertently and occasionally been permitted to insinuate themselves' into the hospital. Nevertheless, for the benefit of the Brothers in the congregation, he mentioned the qualities which they should exhibit: patience, resignation, sobriety of manners, a spirit of peace, a brotherly demeanour amongst themselves, a respectful submission to their seniors, and attention to their public and private devotions. They should also, he added, lay aside the vices of the world and be aware of that 'querulousness of temper' which tended to come with old age.[54] His notion of appropriate behaviour, and the society which it would produce, was not greatly different from those of Sutton's contemporaries who advocated the foundation of almshouses.

Fisher's perspective was indeed that of someone immersed in the life of the charity and aware of its past, with the considerable expectations which had been placed upon it because of its scale and close links with the political and ecclesiastical establishments. Those connections had been maintained, but the hospital's iconic status as England's pre-eminent charity had waned, as charitable giving had been channelled into other causes, especially medical hospitals, both general and specialised, and children's charities. Almshouses had, in any case, never been able to accommodate more than a small proportion of the elderly poor and, as the population expanded during the late eighteenth century, they provided a steadily diminishing contribution to the growing problem of poor relief. Fisher did not address this, using the Founder's Day sermon to look back over the history of the charity during the previous two hundred years and justify the present, rather than to outline a vision for the future, as Sutton's Hospital began its third century.

CHAPTER 8

THAT EXCELLENT HOSPITAL

Ramsden's time as Master saw a number of changes, including the steady growth of the school, both in terms of numbers of pupils and its relative importance within the charity. Philip Fisher then held the post of Master for the unprecedentedly long period of thirty-eight years, until his death in 1842 at the age of ninety-two. He was succeeded by William Hale Hale, who had been Preacher for nineteen years and who, like Fisher, served as Master until his death, in 1870. Fisher came from an ecclesiastical background: his father was vicar of Peterborough and one of his brothers was Bishop of Salisbury. Hale was the son of John Hale, a surgeon of King's Lynn, Norfolk; the repeated surname was most unusual. His father died when he was a boy and he became ward of James Palmer, who was Treasurer of Christ's Hospital. Hale therefore grew up having a close connection with London's charitable institutions.

Fisher attended Charterhouse and later became a fellow and tutor at University College, Oxford. He was a friend of Sir Walter Scott and Lord Eldon and his interests were mainly scholarly. He had an able deputy in Hale, who dominated the Charterhouse throughout the mid-nineteenth century. Despite the later characterisation of Fisher's Mastership as a time of 'tranquil inactivity', the long period under Fisher and Hale was in fact one of change and reform, at first in the school, and later in the hospital.

The number of pupils rose during Ramsden's time and its reputation was high. When James Boswell wondered whether to send his elder son Alexander to Westminster or Charterhouse, in 1786, he decided on Charterhouse 'as by much the safest for his morals'. In fact, he had not acted early enough, and there was no place available for Alexander.[1] Information on the backgrounds of the Scholars who were admitted in the late eighteenth and early nineteenth centuries is imprecise. One was the son of a bishop and another the son of the headmaster of Rugby School, but terms such as esquire and gentleman had become too inexact to convey social rank, and in many cases no parental occupation or status was recorded. A clearer insight into the background from which the Scholars were drawn was provided in 1811 by Fisher, who admitted that the pupils did not include 'the sons of the inferior and labouring classes'. They were provided

for in other establishments and not at the Charterhouse, which was intended for those who would benefit from 'the advancement of learning' and so provided an education for those whose parents were between the extremes of wealth and poverty, especially the sons of the clergy. They gained more places than those from all of the other professions combined. He justified this on the grounds that clergymen's 'liberal habits and pursuits entitle them to expect for their sons those advantages of a learned education' which would not otherwise be available to them because of their modest incomes.[2]

The governors had created the basis of a public school, by encouraging the wealthier and higher social classes to send their sons to the Charterhouse, where they mixed with boys from more humble backgrounds. For example, Edward Spencer Cowper, a boarder in the 1780s, was the third son of the Earl Cowper and, a generation earlier, Edward Law was the fourth son of Edmund Law, Bishop of Carlisle from 1769 until 1787. Law went into the legal profession, establishing a considerable reputation and a successful practice in London. He was appointed Attorney General in Henry Addington's government in 1801, and Lord Chief Justice of England in the following year, when he was created Baron Ellenborough.

Charles Manners-Sutton was five years younger than Law and the fourth son of Lord George Manners-Sutton and grandson of John, third Duke of Rutland. He was created Archbishop of Canterbury in 1805, the only Charterhouse pupil who has held the post. He was translated from Norwich, and had held the post of Dean of Windsor, being much liked by George III and the royal family. On the death of Archbishop Moore, the King intended that Manners-Sutton would succeed him as primate, although the Prime Minister, William Pitt, preferred his old tutor, George Pretyman-Tomline, Bishop of Lincoln. The King pre-empted his Prime Minster by riding over to the deanery at Windsor, where he interrupted a dinner party to congratulate Manners-Sutton on his appointment to the primacy, telling him not to mention the fact but to return to his guests. Pitt was not pleased with this stratagem, but the King got his way regardless, and Pretyman-Tomline had to wait for fifteen years until he was translated to Winchester.[3] Through the King's rather irregular intervention, the former pupil became chairman of the governors of the Charterhouse, until his death in 1828. During those twenty-three years he missed only four assemblies, all of them after he had turned seventy.

Robert Banks Jenkinson, a pupil in the 1780s, was the son of Charles Jenkinson, later created first Earl of Liverpool. Robert succeeded to the title in 1808 and his long career in politics culminated in him becoming Prime Minister in 1812, a post which he held until 1827, serving as a governor from 1805. Between 1812 and Ellenborough's death in 1818, the Prime Minister, the Archbishop of Canterbury and the Lord Chief Justice were all Carthusians.

A feature of the late eighteenth and early nineteenth centuries was the gradual division of the site into distinct areas for the Brothers, Scholars and officers.

This had always existed to a certain extent, but was reinforced following the construction in 1794 of a tunnel from Scholars' Green into Rutland Court, off Charterhouse Square. Boarders were then prohibited from passing through the main gate, and also excluded from the courts except when going directly from the Schoolmaster's, Usher's and Matron's houses to the school and Scholars' Green.[4] The Brothers were gradually moved out of the historic core as the officers' accommodation was enlarged. The effect was that the Brothers' area was chiefly on the west side of the site, with most of their accommodation in the Wren Building and the range along the boundary wall. The accommodation for the principal officers was around Master's Court, although it was still referred to as the Pensioners' Court. The areas common to all three groups were the Great Hall and the adjoining upper hall (now the old library), where the Brothers and officers dined, and the Chapel, where the whole community worshipped.

With the increase in revenue a new school building could be erected. Completed in 1803 on the north side of Scholars' Green, this was a single-storey building with a symmetrical façade, containing a large schoolroom. The new school allowed much-needed improvements to be carried out to the existing building, where three dormitories with beds for forty Scholars were arranged. A recently introduced reform had stipulated that each boy should have a separate bed. Apartments for the Schoolmaster and Usher were added to the new building in 1805.[5]

The Scholars' Green had been the formal garden and bowling green, which had become the scholars' playground; in 1804 a fives court was made in the south-east corner.[6] This transformation was justified by Robert Smythe, in somewhat heroic terms, for here 'the future warrior contends for the palm of victory at foot-ball or cricket ... the swift strives to reach the goal before his companions, and fits himself for the race of life'.[7] Cricket was being played by the 1770s, and before the end of the eighteenth century football also. The area was also used for hoop-racing, with two to four big hoops at once driven around a large square. By tradition, the word 'CROWN' on the east wall of the playground was painted by Edward Law, when a boy at the school in the 1760s, to mark the finishing post, and remains there. Coaches for Oxford left from the Crown Inn in Newgate St.[8]

The Wilderness garden to the north also underwent a major change, due more to atmospheric than scholastic pollution. By the early nineteenth century this 'handsome plot of ground' contained walks of gravel and grass, and a summer house, and it still had fine trees. But the clouds of smoke that hung above the city had 'shed a very sombre hue' on the vegetation.[9] It became little more than a 'gloomy grove of smoky, black, trees' and in 1821 they were cut down, the area was levelled and the wall separating it from the Green was demolished. The two areas were then used as playgrounds, separated by a slight rise, designated 'Hill', and known as Under Green and Upper Green.[10] In 1821 the Master stressed that the two and a quarter acres of open space was larger than that available at any school in England, with the sole exception of Eton.[11] He was clearly anxious to

deflect a possible criticism of the school, that it lay in the centre of the metropolis, cramped for space and hemmed in by other buildings.

Perhaps related to the changed use of the formal garden was the removal of glazing from the Norfolk Cloister. This was the surviving section of the west side of the cloister walk of the monastic great cloister, rebuilt by the Duke of Norfolk *c.* 1571 with a substantial brick vault that had a terrace walk above. It had been repaired for much of the eighteenth century, but by 1810 the windows were unglazed, and it was in a state of neglect by 1840, not surprisingly, because football was played there.[12] The goals were the side doors at opposite ends, at the north into the old school building and at the south into the green. Teams could number as few as six or nine on each side, although larger games, with the Scholars versus the remainder of the school, were also played, when the numbers involved could produce 'a terrific scrimmage … [which] sometimes lasted three-quarters of an hour'. This could be avoided by climbing out of one window and in at another, to keep ahead of the play.[13] The cloister was also used for cricket, with two players on each side, and hockey too.[14]

A more conventional form of football was played on Under Green and the rules were regularised in 1862. The Football Association was formed in 1863 and drew up a set of rules, broadly similar to those used at the Charterhouse, which was the only school represented at the initial meeting. However, it did not join the Association until 1867, when Westminster School also joined, although Charterhouse did not adopt its laws in full until 1875. The Association had modified them in 1867, and adopted the offside rule observed at the two schools.[15] Charterhouse School thereby contributed an aspect of the game which would spawn innumerable controversies, as football developed and spread worldwide to become the most popular sport during the twentieth century.

The boys' exuberance was not limited to the cloister and the greens, and on Founder's Day in 1808 it erupted into a rebellion, similar to that in 1741. Disorderly conduct in the hall during the celebrations in previous years was alleged to have been the result of the Scholars' guests dining there, and this prompted an order in 1790 prohibiting their admission.[16] The practice may have continued, because the order was repeated after the 'great outrage and riot' in 1808, which perhaps was a rather extravagant reaction to the ban on Scholars' guests, or the culmination of 'a long course of previous indiscipline'. The windows of the Master, Receiver and Matron were bombarded and broken, and the Master himself pelted by mutinous boys when he bravely appeared to try to quell the disorder. Three ringleaders were expelled for their part in the outburst, but such scholars' rebellions were not unusual occurrences in the leading schools between the 1760s and 1830s.[17] As with the earlier major breaches of discipline, the culprits were among the senior pupils, lending support to William Cowper's criticism that, given the difficulty of controlling 'tyros of eighteen', boys were kept at the public schools too long. Their 'wild excursions, window-

breaking feats, Robbery of gardens, quarrels in the streets' set bad examples for the younger boys, who arrived 'meek and bashful' but at school learned to be 'bold and forward'.[18]

The Schoolmaster, Matthew Raine, had been feeling the strain of his duties before this incident, for in 1805 he had asked if he could relinquish the care of a boarding house, pointing out that only two of his predecessors had been expected to carry out that duty. He wished to reduce his responsibilities to a general superintendence of the school and a few years later he asked if he could retire.[19] The governors agreed and appointed him to the living of Little Hallingbury, but before his retirement he died, in September 1811. After serving as Schoolmaster for more than twenty years, was buried in the Chapel, where he is commemorated by a substantial monument designed by John Flaxman.[20]

Raine's successor as Schoolmaster (now designated School Master), Dr John Russell, introduced the Bell, or Madras, system, with lessons relayed to the pupils by monitors, so that many boys could be taught by relatively few masters. The numbers increased steadily, from roughly 80 boys before *c.* 1780 to 170 or 180 during the following thirty years, 238 in 1818 and 480 in 1825. This was a reflection of the Charterhouse's reputation; in 1818 the Duke of Wellington described it as 'the best school of them all'.[21]

Despite Wellington's approbation, in practice the high ratio of boys to masters caused problems, and, as the governors no longer insisted on the School Master being resident, Russell lived at Blackheath and rode in every day. He was later described as 'vigorous, unsympathetic, and stern, though not severe'. This is hardly borne out by the recollections of Martin Tupper, who declared that under Russell the school had been 'despotically drilled into passive servility and pedantic scholarship'. He remembered having seen him 'smashing a child's head between two books in his shoulder-of-mutton hands till the nose bled'.[22]

Discipline and truancy were problems, and Russell faced a scholars' rebellion in 1818, against his proposed system of fines and, rather surprisingly, in favour of corporal punishment. One pupil's letters home included the comment that Russell 'has no great authority over the boys'. Some of them, including the poet Thomas Lovell Beddoes, took advantage of the circumstances and the fagging system to indulge in merciless bullying. Beddoes's fag Charles Dacres Bevan was harassed by his 'persevering and cruel tormentor' and another boy remembered Beddoes as a 'clever little fella, but a cruel bully to me'. The boys also amused themselves by attacking those Brothers, known to them as 'codds', who had attracted their particular attention, although the skirmishes usually ended with a truce followed by a repast of lobsters, oysters, porter and gin.[23]

The growth in numbers produced severe overcrowding in the houses occupied by boarders, and therefore five new ones were opened by 1823. The houses, in Charterhouse Square and Wilderness Row, were later criticised by those who had to live there. Henry Liddell, who was to be Headmaster of Westminster and Dean

of Christ Church, recalled his impressions when he first arrived at Mr Watkinson's house in the square, in 1823:

> Here I was turned into the 'Long Room', a low, dark, dirty apartment, measuring (I should think) about 70 feet by 15, with an excrescence at the upper end, added to accommodate the increasing number of boys. Here we breakfasted, dined and supped; and this was our only sitting room.

The arrangements for studying were difficult, the bedrooms were small and crowded, and the only place to wash was 'a narrow room, with leaden cocks on either side, and cocks to supply water, which was caught in small leaden or pewter basins'. Yet he emerged from the school as 'a fair grammar scholar' who had also read much English literature and 'amassed a good deal of general information'.[24]

Among Liddell's contemporaries was William Makepeace Thackeray, who entered the school in 1822 and remained for six years. At first he lodged in one of the school's houses in Wilderness Row, but later was transferred to a lodging house in the square. His reaction to the school was coloured by his conviction that Russell was hard on him (he was remembered as being a lazy pupil) and perhaps because he felt intellectually inferior to some of his contemporaries. He was critical of the staff, their bullying and social pretensions, referring to:

> a brute of a schoolmaster, whose mind was as coarse-grained as any ploughboy's in Christendom; whose manners were those of the most unsufferable of Heaven's creatures, the English snob trying to turn gentleman; whose lips, when they were not mouthing Greek or grammar, were yelling out the most brutal abuse of poor little cowering gentlemen standing before him.

After he had left, he complained that the school had imposed on him 'a discipline of misery' and he wrote to his mother that 'I have not that gratitude and affection for that respectable seminary near Smithfield which I am told good scholars always have for their place of education; I cannot think that school to be a good one'.[25]

Charterhouse certainly seems to have cast a long shadow across Thackeray's life and work, but his opinions of the school gradually mellowed; he had fond memories of his landlady's care, and kept in touch with several of his fellow pupils, including George Venables, who had broken Thackeray's nose in a fight. Indeed, he became really rather nostalgic for his schooldays, and enjoyed reminiscing about them with his friends, referring to some of them in his writings, and to the Charterhouse itself. The sights, sounds and smells of the nearby meat market at Smithfield also made a lasting impression. Between the 1730s and the 1790s the number of cattle and sheep sold there increased by a third, and the numbers continued to rise as London's population grew. Many were killed in the

vicinity of the market and by the 1820s the slaughterhouses and butcheries, some of them in cellars, were attracting criticism, with *The Times* fulminating against 'these abodes of cruelty, filth and pestilence'.[26] It is not surprising, then, that in his early fiction Thackeray should describe the Charterhouse as the 'Slaughter House School, near Smithfield'. But it was as the Grey Friars that it featured in his novels *Pendennis* (1849-50), *The Newcomes* (1853-5) and *The Adventures of Philip* (1862), and the Carthusians are described as the 'Cistercians'. Arthur Pendennis, Thomas Newcome and his son Clive, and Philip Firmin are educated at the school, and other characters are old boys. It was as the Grey Friars that the Charterhouse became widely known, and Thackeray's change of heart was to have considerable significance for the way that it came to be perceived.

With the increase in the number of boys, extra seating was required in the Chapel, and so an extension was built on the north side, with a gallery. A subscription from the boys covered much of the cost of £2,000.[27] The Usher's pew there is strategically placed to give its occupant a clear sight of the boys, but that did not prevent them from carving graffiti on the rails of the benches, much of it defiantly close to that pew. Among the graffiti is 'Le Bas', deeply incised into one of the rails. Having disfigured the Chapel in this modest way, Henry Vincent Le Bas later presided over it as Preacher from 1871 until 1910. The Scholars' seats remained separate, in the north aisle, between the founder's tomb and the Master's substantial box pew on the north side of the sanctuary. The extension for the boys in the mid-1820s coincided with the high point of numbers at the school, which declined steadily thereafter, from 432 in 1827, to 226 in 1830 and 137 in 1832, the year of Russell's departure. This may have been because of the effects of overcrowding or a growing disillusion with the Madras system, which was discontinued by his successor, Augustus Saunders.[28] With the decline in the number of pupils, the much-maligned boarding houses could gradually be abandoned.

The changes at the school were followed by a period of improvement in the Brothers' living conditions. This followed the appointment of William Hale as Preacher in 1823. He probably owed his appointment to the two ecclesiastical governors, William Howley (Archbishop of Canterbury from 1828) and Charles Blomfield (Bishop of London from 1828). Hale was a pluralist, appointed Archdeacon of St Albans in 1839. He was translated to the Archdeaconry of Middlesex in the following year and, in 1842, to the more lucrative Archdeaconry of London. He was also Rector of St Giles, Cripplegate, Chaplain to the Bishop of London, Almoner of St Paul's and served as a governor of Christ's Hospital for fifty-five years. An energetic administrator, who, as Archdeacon of London, was responsible for a number of changes at St Paul's, Hale was a High Churchman who was described after his death as a 'Tory of the old school' and a 'determined opponent of reform'.[29] He was also a distinguished scholar and campaigner, who published more than fifty books and pamphlets, on topics ranging from sermons

and commentaries on the gospels, to editions of medieval church manuscripts for the Royal Historical Society's Camden Society series.

The changes at the Charterhouse during his period as Preacher and then Master, are inconsistent with the charge that Hale opposed reform. The 1820s saw major building work, with the demolition of the Wren Building and the adjoining accommodation for the Brothers, and their replacement by Pensioners' Court and the first stage of Preacher's Court. The extent of the investment can be gauged from the cost of the new buildings, which was £46,319, equivalent to more than two years' revenue. This was the most expensive building programme since the conversion of the mansion in 1613-14, and replaced the former layout to provide two rectangular courts. But the new arrangement did respect the Brothers' burial ground, which was left undisturbed in the open space of Pensioners' Court, although it was no longer used, and a new one was consecrated beyond the north side of the court. Further work followed, with additions to Preacher's Court in 1839-41, designed by Edward Blore. The new ranges in the two courts provided rooms for the Brothers, placed on either side of staircases in a collegiate manner, an apartment for the Preacher in the north-east corner of Preacher's Court and a house for the Manciple on its east side. Between the two quads was an arcaded ground storey, which, with the crenellated buildings in a 'Tudor' style, created an atmosphere that was reminiscent of an Oxbridge college.

Blore also remodelled the Chapel, taking down the organ gallery in the south aisle and moving its decorative front and elaborate carvings to the gallery at the end of the north aisle. That gallery was adapted for a new organ, made by Joseph Walker and installed in 1842.[30] William Horsley had been selected as Organist in 1838, continuing the practice, commented upon by Stevens, of appointing a distinguished musician to the post. A founder of the Philharmonic Society and close friend of Felix Mendelssohn, he was, like Stevens, a noted composer of glees, although he is best known today for the tune of the hymn *There is a green hill far away*. His successor, in 1858, was John Hullah, who was prominent in musical education in mid-Victorian London, and in the Christian Socialist movement. A friend of F.D. Maurice, Hullah gave classes at the Working Men's College and played an important role in establishing Queen's College in Harley Street, the first institution in the country to provide higher education for women. As Hullah became elderly and found it difficult to fulfil all of his duties, his pupil Mary Taylor acted as his assistant, and was appointed Organist after his death in 1884, holding the post until 1911. It was highly unusual in late-Victorian England for a woman to hold such a post.

Blore's other work in the Chapel included placing collegiate-style pews against the south wall, carved screens across the arch at the west end of the south aisle and the front of the north extension, and providing new access for its gallery by adding a turret in the angle between the north wall and the extension. He also re-roofed the north aisle, installed new ceilings throughout and took down the north

part of Chapel tower to relieve the pressure on the broad arch in the north wall. The result of his partial demolition of the tower is that the bell turret, which had been in its centre, now stands on its northern side, slightly overhanging.

The new buildings for the Brothers brought improvements in cleanliness, a development much approved of by Dr John Vetch, who had been appointed Physician in 1823. He introduced new arrangements for looking after the Brothers and the much-derided basket-women were replaced by ten nurses.[31] In 1829 the governors considered how sick and infirm Brothers should be cared for. They recognised that 'in a place which most resembles a College' the residents were attached to their own rooms, which they regarded as home, and were unwilling to leave them when they were sick. But that was inefficient and impractical, and the existing members of staff were not well suited to the task of nursing them. Aware that no post carried responsibility for caring for Brothers who were ill (comparable to that of the Scholars' Matron), they ordered the appointment of an Under-Housekeeper, who was to have 'a rank superior to that of the present nurses'. This, however, was unpopular, because it broke with the practice of not employing females to care for the Brothers, with the exception of the basket-women.[32] For the greater efficiency of caring for those Brothers who were infirm or had a long-term illness, in 1829 a row of five contiguous rooms in Preacher's Court was allocated for the purpose, creating the first infirmary in the almshouse. Ten years later, an infirmary was formed for the Scholars where infectious cases could be isolated.[33]

In 1830 space in the same wing was provided for the Physician's consulting room and a dispensary. He could now dispense medicines, without having to be concerned about the apothecary making a charge for every dose.[34] Following Dr Vetch's death in 1835, no new physician was appointed, and the apothecary's responsibilities were expanded; in 1840 the post was re-designated Medical Officer. His duties included regular reports on the health of the Brothers and Scholars, and he was authorised to permit Brothers to take meals in their rooms if they were too ill to dine in hall.[35]

Another major change in this age of reform at the Charterhouse came in 1832, following the Manciple's death. The staff had been entitled to some perquisites in kind, such as taking food left over at the end of a meal and unwanted clothes, but all of these were abolished, and their salaries were raised to compensate them. Their responsibilities were examined to see if some posts could be combined, and in future provisions were to be supplied by contract, rather than purchased directly by the Manciple.[36] More radically, the order prohibiting any of the posts of Registrar, Steward of the Courts, Auditor and Receiver from being held jointly, partly revoked in 1790, was now repealed. The Registrar also held the post of Steward and, on his retirement in 1835, the Auditor, Thomas Gatty, was appointed to all four posts. Thomas Ryder had been Registrar since 1789 and was ninety-four years old when he retired. His accounts were approved and he left with the

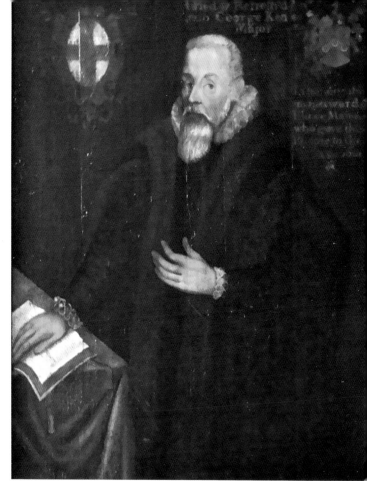

1. Portrait of Thomas Sutton, artist and date unknown. It was given to the City of Lincoln by the Mayor, Edward Blawe in 1622.

2. Thomas Sutton's tomb in Charterhouse Chapel, erected by Nicholas Johnson (or Jansen). Edmund Kinsman and Nicholas Stone.

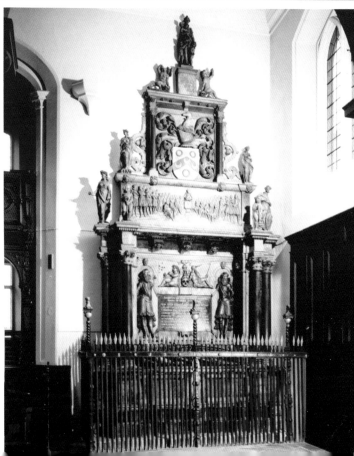

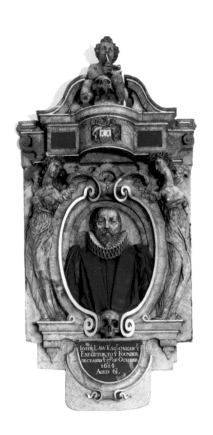

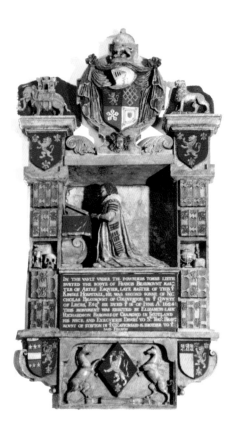

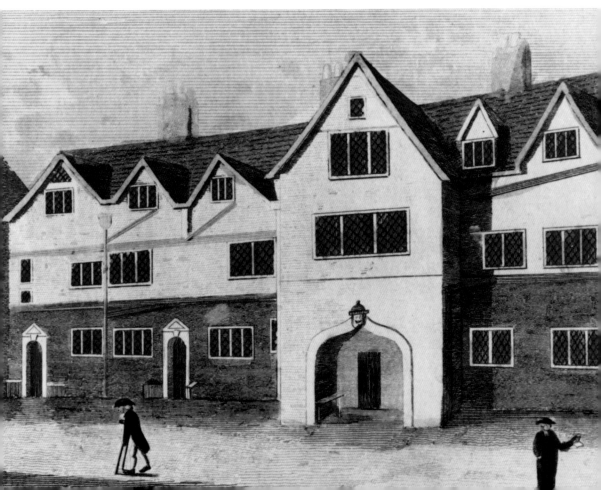

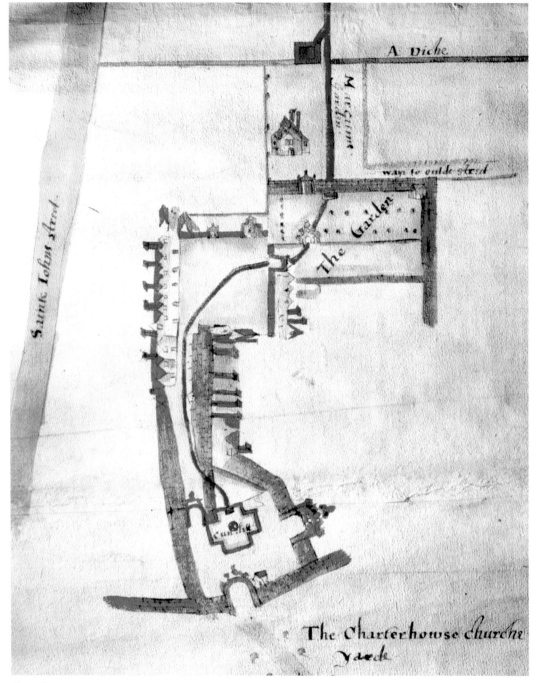

Within the plan image: A niche. / Maesteme garden / way to oulde street / The Garden / Saint Iohns street / The Charterhowse churche yarde

Opposite page

3. *Above left:* Memorial to Thomas Sutton's executor John Law, by Nicholas Stone, 1614.

4. *Above right:* Memorial to Francis Beaumont (*d.* 1624) maker unknown.

5. *Below:* The Brothers' lodgings on the west side of the Great Court, built in 1613-14, shown in a print by J. Sewell of 1797, from the *European Magazine.*

This page

6. A plan of *c.* 1624 showing the line of the water pipe through the Charterhouse to the conduit house. The pipe runs through the Great Court, between the Brothers' lodgings on the west side and Wash-house Court on the east. The conduit house was built by Francis Carter in 1613-14.

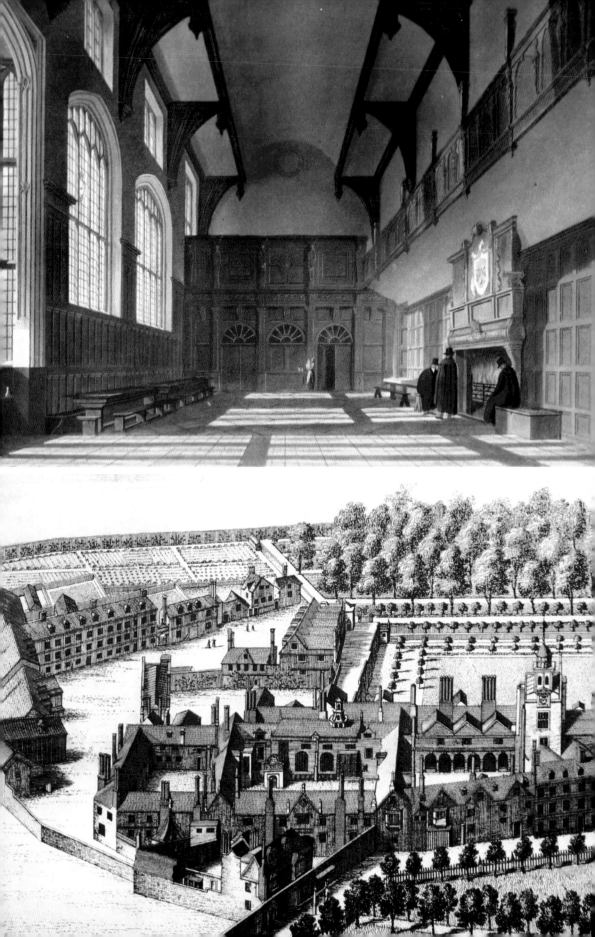

Opposite page

7. *Above:* The Great Hall, by Rudolph Ackermann, 1816.

8. *Below:* Detail from Johannes Kip's perspective view of the Charterhouse, originally drawn *c.* 1688-94. Master's Court has the Great Hall on its north side, Wash-house Court to its west and Chapel Court, Chapel Cloister and the Chapel to its east. The Queen's Walk, above the Norfolk Cloister, leads north to the gabled school building. The Wren Building faces the Great Court; the Brothers' lodgings are on the west side of the court.

This page

9. *Above:* Portrait of Anthony Ashley Cooper, Earl of Shaftesbury (1621-83), Lord Chancellor. He was appointed a governor in 1662, and was a follower of John Greenhill.

10. *Below:* Portrait of Thomas Burnet (*c.* 1635-1715), 1685, attributed to Benjamin Wilson.

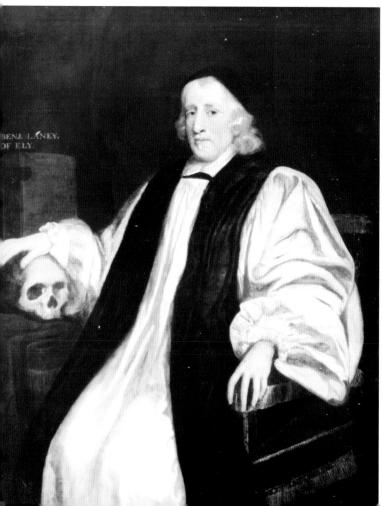

11. The Great Chamber, by Frederick Smallfield, 1868. It was here that the governors' meetings were held. The large window was inserted in 1840. By Frederick Smallfield, 1868.

12. Benjamin Laney, Bishop of Ely (1591-1675), appointed a governor in 1668, after Sir Peter Lely.

Opposite page
13. *Above:* Charterhouse painted in 1756 for Philip Bearcroft (1695-1761), the Master. Artist unknown.
14. *Below:* Martin Benson (1689-1752), Bishop of Gloucester, an Old Carthusian (after Jonathan Richardson).

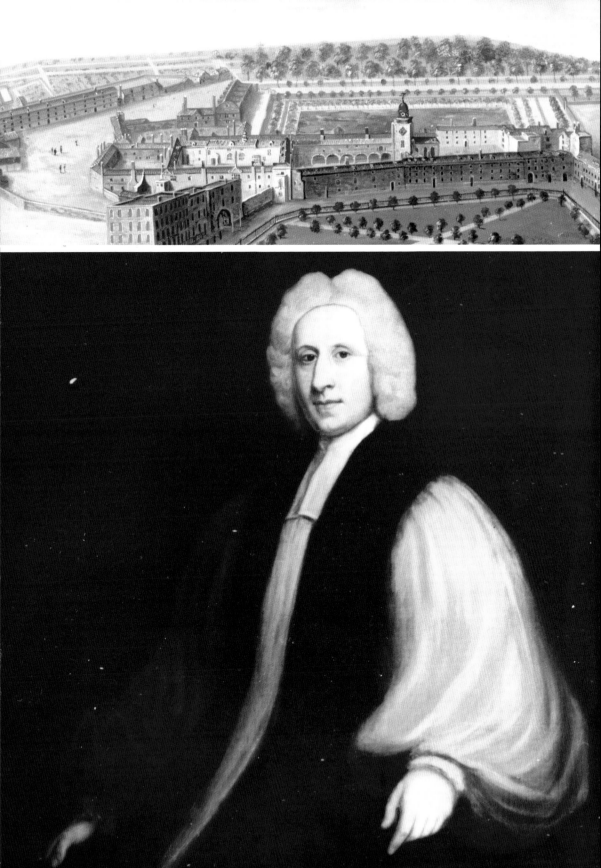

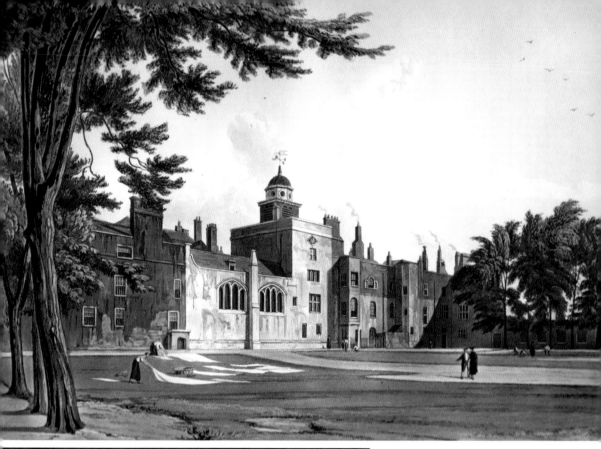

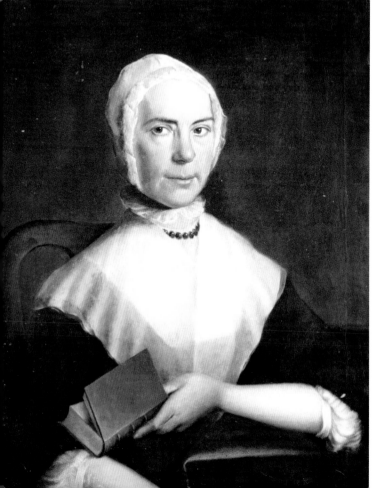

15. Lower Green and the north side of the Chapel, by Rudolph Ackermann, 1816.

16. Elizabeth, wife of Samuel Salter, Master 1761-78. She was described as the first lady of the Charterhouse (*d*.1751). Artist unknown, previously attributed to William Hogarth.

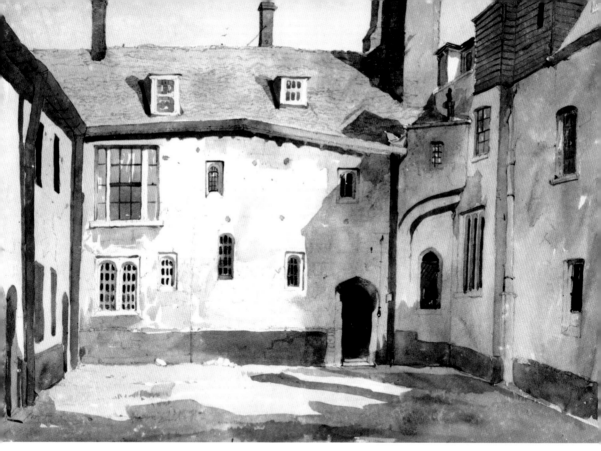

17. Wash-house Court, the service buildings of the Carthusian priory, adapted for Brothers' accommodation in 1613-14. By John Wykeham Archer, *c*.1840.

18. Preparations for a cricket match in front of the Great Hall in Master's Court, by Thomas Hosmer Shepherd *c*. 1830.

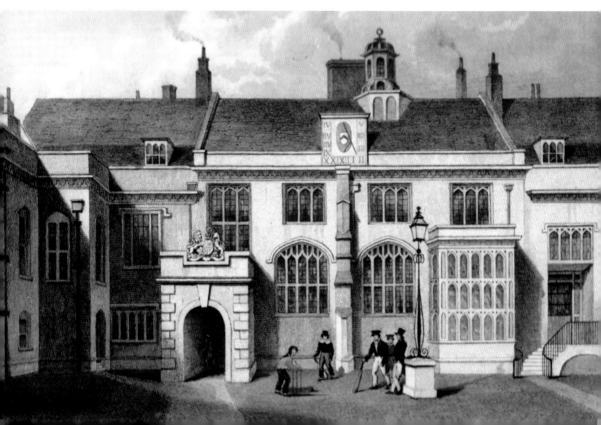

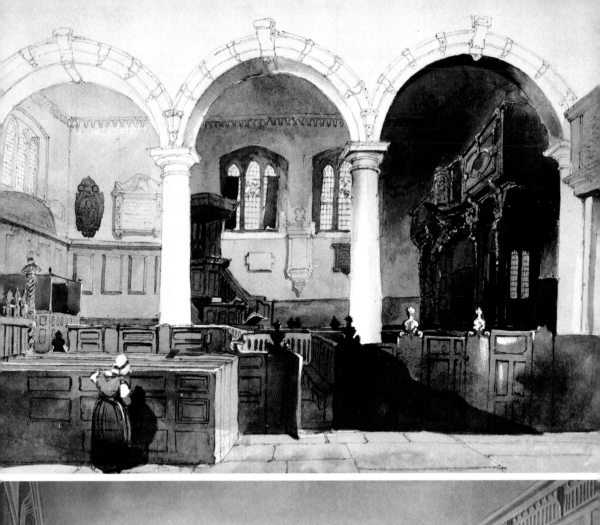

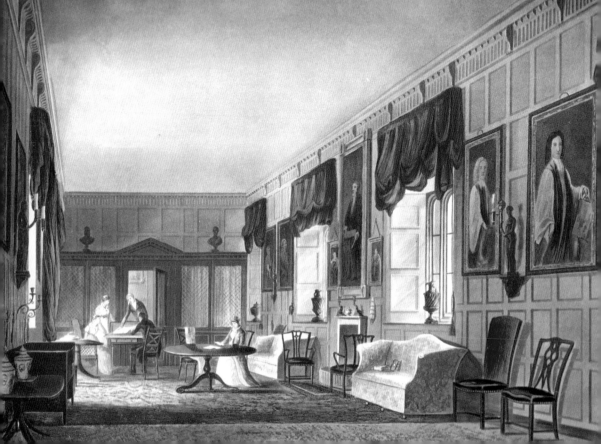

Opposite page
19. *Above*: Charterhouse Chapel by John Wykeham Archer, *c*.1840. The organ gallery was then in the south-east corner.
20. *Below*: The Master's Lodge, by Rudolph Ackermann, 1816. This room was the long gallery of the Tudor house, built in 1545-6.

This page
21. *Above*: The Norfolk Cloister. The west cloister walk of the Carthusian great cloister, with a brick vault of 1571.
22. *Below*: The Charterhouse from Charterhouse Square, with the gateway and Physician's house on the left. Rudolph Ackermann, 1816.

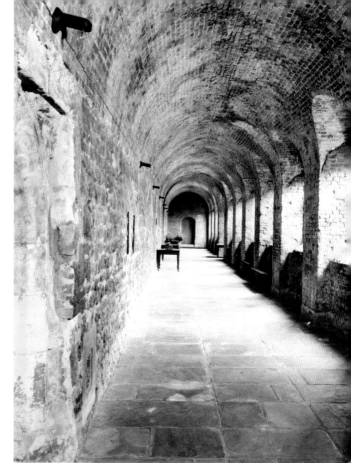

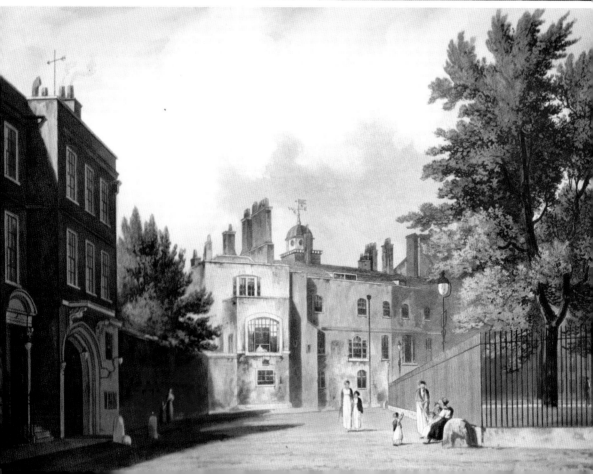

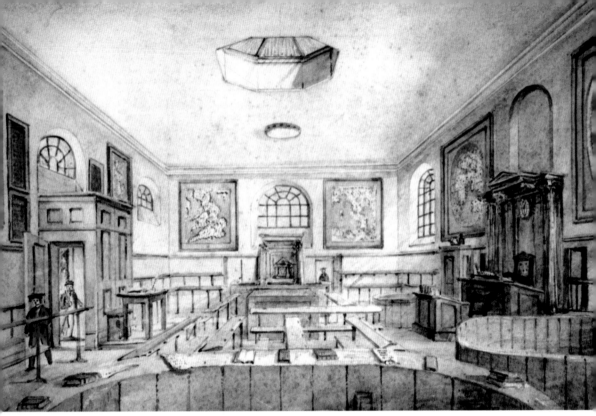

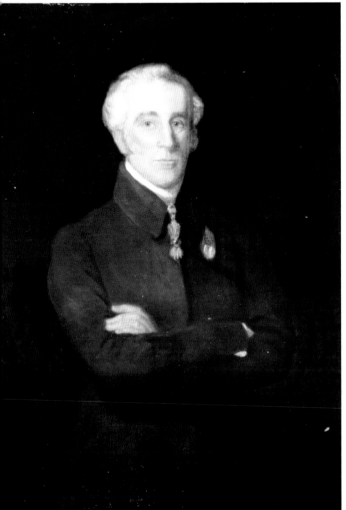

23. The old schoolroom, 1856, painted by Aiskew Clay, a pupil.

24. Arthur Wellesley, first Duke of Wellington (1769-1852), appointed a governor in 1828; by Henry Perronet Briggs.

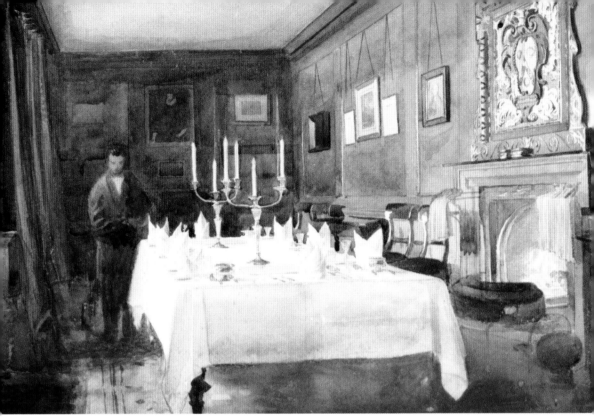

25. Brooke Hall, by
Frederick Smallfield, 1868.

26. Charles Manners Sutton
(1755-1828), Charterhouse
Scholar, appointed
Archbishop of Canterbury in
1805. Copy by G.R. Ward
of an original by Sir Thomas
Lawrence.

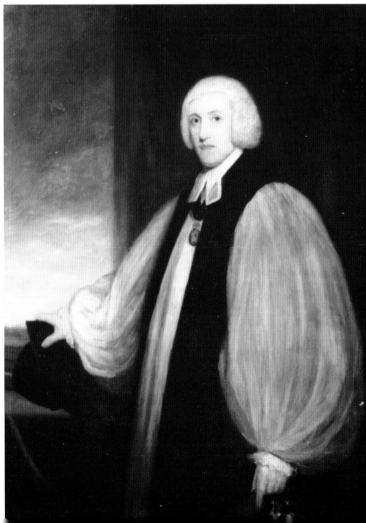

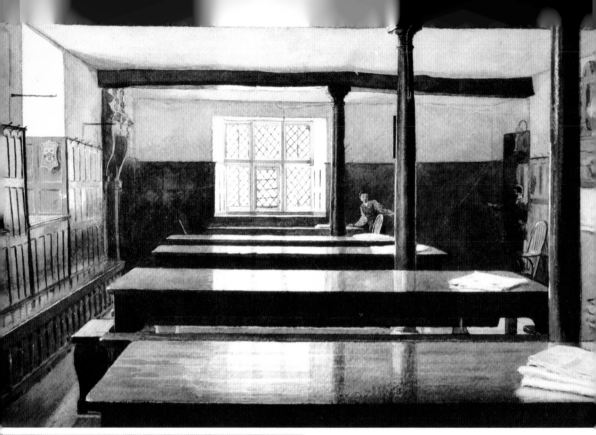

27. The Scholars' dining-hall, later the Brothers' library. By Frederick Smallfield, 1868.

28. The scene at the Founder's Day service in W.M. Thackeray's *The Newcomes*, when Colonel Thomas Newcome is recognised by Arthur Pendennis in the gallery. Painted by Daniel Thomas White.

29. Gerald Davies (1845-1927), Master 1908-27, by F.H. Round, *c*.1912.

30. 'What's for dinner?' After morning service, the Brothers eagerly peruse the menu in the Great Hall, September 1939. By Brother Ronald Gray (1868-1951).

31. *Left:* The doorway of Cell B. It was built in 1349 and uncovered during post-war restoration work in 1947.

32. *Below:* Charterhouse restored: Master's Court and the Great Hall.

33. *Below bottom:* Charterhouse restored: Wash-house Court.

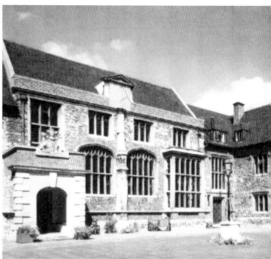

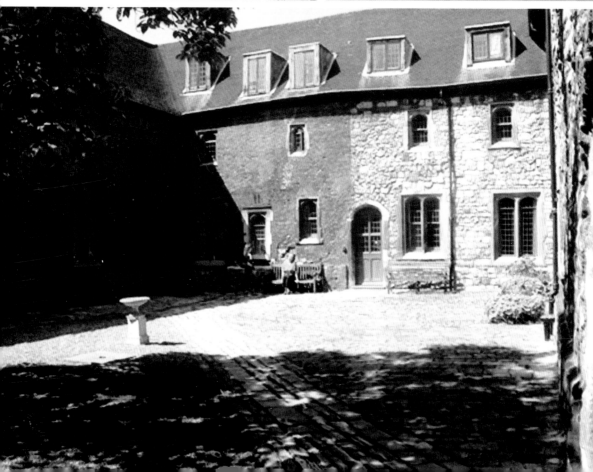

thanks of the governors, who clearly had no fears of the kind of dishonesty by the financial officers that had occurred in the seventeenth and eighteenth centuries.[37] Their confidence may not have been misplaced; standards of professional probity generally were rising.

Among the domestic changes, the Brothers were now served food individually, not in mess groups of five, and, according to Hale's account, could eat and drink as much as they required, as the servants no longer needed the food that was left over. This was designed to bring more orderliness and decorum to mealtimes. Hale clearly did not approve of the earlier arrangement by which each man in a mess helped himself from the dish in turn, with his own knife. The meat was served on pewter dishes that were cleaned at set (but 'long') intervals. Bread was issued not with the meat, but after dinner had been eaten, and so those Brothers who preferred to take bread with their meat were obliged to keep some from the previous day, and they also had to carry into the hall beer from their rooms, having collected it from the buttery earlier. On some days the Brothers departed to their rooms at the end of the meal, carrying butter or a piece of pie or pudding. Hale also frowned on the habit of the Brothers keeping their hats on during dinner, while admitting that the hall was 'imperfectly warmed'.[38]

The officers no longer witnessed the Brothers' behaviour at dinner, taking their meal in Brooke Hall, not the Great Hall, and at five o'clock, two hours after the Brothers were served. Until 1806 dinner had been served at one o'clock and when it was put back by two hours the new time applied to both the Brothers and the officers.[39] The move to Brooke Hall broke the practice that they dined together, which had been in operation since the beginning of the charity, and reflected a social as well as a physical separation, for the later dining time followed a pattern that was becoming common in middle-class circles. Space was now available in the Great Hall for all of the Brothers, and so from 1846 the upper hall became the Scholars' dining-hall, approached along the Norfolk Cloister from the school.[40]

These changes improved the Brothers' living conditions and the level of care that they received. Yet it did not bring contentment, and in 1835 they submitted a petition to the governors, outlining their grievances. The reformed administration at the hospital had produced the disciplined society favoured by Hale, but disliked by the Brothers, who now complained that they were 'living under the rod of oppression'. They also resented the way in which they were treated by many of the staff, who, they claimed, regarded them as 'no better than paupers sent by the Mendicity Society to the workhouse'.[41]

The increased use of workhouses to isolate and provide for the poor, under harsh conditions, invited comparisons with almshouses and their residents, and the Brothers obviously were sensitive to such parallels, with the sense of shame which those who had become poor were expected to feel. By the early nineteenth century the workhouses of the Old Poor Law were seen as moral and social failures, and the Commissioners who prepared the Poor Law Report of 1834

regarded them as exposing the elderly, who were mixed with the other inmates, to 'all the misery that is incident to dwelling in such a society, without government or classification'.[42] Workhouses set an example of care which the trustees of almshouses, dispensing 'respectable' charity, would wish to contrast with that which they were providing, and at the Charterhouse the classification was clear, for it provided a home for elderly gentlemen.

The Brothers also requested an addition to their pensions, as their value had been eroded by inflation, and the charity's income was increasing. The governors attributed the complaint to the agitation of just two Brothers, although they did order the Registrar to investigate the points which had been raised. The annual revenue averaged £19,325 and the charity was wealthy enough to have extended the Chapel, rebuilt the Brothers' quarters and provided new houses for the Preacher, Manciple and Matron, and the governors agreed to increase their pensions by £2 per annum. Their other complaints were dismissed as unjustifiable.

A history published in 1849 gave an approving description of the Brothers' living conditions.[43] These were appropriate for men who had 'occupied stations of respectability in the world; householders of good reputation' and the Brothers were treated by the officers and servants with 'all the respect that can be considered due to their character and station as gentlemen'. They could come and go when they wished 'at all reasonable hours', their food included 'a substantial dinner' every day, and they were allowed a pension that was adequate for their personal needs. The Brothers occupied a 'neat and commodious apartment; or else, as in some instances, two smaller rooms'. But the author did not ignore the criticisms made by Malcolm in 1802. He was referred to not by name, but as a 'popular historian of London' and his comments were offset by those of Herne and Smythe. The author also pointed out that the Brothers were taken 'from desolation and poverty' and their condition was greatly improved in all respects by the 'provisions and comforts' of life in the Charterhouse, although elsewhere he also noted that 'The seclusion of an asylum must necessarily be attended with some privations ... but in judging rightly of that excellent Hospital, the provisions and comforts of it ought not to be forgotten.' Regulations were necessary, and could not be so wide that they would suit the needs of every individual.[44]

This was a favourable account, written when the changes introduced since the early 1820s had much improved the standards of care for the Brothers, and in the calmer period after Russell's boom years, when the school had been bursting at the seams. Even so, it did acknowledge some of the controversial issues at a time when concern about the administration of almshouse charities was increasing. They were about to be focused on the Charterhouse, which came under close scrutiny.

A FITTING ASYLUM FOR ANY MAN

The growing criticism of residential charities culminated in the 1850s in an outburst of disapproval. As the largest and most prominent almshouse, Charterhouse was bound to attract attention. Indeed, disapproval focused partly on disquiet that the masters or wardens were enriching themselves at the expense of the alms-people, precisely the concern that had been expressed by Sir Francis Bacon with respect to Sutton's charity.

The most prominent articulation of this was set out by Anthony Trollope in his novel *The Warden*, published in 1855. His fictitious almshouse, Hiram's Hospital, contains eleven almsmen and a Warden, the Rev. Septimus Harding, who is living in some comfort from the income of the charity which should have benefited the almsmen. The basis for Trollope's novel probably came from a scandal which erupted at the Hospital of St Cross at Winchester, where the Rev. Francis North, a pluralist, was appointed Master by his father, the Bishop of Winchester, who, in turn, owed his appointment to his brother, the Prime Minister. The Rev. North received an estimated £300,000 during the time in which he held the post, which amounted to more than forty years, until an enquiry in Chancery ruled that he had misappropriated the hospital's funds.[1]

In some respects the Charterhouse provided a parallel with St Cross, and Hale certainly was a pluralist with a good income from several positions within the Church. But this was only one aspect of a wide-ranging attack, prompted by William Thomas Moncrieff, a dramatist and friend of Charles Dickens. After his admission as a Brother in 1844, his descriptions of life in the Charterhouse roused Dickens to publish two articles in *Household Words*.[2] The first, written by Henry Morley, appeared in June 1852 and the second in December 1855, following Hale's response, a petition from the Brothers and Thackeray's novel *The Newcomes*. The articles criticised the stipends of the Master and officers and the scale of their accommodation, contrasting the increases in their remuneration and conditions since the foundation of the charity with those of the Brothers. Hale was described as 'the great pluralist' who had an annual income estimated at £4,000, of which £800 came from his salary as Master, with other perquisites and a 'luxuriously fitted' apartment that contained thirty-three rooms. The

Master's salary was originally nine times the value of a Brother's pension, now the multiple was thirty-two. Similar comparisons could be made with the officers' remuneration. The Manciple's income had been £8 when the Brothers' pensions were £5 6s 8d, but now it was £200 and they received just £25.[3]

The initial article also asked if the living conditions were suitable for those 'decayed gentlemen' who were supposed to benefit from the charity, with the governors' definition of 1613 interpreted in contemporary terms as 'a merchant, artist, author, or the like'. If they had fallen on hard times they would hope to find in the Charterhouse 'an honourable place of refuge and an easy home' for their old age. Examination of the Brothers' apartments, clothing, meals, attendance and care suggested that this was not the case. Rooms were cleaned once a week and windows once a year, and these rules were strictly applied. Arriving late for dinner meant missing the meal, taking food to their rooms had been condemned as 'exceedingly ungentlemanly' and no visitor was permitted to stay overnight, but nor was help available when a Brother was taken ill during the night. Their eighty rooms were looked after by the ten nurses, while the six principal officers had a total of twenty-one women servants. And the expulsion of John Dingwall Williams, just before Christmas in 1851, for writing letters to the governors and officers that were deemed to be insulting, was interpreted in the article as a warning, that a Brother was liable to be expelled for speaking impertinently to the Master.

These were not the conditions which would bring consolation to an elderly gentleman, and a 'sensitive and educated man', who would not be attracted to life in the Charterhouse. Indeed, the Brothers consisted of the fathers of footmen and 'people of that class'. The conclusion which was drawn, was that the 'Poor Brothers are simply the discomforts of the place; which otherwise provides good salaries, and dwellings, and dinners, and daily pints of wine to the gentlemen and ladies who are really fed upon its funds'. But the article did not make any demands on behalf of the poor. Indeed, Morley displayed his own social prejudice by expressing contempt for the Brothers' social background, commenting sarcastically that they would find the Charterhouse 'a great scene of luxury' compared with the circumstances from which they had come.[4]

This was a potentially damaging attack, because of both Dickens's standing, and the popularity of *Household Words*, which had a circulation of 38,000 and a much wider readership, as copies were handed around. The article was seized upon by the press, which took up the Brothers' case, and in 1853 they were emboldened to present the governors with a petition, which differed from its many predecessors in the style in which it was written, the scale of the evidence which it set out to support their claim for increased pensions, and the fact that it was printed, presumably for circulation designed to maintain outside support.[5] The statutes were cited and so was Bacon's warning that the Master would benefit from the charity at the expense of the poor almsmen. Much of this was taken from the information presented in *Household Words*, but although Morley deplored

the quality of the living conditions, the Brothers did not make any reference to them in the petition, concentrating on their case for higher pensions.

A response was required, and Hale issued a pamphlet, with the governors' support, to refute the points made in the article, the petition and the newspapers.[6] In it he dealt at length with the question of who should benefit from the charity, citing the founder's will, the Letters Patent of 1611, the Act of Parliament of 1628, and the minutes of the governors' assemblies. His own preference was for a society 'with the character of gentility'. Thus, unlike earlier advocates of the Charterhouse, he approved of Bacon's advice to James I, because he had foreseen the danger that the hospital would become a 'Pauper Hospital' of the kind then 'in fashion', providing for 'a class of society little above that of the common pauper'. He recognised that the governors had adopted Bacon's terminology when setting out the categories of those who should be admitted, and commended them for doing so. Hale then drew the contrast between the institution thirty years earlier with the situation in the 1850s, when (quoting Bacon) it really had resembled, 'a cell of loiterers, cast serving men and drunkards'. The reforms that had been introduced, and which he described, had changed the hospital, by 'giving a better tone to the Society, contributing to its comfort and respectability, and rendering the Hospital a fitting asylum for any man, whatever has been his station'.[7]

Reform brought order and discipline, the problems of drunkenness and 'other immoralities' had been addressed and every 'deviation from propriety in language or behaviour' that was noticed, was investigated and punished. Brothers guilty of drunkenness had been expelled.[8] But this had not brought peace of mind for the Brothers, who, as Hale admitted, were afraid of being chastised. The fear had been conveyed by Morley in the *Household Words* article, drawing attention to the system of fines, for not attending service in the Chapel and for being out of the hospital after curfew at eleven o'clock. But Hale insisted that the fines were small, and an enquiry was held and witnesses heard before punishments were imposed, for serious offences, especially immorality, drunkenness, quarrelling, and insolent or improper behaviour. Improvements in society were matched by those at the Charterhouse.[9]

Hale also deployed statistics to support his case. In 1854, six of the seventy-nine Brothers were aged between fifty and sixty, twenty were in their sixties, forty in their seventies and thirteen were over eighty, although none had reached ninety. The death rate was just over seven per year, and nineteen Brothers had been in residence for more than ten years. On the more contentious question of social background, he categorised just over a half of them as 'Tradesmen, Clerks, Servants', fifteen were military and naval men, eight had been merchants, seven were described as schoolmasters and literary men, and five had practised law or medicine.[10] Those admitted during the preceding ten years had included men who had been booksellers, stationers, innkeepers, farmers, coal merchants, a clock and watch maker, a sugar refiner, a silversmith, a florist and an organ builder. This

suggests that Hale's broad grouping of tradesmen, clerks and servants contained a variety of backgrounds, if not of fortunes.[11]

Hale and his fellow officers had addressed the problems which their predecessors had tackled two hundred years earlier, and, like them, had succeeded. Just two Brothers had been expelled since 1843, one of whom was John Dingwall Williams, and the other was a temporary expulsion for six months, imposed on a Brother for 'indecent conduct' towards a nurse.[12]

As far as its 'moral condition' was concerned, outwardly all seemed well. But in some ways Hale's pamphlet could be read as an indictment as well as a defence. On his own admission, the reforms introduced between 1825 and 1839 'failed to produce either gratitude or content' and more than twenty years later, after further improvements, some Brothers displayed 'unkindness and ingratitude'. His explanation was that the government of the charity was difficult and he acknowledged that an ideal society could not be achieved within the hospital, conveying his strong sense of disappointment in writing, 'how hopeless to expect in it perfection, how impossible to insure the existence of gratitude and content'.[13]

He conceded that it had the appearance of a Protestant monastery, containing poor and unfortunate widowers and bachelors, some of whom were soured in their outlook as well as disappointed, because 'many [are] the victims of expensive and undutiful children, many more, the dupes of artful men'. They were grateful when they were first admitted, but within months became dissatisfied. This, Hale attributed not to the conditions in the hospital and the paternalistic approach which he fostered, but to a few of the Brothers spreading discontent among the others, by pointing out the disparity between the income of the charity and the increases in the officers' salaries on the one hand, and the small additions to the Brothers' pensions on the other. Hale chose to interpret the support which this attracted among the Brotherhood as the inevitable response of those who were destitute and disappointed, and so naturally wished for an increase in their allowances. Despite the certificates of character required, the hospital had admitted 'some men of the very worst character', who had subsequently been expelled. But even allowing for some eccentricity and despite having sympathy for those who had met with misfortune, he was unhappy to find discontent in a place 'where no other feelings ought to abound than those of heartfelt thankfulness to God, and gratitude to man'.[14]

The administration of the charity, rather than the temper of the Brothers, was examined by the Charity Commission in an investigation conducted in 1854. Its inspector looked at the accounts and interviewed the officers, but only one of the Brothers. With the continued high level of food prices and farm rents, its income had continued to increase, to an annual average of £20,995. The inspector anticipated that revenues would rise further, which would justify increasing the Brothers' pensions. He considered that the Master's stipend was adequate for maintaining the

position which was required and to live in the lodge. So far as the Brothers were concerned, he commented that if the Scholars were correctly defined as the sons of poor gentlemen, then those poor gentlemen could become Brothers when they were elderly. He cited the order of 1842 that no nominee was to be admitted without a certificate signed by two 'respectable persons', and concluded that in recent years they had indeed been drawn from the higher, rather than the lower, sections of society. These findings were included in his report, issued in 1857, and were as Hale would have wished them to be, although he qualified his generally favourable conclusions with the comment that a new scheme of government within the charity would make clear what was legal, and so remove the doubts of those who thought that some of the practices were illegal.[15]

The Charterhouse received wider and altogether more favourable attention through Thackeray's novels, especially in *The Newcomes*, written between 1853 and 1855. Thomas and Clive Newcome are educated there and many years later the narrator, Arthur Pendennis, returns for a Founder's Day service, to what seems a 'dreary place', only to discover with a shock that Thomas Newcome was one of the Brothers, having gone bankrupt. He fitted the definition of a Brother as specified by the Jacobean governors, for he was a retired soldier who had lost his money through no fault of his own, and he was virtuous, having scrupulously repaid those from whom he borrowed money before his bankruptcy. His very proper conduct showed him to be a true gentleman. But the concept of the deserving poor in Victorian England was not as it had been in the seventeenth century, certainly no one would now be prepared to pay a bribe to obtain a place, and Thackeray makes the reader aware of both the shame felt by a bankrupt, and the humiliation for someone from a respectable background being forced by his circumstances to spend his final years in an almshouse. Indeed, Thomas has not told his family of his whereabouts, which increases Pendennis's feeling of surprise, verging on dismay, when he recognises him in the Chapel, wearing the distinctive Brothers' black gown, which Thomas later feels the need to excuse, with the question 'is not that uniform as good as another?'. But his conditions were good, his room was 'neat and comfortable' and he was treated respectfully by the staff. Before he died he became friendly with one of the boys, reflecting on his own days at the school, neatly focusing on the Charterhouse as the place where he had spent his early years as well as his old age. The book ends with his death in his room; his last word being 'Adsum', the response of the schoolboys when their names were called.

In this fictional account Thackeray did touch upon some of the controversial points, while drawing a picture of the Charterhouse that was sympathetic, if overly sentimental, and a reviewer commented that it presented an idealised picture of the Brothers' circumstances, rather than a true one.[16] Yet, unlike Dickens, Thackeray had a personal knowledge of the community, from his schooldays and from later visits. He returned in 1854 to attend the Founder's Day service, and refreshed his

memory of the conditions there in the following year, when he visited a Brother, Captain Thomas Light, in his room in Preacher's Court. That visit formed the basis for Thackeray's description of Thomas Newcome's circumstances. He also went there occasionally to regale the pupils with stories of his own schooldays, his fight with George Venables, and keeping them happy by tossing them coins.[17]

Captain Light was typical of the Brothers at that time. After a career in the army, in which he had seen action in the French Revolutionary and Napoleonic wars, he had entered on the Queen's nomination in 1848, even though he was blind. He was looked after by his daughter because of his blindness, until he died in 1863, at the age of eighty-six, just a few months before Thackeray.

Given the rivalry between Thackeray and Dickens, *The Newcomes* was bound to provoke a response and, sure enough, Dickens wrote that this was a good time to 'hit the Charterhouse again, hard'. The second article in *Household Words* followed in December 1855, replying to the description of Thomas Newcome's circumstances, as well as to Hale's rejoinder and the Charity Commission's investigation.[18] The Brothers' conditions were described again, with emphasis on the bare furnishings of their rooms – where they were provided with 'less bedding than is to be had in gaols' – and attention was drawn to the extent to which they were patronised by the staff, and browbeaten by the officers if they complained. Hale was described as a 'haughty Master' and criticised for his wealth, the number of positions which he held, for his treatment of the Brothers, which they resented, and for his lack of humility. The article also widened the attack by including the school, hitherto omitted from the debate. The Scholars were the sons of prominent men or of those connected with the charity, which had increasingly fallen under the control of the clergy, so that the school had become 'a notable Church seminary' and the dominant element, with the almshouse regarded as 'an incumbrance'. Indeed, the charity's wealth had been 'diverted into the lap of the Church', which was all very well, but the sons of the ecclesiastical hierarchy and aristocracy had benefited, rather than those of the parish clergy, who had to struggle to educate their children.

Perhaps more persuasive evidence than the attack orchestrated by Dickens came from Augustus Saunders, who left the post of School Master in 1853 and nine years later alleged that 'The pensioners are simply worn-out servants or dependants of the Governors, and the boys are to a boy almost connexions – Lord G's grandsons, and Lord H's nephews.'[19] Such claims had become commonplace and, despite Hale's response, were difficult to refute. Yet the notion that the school had become a seminary for the Anglican Church manifestly was not true, for barely a fifth of the boys who were there in the 1850s went on to an ecclesiastical career, the others entering a range of professions, including the law, the armed forces, school teaching, civil engineering, commerce and administration.[20] At the time of the 1851 census, seventy Scholars and boarders were in residence, ranging in age from nine to eighteen, with half of them aged thirteen, fourteen and fifteen.

The majority had been born in England, although the youngest boy was from Hong Kong. There were also two sets of brothers from Tasmania and Adelaide, as well as boys from Jamaica, Bombay and the East Indies.[21]

Changes became possible following an increase in the charity's income at the end of the ninety-nine year lease of the Clerkenwell estate, in 1859, and the granting of new ones for twenty-one or thirty-one years. At long last the London property was generating a good income, with rents increased from £650 to £6,000, and by the late 1860s the charity's receipts from rents were approximately £30,000 per annum.[22] The governors decided that more could be paid to the Brothers, and that the number of Scholars should be increased. A report in 1860 recommended that the Brothers' pensions should be raised to £36 per annum and showed that the sum then available from the annual surplus was £2,278, which could provide an additional sixteen more Scholars' places. The governors accepted the recommendations.[23] In 1862 a new building was erected to accommodate the extra numbers.[24] As well as the Scholars' house, or Gown-Boys, there were three other houses, named after staff: Saunderites, after Augustus Saunders; Verites, after Oliver Walford (nick-named 'Old Ver'), Assistant Master 1836-8 and Usher 1838-55; and Dickenites after the Rev. Charles Dicken, Assistant Master 1824-30 and Reader 1838-61. In 1862 there were thirty-five day boys, mostly the sons of clergymen, lawyers, doctors and other professional men.[25]

The Charterhouse was one of the nine schools investigated by the Clarendon Commission between 1861 and 1864, reflecting the increasing intervention of the state in education. Inevitably, the question of the Scholars' and Brothers' backgrounds was raised. The unsurprising conclusions were that the Scholars were not 'poor children' and that society had changed so much since the early seventeenth century that a poor man in Thomas Sutton's time may have been a very different person from a poor man in the mid-nineteenth century.[26] One of the Commission's more important recommendations was that all scholarships and exhibitions should be competed for, and town boys were to be eligible. But it had also addressed rather more mundane matters, such as the fitting of gas burners in the passages of the boarding houses, and the serving of meat twice each day.[27]

The most far-reaching point which the Commission considered was whether the school should be separated from the almshouse and moved out of London. Public schools, such as Marlborough, had opened outside the capital, and the fresh air and space which they provided was thought to give them a strong advantage over those in the metropolis in attracting pupils. Two influential former School Masters, Saunders and Richard Elwyn, who held the post from 1858 to 1863, spoke in favour of a move. Elwyn believed that, as it would allow more boys to be educated, the 'influence and power' of the school would be increased. His successor was William Haig Brown, who had not been educated at the school, which broke with the long-standing custom of appointing a Carthusian. Indeed, not since the appointment of William Middleton in 1626 had a non-Carthusian

been given that post.[28] Haig Brown, too, was strongly in favour of moving the school, as the Commission recommended in its report, because of its constricted site, which was now surrounded by buildings and overlooked from adjoining properties.

Hale was opposed to the idea and believed that the Charterhouse had the opportunity to become the great school of the metropolis. He regarded the school and almshouse as 'inseparable parts of the same institution' and claimed that statistically the Clerkenwell site could be shown to be as healthy as any in the provinces. The Commissioners did not dispute this, but thought that parents' perceptions, rather than statistical evidence, influenced their choice. Saunders had objected that, as the Master was also a governor, Hale had undue influence over the school's affairs.[29] His views certainly were reflected in the report of a committee of the governors in 1865, which opposed the implementation of the Commission's principal recommendations, stating that the opening of all scholarships to competition was 'not desirable' and that the school should not be moved to the country. The Earl of Derby, one of the governors and a former Prime Minister, made a statement in the House of Lords to that effect. But, despite his and Hale's opposition, upon the report of another committee, a submission by the School Master and Usher, representations from parents and comments in *The Times*, in 1866 the governors reversed their earlier decision and came out in favour of moving the school to the country. The Public Schools Act of 1868 provided for the division of the charity into two branches with separate boards of governors. The title of 'The Hospital of King James founded in Charterhouse' was dropped and the almshouse was named 'Sutton's Hospital in Charterhouse'.[30] Sites outside London were considered, and eventually land at Godalming in Surrey was bought for the new school, with the eastern part of the Charterhouse site sold to the Merchant Taylors' Company, for its school, at the modest price of £90,000.[31]

The school was completed in time for the move to take place in 1872. The financial arrangements were that, after certain common expenses had been discharged, the revenue was allocated equally to each branch. This was done on the recommendation of the Charity Commission but, although the governors agreed to the settlement, it proved to be not entirely equitable.[32] Before the separation, the annual cost of each of the sixty Scholars was roughly £20, leaving £157 per head for each of the eighty Brothers.[33] On the basis of these figures, the division of revenue disadvantaged the almshouse, which now needed to make savings. And the sum received from the Merchant Taylors' Company proved to be inadequate for buying the site at Godalming and erecting the school buildings, and so the financial arrangements accompanying the division were not as straight-forward as initially envisaged.[34]

Neither the Charity Commission nor the governors could have foreseen the major changes that were to follow, stemming from the decline in the value of the

charity's once impressive fortune. Within a few years of the removal of the school the long agricultural recession set in, and rents began to fall. In 1885 the country rents produced only 73½ per cent of the sum which they had contributed just six years earlier. The almshouse, which, unlike the school, was unable to generate income from additional sources, became so impoverished that from 1882 the designated number of eighty Brothers could not be maintained, and it has not been achieved since.³⁵ The governors were so gloomy about the prospects for the future that they proposed to close the almshouse and pay the Brothers out-pensions, which would allow more than a hundred pensioners to be provided for. The possibility of using some of the revenues to support out-pensioners had been included in the Charity Commissioners' Scheme of 1872, although it had then been envisaged that they would be in addition to the eighty Brothers maintained in the Charterhouse. The Scheme had also raised the possibility of breaking the rule which specified that all of the beneficiaries should be men. By stipulating that the out-pensioners would be men with the same qualifications as the resident Brothers, 'or the widows of any such persons', the Scheme therefore allowed widows as well as widowers to be considered.³⁶

The Merchant Taylors' Company had helped to fund their new school buildings by selling building leases of parts of the site that it did not need. These were developed with shops and warehouses. This was an attractive precedent for the governors of the hospital and two street improvement schemes of the 1870s also raised the possibility that the site of the almshouse itself was now so valuable that the charity could benefit from its redevelopment. Wilderness Row, along its northern boundary, was widened to form Clerkenwell Road, and the carriageway along the south side of Charterhouse Square was widened as part of a new street that connected Smithfield Market directly with the square, part of a direct and straight connection from Holborn to Aldersgate Street. A street through the Charterhouse site from the square to Clerkenwell Road could generate an annual income estimated to be as high as £9,000 or £10,000 from building leases for the properties erected along it. This would require the demolition of most of the buildings, although it was considered possible to retain some of them, including the Chapel.³⁷

While the economic situation was the immediate cause of the proposals which were now formulated, it also grew out of continued dissatisfaction among the governors regarding the provision in the almshouse. This was expressed in a paper submitted in 1871 by the Archbishop of York, William Thomson. He regarded it as an expensive way of maintaining the elderly, compared with the costs incurred by similar institutions, and while that could be justified if the standards of comfort and welfare were commensurately superior, they clearly were not. The Brothers were moved at a relatively advanced age into an institution with which they were unfamiliar, governed by 'collegial and quasi-monastic rules', and so it should not be surprising that intoxication and 'other irregularities' of behaviour resulted.

The Archbishop suggested that relief could be provided more appropriately in 'the gentle influence' of a family home, with the company of the Brothers' own relatives. His arguments displayed a sympathetic awareness of the problems that could produce the more disagreeable aspects of the Brothers' behaviour, which contrasted with the hitherto mostly punitive response. They reiterated the points made by Malcolm seventy years earlier, which were also considered by Haig Brown in his history of Charterhouse, published in 1879. Although this avowedly was more concerned with the school and the justification for the division of the charity, Haig Brown also reflected on conditions in the almshouse. This he described as, 'a religious society without the bonds of religion', where the 'rules of monastic life' still provided the basis for the arrangements that the Brothers had to observe. Following Thomson, he questioned whether it was sensible to take elderly men from the context with which they were familiar, and ask them to live in almshouses, with the attendant stress of creating new social contacts and adapting to changed routines.[38]

As in its early days, the very purpose of the almshouse, as well as its management, was being called into question and was now assessed in contemporary terms, rather than justified with reference to Bacon's paper to James I. Similar points to those which Malcolm had made were now considered, not only by writers outside the charity, who in the past could have been dismissed as envious, sceptical or even hostile, but by the governors and the Charity Commissioners, who were prepared to give thoughtful attention to such issues. Indeed, the Commissioners regretted that the measures which separated the school and almshouse had not made provision for closing the Charterhouse as a residence for the Brothers, and paying all of them relief as out-pensioners in order to avoid the problems caused by a double establishment. The replacement of the community in Clerkenwell with a charity that paid for Brothers to be housed in lodgings would allow more of them to be supported than in the almshouse. For those who were 'friendless' and unsuited to life in lodgings, a hostel could be built in the countryside, preferably on a part of the Godalming site.[39]

Proposals drawn up in 1886 were, therefore, a revival of those made fifteen years earlier, now given added impetus by the decline in revenues, and the expression of concerns about the appropriate care of the elderly, which had been under consideration for much of the century. Other almshouse charities were being reassessed in similar terms, and some were being closed. The almshouses of Dr Thomas White's charity in London Wall, attached to Sion College, were abolished by an Act of Parliament in 1884, with the beneficiaries paid out-pensions. Under the new arrangements, more poor people could be provided for than the twenty who had been maintained in the almshouses.[40]

The proposals formed the basis of a Bill that was introduced in the House of Lords in 1886, which would have allowed the changes to Sutton's charity to be implemented, and it passed smoothly. But it met with considerable opposition in

the Commons. An amendment questioned whether the charity, which in its present form was carrying out the founder's intentions, had indeed been demonstrated to be unsuitable to modern needs and had given rise to abuses. This challenged the basis of the scheme. The threat to the historic buildings was one concern that was strongly voiced by, among others, the Society for the Preservation of Ancient Buildings and the architect Basil Champneys, who saw the proposal to demolish a large part of the Charterhouse as typical of a wider risk to historic structures, because 'the surrender of one building renders the next work of destruction that may be proposed more feasible'.[41] This had not been an issue during the 1860s, when the departure of the school was being considered, and the Merchant Taylors' demolition of a long section of the cloister, monastic in origin and rebuilt by the Duke of Norfolk *c.* 1571, had been carried out almost without comment.

John Talbot, one of the governors, spoke in the Commons and commented ruefully that, 'the beautiful and romantic picture' of the Charterhouse conveyed by Thackeray had contributed to the interest in the Bill, reflected in the number of Members who were in the chamber to hear the debate, and the extent of the opposition. Thackeray's description certainly was in the minds of some Members. Sir Edmund Lechmere referred to the Brothers as 'the successors of Colonel Newcome'. But they also took the opportunity to comment on various aspects of the charity, especially the sale of the school site to Merchant Taylors' for such a small sum, the granting of scholarships to sons of the aristocracy, the disproportionate amount spent on the school and the financial management of the charity.[42] The Bill was withdrawn after the House divided on an amendment and was not reintroduced, and the proposal to develop the almshouse site was dropped.

Evidently, the earlier controversies had not been laid to rest, and discussion of the Bill provided the opportunity for the charity's critics to give them a further airing. Champneys, for example, did not limit his attack to the impact on the historic buildings, but also criticised aspects of the administration, including the number of staff and the level of their salaries. Reducing expenditure in that area would, he thought, provide some of the economies needed. An article in the *English Illustrated Magazine* was especially critical, attributing the separation of the school from the hospital and its removal to Godalming to its 'conversion ... into a fashionable if not aristocratic place of education'. The author added that the current preference was for the Brothers to be non-resident and that the effect of the proposals would be that Sutton's Hospital would disappear, 'in favour of a middle-class school on the Surrey hills, and a few scattered annuitants'.[43]

The decision to introduce the Charterhouse Bill proved to have been a political misjudgement, failing to achieve its objective and opening the charity once again to public criticism. Yet the seniority of those who served as governors had not diminished since the eighteenth century. The Archbishops of Canterbury continued to act as chairmen, it had become customary for the Archbishop of York to be a governor, and nineteen of the twenty Prime Ministers during the century served as

governors, the sole exception being the Earl of Rosebery. But their eminence may in itself have stimulated opposition to the Bill. One speaker during the debate in the Commons condemned the threat to the buildings as an 'act of Philistinism, of barbarism, and of vandalism' which the House was being asked to sanction 'under the patronage of these great names of the Governors of the Charterhouse'.[44]

The failure of the governors' scheme prevented the achievement of a solution to the problems in the short term. The arrangements made when the charity was divided had allowed the school to flourish and quickly reach its designated number of 500 pupils, and could not now be revised in favour of the almshouse. Indeed, a Charity Commission Scheme of 1905 reinforced the division of the charity by ordering that the educational branch be administered as 'The Charterhouse School'. Nor did the economic situation improve. The difficulties faced by the almshouse after 1872 were partly those which had been encountered during the long period of low agricultural prices from the late seventeenth century until the mid-eighteenth century. But the problems in those years, compounded by the peculation of some officers, had not led to a reduction in the number of Brothers. And the development of the London estates, which contributed more than a half of the rental income by the mid-1890s, with the availability of a wider range of investments, generated additional income in the late nineteenth century that lessened the reliance of the almshouse on rural rents.[45] These persisted at low levels into the early twentieth century, and between 1914 and 1919 most of the country estates, bequeathed by Thomas Sutton or purchased with his legacy, were sold. The revival of agricultural prosperity during the First World War made this an opportune time to sell, and the land market was particularly buoyant at the end of the decade. The proceeds were invested in securities. Although for many years these failed to produce significantly greater revenue than the estates had done, they provided a more stable and predictable income, and were easier and cheaper to administer. Even so, the almshouse branch could only deal with the financial disadvantages imposed upon it when the almshouse and school were separated by cutting costs, which effectively meant reducing the number of Brothers.

In the context of the debate regarding the nature of the provision that should be made for the elderly poor, its financial problems were not so evident. A writer opposed to the introduction of old-age pensions favoured the maintenance of workhouses, so long as the inmates could be classified and segregated socially. The aim was institutions that combined, 'the economy of collective life in a workhouse with the liberty and individuality of the almshouse', and he regarded the Charterhouse as the ideal establishment of that kind. Not only was it 'run on almost a lavish scale', but the Brothers had their own rooms and took their minor meals alone, while having dinner together in the hall. Catering on that scale produced a better meal at a lower cost than they could have provided themselves. And there were other advantages to this 'compulsory common meal', not least its civilising influence. If the Brothers were left to their own devices all

day, every day, 'many of them would drop into semi-piggish habits, living on scraps of food, and perhaps spending the balance of their pensions on gin'. Men, even more than women, needed social intercourse if they were to maintain 'even a moderate standard of refinement'.[46] Although that was a favourable account on economic and social grounds, such a portrayal of Sutton's Hospital as a kind of model workhouse was hardly what earlier generations of governors and officers had aimed for.

The charity's character had undoubtedly changed, so that Walter Thornbury could describe the Brothers as 'an interesting feature of Sutton's rather perverted charity'. He did, however, describe it as providing, 'a refuge the rough outer world denied' for members of the 'respectable brotherhood [which] used to contain a good many of Wellington's old Peninsular officers, now and then a bankrupt country squire, and now and then – much out of place – came the old butler of one of the governors'. They lived in 'comfortable rooms rent free', with an annual pension of £36. They were required to wear a long black gown within the buildings and to be in every evening by eleven o'clock. He also commented that the levying of fines for non-attendance at chapel 'secures, as might have been expected, the most Pharisaic punctuality at such ceremonials'.[47]

That aspect of the charity's 'compulsory conformity' went on attracting unfavourable comment. The younger Charles Dickens continued his father's interest in the Charterhouse and in 1888 wrote that the needed reforms had been carried through, but added that, 'There is a good deal of chapel-going, with a system of fines of a rather objectionable sort.' Twenty years later the matter was raised in the House of Commons and Sir Charles Trevelyan, Parliamentary Charity Commissioner, replied that the Master, Canon George Jelf, had discontinued the practice and he hoped that it would now fall into disuse without intervention from outside, 'as inconsistent with modern ideas of the conduct of denominational institutions'. But Jelf's predecessor, Haig Brown, who had been appointed Master of the Hospital after he had retired as Headmaster of the school, had enforced it. This remained an issue, and in 1927 a committee of the governors recommended that the number of weekdays on which attendance was compulsory should be reduced from six to four.[48]

The almshouse continued to operate on an income which was barely sufficient. Aware of the problems, some Brothers decided that the solution did lie in the sale of the site and the establishment of a system of out-pensions. In 1918 they attempted to drum up support by a campaign in the press. Neither the use of the press to change the Brothers' circumstances, nor the proposal to sell the site, were new, but the Brothers did have a fresh channel for their proposals in the Ministry of Pensions, created just two years earlier in 1916. However, officials at the Ministry tipped off a governor, Sir Ernest Pollock, and the identities of the Brothers leading the campaign were discovered, apparently from perusing the entries in the diaries of one of them after he had died. The governors' predecessors had themselves

promoted a similar policy in the 1880s, but sale of the country estates rather than the Charterhouse itself was the course of action now being pursued. In any case, they were not prepared to tolerate such an attempt to influence their management of the charity, and two Brothers were warned as to their behaviour, described as 'fomenting discord or discontent'.[49]

An opportunity to enhance the almshouse's reputation by presenting the positive achievements of the charity, came with the tercentenary of Thomas Sutton's death in 1911. Gerald Davies, the Master, who had succeeded Jelf, was commissioned to write a full-length history of the priory, the mansion and the charity. He had been a Scholar between 1856 and 1864, had returned to the school as an Assistant Master in 1873, remaining there until appointed Master of the Charterhouse in 1908. The First World War delayed publication of his history until 1921, although a short account was issued in 1911.[50] Davies did not address many of the underlying problems, and was an indulgent historian of the charity which occupied so much of his life. He had been instrumental in the defeat of the Charterhouse Bill in 1886, and was circumspect when writing about the nineteenth century, concentrating largely on the history of the school, attributing the reversal of the governors' policy regarding separation to Haig Brown's sense of purpose and energy.

Davies not only avoided the controversies raised by the articles in *Household Words* and the debate in the Commons, but dealt only briefly with the reforms of which Hale had been so proud. Indeed, Hale's views had been rejected in the period of change that followed the Royal Commission's investigation. Perhaps symbolically, within four months of his death, the stained-glass window in the north aisle of the Chapel which he had presented in 1844 was removed, while that in the east window of the south aisle (also by Charles Clutterbuck and donated by the Scholars at the same date) was retained.[51] Davies also overlooked Hale's analysis of Bacon's paper to James I, and preferred to follow earlier historians of the charity in being rather dismissive of it. Haig Brown, on the other hand, had confronted and explained the more controversial decisions made during the nineteenth century and applauded Hale's improvements, which he contrasted with Fisher's conservatism. But he had included a transcript of Bacon's paper in his history without any analysis, and contented himself with castigating Bacon for his initial 'eloquent abuse of the intended Hospital' and subsequent acceptance of a place as a governor.[52]

While avoiding many issues, Davies did acknowledge that the almshouse had stagnated and required an additional benefactor, and suggested that none had emerged because of its reputation for wealth. That reputation was no longer appropriate and he, like so many others, had hopes of that shadowy figure 'the great practical philanthropist with his spare millions of money'.[53]

PRAISED BE THE LORD AND THOMAS SUTTON

Hopes that a generous benefactor would donate a large sum of money were not realised, and in the first half of the twentieth century the charity's income was barely adequate. With the continued low level of receipts, even after the sale of the country estates, the full number of Brothers could not be restored, and by the beginning of the Second World War the Master was preparing to implement a series of severe economies. Yet the Charterhouse's public image had been much improved.

In 1919 the prefix 'poor' to the term 'Brothers' was dropped.[1] Just eight years later the charity, established to provide for elderly men with inadequate means, was glad to receive assistance from one of them, William Cusens Neats, who thoughtfully left a bequest of £5,000. He is the only Brother to have a memorial in the Chapel. Without the interest earned from his bequest, the accounts in the late 1920s would have shown a deficit. Indeed, throughout the 1920s and 1930s the hospital was impoverished. In 1929 a part of the Wray library was sold, with nearly £3,000 raised from the sale of fifteen books, and much of the remainder was disposed of two years later.[2] A valuable new addition to recurrent income came from a share of the charges for parking cars in Charterhouse Square, which was producing £400 per annum by the late 1920s, when annual receipts were roughly £18,500, and £450 ten years later.

Expenditure during the 1930s averaged £18,395 per annum. Staff costs accounted for twenty-eight per cent, provisions and housekeeping for twenty-two per cent, and the Brothers' pensions twenty per cent. Edward StGeorge Schomberg became Master in 1935, and three years later resolved to tackle the worsening financial problems. Income came from an almost equal mixture of property rents and financial investments. Rental income was reduced by the amounts absorbed by repairs, while the return on investments was restricted by the low level of interest rates, with bank rate set at only two per cent in June 1932, and not increased until August 1939.[3] To reduce the salary costs, the Registrar since 1911, A.M. Walters, was asked to resign and was not replaced. Schomberg argued that with the sale of the country estates the post carried far fewer duties and had

become 'virtually a sinecure'. The Assistant Receiver of Rents took on some of the Registrar's responsibilities, and the Charity Commission approved the merger of the post of Registrar with that of Master.[4]

The financial and other problems were not immediately apparent to visitors, who saw the charity in terms of Thackeray's perspective rather than that of Dickens. The connection with Thackeray was fostered by the charity: a memorial tablet to him was placed on the wall in Chapel Cloister; plaques marked Captain Light's old room in Preacher's Court and Penny's boarding house in Wilderness Row, where Thackeray lived when he first came to the school; his daughter and amanuensis Anne Thackeray Ritchie, presented the manuscript of *The Newcomes* to the school in 1874; the Charterhouse magazine, begun in 1884, was entitled *The Greyfriar*; a bust of the author was displayed at the school, and a painting by Daniel Thomas White depicting the scene in the Chapel at the Founder's Day service, where Pendennis recognised Thomas Newcome, was hung in the almshouse. Thackeray's centenary in 1911 was celebrated by an exhibition at the Charterhouse and a lecture by the Earl of Rosebery. This recognition was surely justified, for Thackeray's indulgent portrait had replaced Bacon's sceptical predictions as the touchstone against which the charity was judged. Anne Ritchie was aware of the importance of the depiction in *The Newcomes* in defeating the proposal to develop the site commercially, writing in 1898 that 'there was once some scheme to bring a street through the grounds of Charter-house. May the remembrance of Thomas Newcome long divert the cruel experiment.' Gerald Davies commented in 1911 that 'The public visit Charterhouse and grow tender-eyed indeed over the death of Thomas Newcome.' The journalist Charles Morley confirmed this impression by referring to Thackeray's description as 'one of the tenderest and most beautiful chapters in literature'. He then recounted his own visit to a Founder's Day service among the Brothers, who were 'all imposing in their venerable and senatorial costume'.[5]

Morley was the guest of a former soldier, who identified other Brothers as a naval captain, one who 'used to be at the British Museum' and another who was a former canon of Westminster. The Master called all of them 'gentlemen', although he said he was aware that some 'had probably never been used to the term'. Morley's friend among the Brothers invited him to his room and described the daily routine, as Thomas Newcome had done. Among the anecdotes with which he entertained his visitor was one concerning a Brother who, far from being poor, had a regular income and kept an establishment in the suburbs which he visited daily and where he spent his holidays. His circumstances had not been discovered until after his death. And, although the Brothers should have been bachelors or widowers, Morley was told that 'we have had women come here who claimed some of them!' Such tales would have been familiar to earlier generations of Brothers, as would a clash with the Manciple, although the latest struggle had been not about the standard of the food, which the Master claimed that he had improved, but the quality of the Brothers' gowns.

Morley painted a kindly picture of life at the Charterhouse, but was also a critical reporter of the monotony and solitariness of the Brothers' existence. He perhaps felt some shame at their dependence on charity, at the difficulty of making a new home late in life, among strangers and in new surroundings, subjected to a certain level of discipline, and being checked off as they arrived at the Chapel for services. He sensed that although they were aware of the picturesque antiquity of the buildings, they came to regard them 'with something akin to dislike'. When discussing the meals, he was told that some Brothers had 'no sense of dignity or self-respect, and titter like schoolboys. Even the grand old Hall does not affect them, nor any pretty old English custom' such as the reading of grace. Yet, on the other hand, his host attempted to reassure him with the comment that, 'we are free of earthly cares, praised be the Lord and Thomas Sutton'. But the threat of redevelopment had not gone away, despite Anne Ritchie's confidence, and Morley was sure that the Charterhouse could not remain there much longer because it occupied such a valuable site.

Yet it did survive, as did Thackeray's literary legacy, with the charity attracting attention chiefly because of the fictional character that he had created. A generation later the author Teignmouth Shore wrote that visitors went there 'mainly to see the old Hall in which Colonel Newcome dined and the old chapel in which he worshipped'. A correspondent from the *Evening News* attended a service in the Chapel in 1933 and, as in *The Newcomes*, he recognised an acquaintance among the Brothers, and spoke to him afterwards. He described the Brother not as being like Thomas Newcome, patient, uncomplaining, yet rather sad at his humiliation, but positive and grateful, not least for the diet: '... they feed us like fighting cocks! I never tasted such beef, such mutton. Everything of the best, my boy – and lashings of beer of a special brew.'

The mood in the 1930s was not that of the 1850s, and the reporter evidently did not have a brief to expose the charity's shortcomings. The compulsory wearing of gowns by the Brothers had been criticised in the nineteenth century, because it marked them out as being poor and dependant on charity. That objection was removed in 1917 when the Brothers were required to wear them only within the hospital, and they were now thought to be striking garments, 'long, black Jacobean capes with the deep collars' that were more to be admired than ashamed of. Indeed, the account of the visit reflected the way in which the charity was now perceived and presented, as a venerable and rather mellow institution, regarded in an affectionate way as characteristically English, with a secure reputation as 'this great charity'.[6]

In 1951 *The Times* described it as 'the ancient charitable foundation familiar to the English-speaking world from Thackeray's account of it in *The Newcomes*'.[7] When James A. Waley Cohen considered an institution in which to deposit his collection of works by and about Thackeray, including first editions and some original drawings, he decided that the London Charterhouse was the

most appropriate place. Waley Cohen was an informed collector who met and corresponded with Thackeray scholars, and assembled his collection over a period of more than forty years. It was deposited in 1962.

Such perceptions of the almshouse came partly from the impression created by the pensioners themselves. The selection process was aimed at achieving an atmosphere of gentility. Those who were to be admitted had to be genuine cases, capable of living in the community and able to mix with the existing Brothers. Testimonials were needed and other requirements were observed, such as membership of the Church of England. When a group of Brothers complained to a governor in 1875 concerning the social background of their fellows, in terms that would have been familiar thirty years earlier, the governors' response was to say that they were satisfied that the admission criteria which they applied met the requirements of the Charity Commission Scheme of 1872. This specified 'poor, aged, maimed, needy or impotent people' who had 'become reduced by misfortune or accident without their own wilful default', and the order excluding those who had been menial servants within the previous five years was still in force.[8] Despite the protests of the few complainants, and the problems with one Brother who, despite good testimonials, proved to be an inebriate and was expelled shortly after admission, the governors were confident that the Brotherhood was 'a most respectable body of men of the description which the Charity intends'.[9]

With the other changes during the late nineteenth century, the governors had lost their right of nomination, putting an end to the long-standing imputation that they had used their entitlement to provide for their own former employees and dependants. The Master was now responsible for sifting the applications and choosing suitable candidates. The Masters during the 1920s and early 1930s, Gerald Davies and his successor from 1927, William Baring Hayter, had an image of the kind of man they wanted. Ideally they were looking for one with the characteristics of the applicant in 1931, who was 'gentlemanly in speech and bearing'. A prospective Brother seen in 1927 was described as, 'beyond all question, a gentleman and an excellent candidate' and in the following year someone was interviewed who was, 'palpably a gentleman – and one whose influence would probably be good in every way.' On the other hand, a man who applied in the same year was of 'no social standing', and so was deemed unsuitable. Almost one-quarter of those whose applications were processed between 1920 and 1932 were rejected for social reasons.[10]

In some cases the judgement was harsh – 'socially very common' or 'not the class of man we want' – but in others favourable, apart from falling short of the social requirement. A candidate in 1922 failed to impress in that respect: 'won't do socially. I told him so. A very decent fellow otherwise I feel sure'. A few years later another was described as 'socially, below standard, but very decent and respectable'. Pronunciation and education counted for a great deal in these

subjective social examinations, summed up in the case of a man who was 'Not our sort. H's awful. No education', another summarised as being 'of very inferior social standing. H's uncertain (Described himself as a "Widderer")', and a third, condemned as 'hopelessly illiterate'. Others were thought to be borderline cases because of their standing. Some doubts evidently existed whether clergymen should be admitted, perhaps because places were provided for them elsewhere, hence the judgement: 'A gentleman ... Very suitable for admission, if clergy are considered suitable.'

The Masters between the two world wars were putting into practice the preferences of the Jacobean governors and, perhaps unwittingly, meeting one of the criticisms of the *Household Words* articles. But Thomas Sutton's intentions had not been forgotten. In 1932 a man who was being considered was judged to be 'a good candidate. The sort of case that our Founder seems to have had in view. Has no prospect but the workhouse.'

Among the 130 men admitted as Brothers between 1920 and 1940 were the artist Walter Greaves and the poet Charles Dalmon. Artists were well represented, with eleven admitted, as were authors and journalists (twelve), teachers and tutors (seventeen) and musicians (eight). Other categories consisted of farmers, planters and a land agent (twelve) and those from a broad group of administrative positions (twelve), while seven had served in the armed forces, seven more had made their living as commercial travellers and agents, and just five had been clergymen. The remainder included architects, stock brokers, accountants, merchants, a police officer, two civil engineers, the captain of a pearling fleet who had also been a missionary, a translator, and a man who had been engaged in historical research. None was a manual worker.

There seems to have been an attempt to ease the early stages of the new Brothers' lives in the Charterhouse by admitting men from similar occupations within a short space of time, so that those entering close together had something in common. Only two of the men who entered during that period of twenty years were expelled, suggesting that the admissions policy was effective in selecting those who were adaptable to life in the almshouse, and in limiting as far as possible the potential tensions within the community.

All were over sixty years old on admission, the minimum age specified in the governing Scheme of 1872, although almost a half were under seventy and just ten were in their eighties. Half died or left within nine years of entering the hospital, and only seven remained as Brothers after more than twenty years. The average age at death was seventy-eight, five years higher than the figures presented by Smythe in the early nineteenth century, and the proportion of those living to eighty or more had more than doubled since then, to forty-four per cent, with eight men living into their nineties. On the other hand, the figures for length of residence show little change from those provided by Smythe, when the lowest age for admission had been fifty.

From the late nineteenth century there was an increasing interest in the Charterhouse's past, and a growing awareness of its historical importance. Writers on London began to draw attention to it as a neglected architectural gem. The point had been made in the 1840s, with the observation that few Londoners knew anything about it other than its name, partly because it lay behind a 'high overhanging wall … always threatening to tumble, but never falling … Of its interior, or the noble objects to which it is devoted, or its history, so full of interest, little or nothing is generally known'.[11] The removal of the school did not detract from its appeal. Indeed, it probably concentrated attention on the historic core buildings, and added to its air of seclusion, so that Sir Walter Besant could describe the almshouse as 'the most beautiful and venerable monument of old London'. It qualified for inclusion in *Unnoticed London*, whose author described it in similarly glowing terms as, 'one of the most lovely and gracious things in all London', and added that 'One does not like to think of the number of people who leave London without ever having seen the Charterhouse.'[12]

Its inaccessibility to visitors arose partly from the practical difficulties of maintaining a quiet home for the elderly, while permitting access to those who wished to admire the buildings and glimpse the almsmen who lived within them; the admission of even modest numbers of admiring tourists would threaten to destroy the atmosphere which they came to savour. Despite these concerns, the charity succumbed to the growing vogue of allowing visitors into historical properties, and opened the buildings to the public on three afternoons each week, also producing a set of postcards.

As well as a growing appreciation of the picturesque qualities of the buildings, the late nineteenth and early twentieth centuries also saw an increasing awareness within the charity of its own identity. With this came the publication of memoirs of life at Charterhouse School, the celebration of anniversaries of former pupils such as Thackeray and Wesley, and the erection of memorials to those who had pursued military careers in the empire: Sir Henry Havelock and Sir Richmond Shakespear.[13] William Douglas Parish, a clergyman who had attended the school between 1848 and 1853, began the compilation of lists of Scholars. His work was extended and amplified and three volumes of Charterhouse alumni were published in 1911 and 1913, at a time when other schools and the universities were producing similar lists, and other volumes followed in 1932, 1974 and 1980. In 1936 a book was published containing brief biographies of twenty-six 'Celebrated Carthusians', but all of them were former schoolboys, not Brothers, for whom no lists were compiled after Seddon's register came to an end in the 1650s.[14]

Interest in the foundation and its alumni also came from outside the charity. By the late nineteenth century the significance of Roger Williams' achievement in Rhode Island, establishing freedom of worship, the separation of Church and state, and democratic government, with its importance in the evolution of the

United States, was widely recognised. The great historian of the Civil War and Interregnum, Samuel Rawson Gardiner, paid tribute to Williams as 'a pleader for liberty of conscience' and considered that 'if he was the most combative of reasoners, [he] was also one of the gentlest of men'. This was a period when the leading seventeenth-century Puritans were commemorated in London by statues and busts: Cromwell outside the Houses of Parliament (1899), Bunyan on Baptist Church House in Holborn (1903) and Milton outside St Giles, Cripplegate (1904), and within that church a set of busts of Cromwell, Milton, Bunyan and Defoe (c.1900). In 1899 a plaque commemorating Williams' time as a Scholar at Charterhouse was placed in Chapel Cloister by Oscar S. Straus, who had published a biography of him in 1894. Straus stressed that Williams was 'the pioneer of Religious Liberty' and for that ranked him with Luther and Cromwell as the significant figures in the transition from the medieval world to that of the modern United States. Straus had especial reason to recognise the value of Williams' insistence on the freedom of worship, as a member of a Jewish family from Bavaria that had migrated in the early 1850s to the United States and been accepted there. Other members of his family became successful merchants, while he pursued a legal and political career. He was Minister to Turkey in 1887-89 and 1898-99 and Ambassador there in 1909-10 and was Secretary of Commerce and Labour under Theodore Roosevelt in 1906-9; the first Jew to hold office in an American cabinet. Williams had argued for the readmission of the Jews to England during his stay in London in the early 1650s and Jews from New Amsterdam settled in Rhode Island in 1655-7.[15]

Of course, the founder himself was also commemorated: daily in the grace recited at the meal in the hall, and annually at the Founder's Day dinner on the anniversary of his death, a practice initiated in 1627. But because his date of birth is unknown, no celebration could be held to mark its four hundredth anniversary. According to the inscription on his tomb, he was born at Knaith in Lincolnshire. As he was seventy-nine years old at the time of his death in 1611, he was probably born in 1532. Attention came to be focused rather on the almshouse's antecedents in the Carthusian monastery, exemplified by the service held in 1935 to mark the anniversary of the martyrdom of the monks four hundred years earlier.

At the Reformation, the members of most monastic orders complied with the requirement to acknowledge Henry VIII as the head of the English Church. Only the Carthusians provided significant resistance, especially those in the House of the Salutation in London. In 1534 they subscribed to the first Act of Succession. Nevertheless, their misgivings were such that the Prior, John Houghton, and the Procurator, Hugh Middlemore, were briefly incarcerated in the Tower of London before they were persuaded to swear, and it required three visits to the Charterhouse by the King's commissioners to obtain the oath from all of the monks. But many members of the community who had taken that step felt unable to acknowledge the King as head of the English Church, expressed

in the Act of Supremacy of 1535, and satisfy the commissioners appointed for that purpose.

Houghton was the first to be imprisoned and tried. Convicted of treason, he was executed on 4 May 1535, together with the priors of Beauvale and Axholme. His body was dismembered and one of his arms fixed above the gateway to the London Charterhouse. During that summer three other senior members of the house were imprisoned and executed. In 1536 fourteen monks and lay brothers were removed to other Carthusian houses and the Bridgettine abbey at Syon – two of them were subsequently executed – and in the following year ten more were imprisoned in Newgate, where nine of them died; the tenth was executed in 1540. In all, ten monks and six lay brothers lost their lives.

Those events were chronicled by Maurice Chauncy. Born in 1509, he became a monk *c.* 1531-2. He was exiled from London to the priory at Beauvale in May 1536 because of his refusal to subscribe to the Oath of Supremacy (although he did subsequently subscribe), going into exile in 1546. He returned during Mary's reign to serve as Prior of the Charterhouse at Sheen, and went abroad again in 1559 after the suppression of the house. Between 1546 and 1570 he wrote four accounts describing the events at the London Charterhouse in the mid-1530s. Both Protestant and Roman Catholic historians have commented on his lack of critical ability, superstition and love of the marvellous, while accepting his sincerity and general trustworthiness.

The four hundredth anniversary of the martyrdom prompted an edition of the narrative which Chauncy wrote in 1570. Published in 1935 as *The Passion and Martyrdom of the Holy English Carthusian Martyrs*, it was prepared by Fr. Geoffrey Curtis, an Old Carthusian who had worked with the Charterhouse Mission in Southwark (opened by Old Carthusians in 1885), before joining the Anglican Community of the Resurrection at Mirfield in Yorkshire. The Latin text is accompanied by an English translation prepared by A.F. Fenwick, another Old Carthusian, who had returned to the school as Assistant Master and in 1910 had become a house master. The foreword is by Walter Frere, also a Charterhouse boy, who had been one of the first brethren of the Community of the Resurrection and was Superior at Mirfield from 1902, before serving as Bishop of Truro from 1923 until 1935.

Curtis was unhappy and, as he put it, some Old Carthusians had 'long felt ashamed', that there was no memorial at the Charterhouse to the martyrs. He pointed out that some Roman Catholic writers made 'striking and just comments' on the fact. Curtis set out to remedy this, with Frere's support and encouragement.[16] But there was the implicit difficulty of placing a memorial to Roman Catholic martyrs within an Anglican establishment.

William Hayter was in favour of the project, and the collection taken at the memorial service in 1935 was allocated for the purpose. Unfortunately, he died in August and not until October was Schomberg appointed Master, when

the governors noted that they made the appointment 'greatly regretting the necessity for departing from tradition in electing a non-Carthusian', although they unanimously agreed on the choice of Schomberg. The Head Master of Charterhouse, (Sir) Robert Birley, too, had only recently taken up his post, but, undeterred, Curtis again put forward his case for the memorial and gained their support, as well as that of the distinguished Old Carthusian and Classical scholar Dr Thomas Page, who had been a Master at Charterhouse School for thirty-seven years. The governors did not attempt to resist such a distinguished group, and when Schomberg presented the proposal to them, they agreed.[17]

A short Latin inscription was drafted by Curtis and Frere and modified by Page, leaving the form and location of the monument to be decided. The Chapel was the obvious place. Chauncy describes Prior Houghton delivering a sermon and then going from monk to monk, kneeling at the feet of each in turn and asking forgiveness for any wrongs he may have done them. He then repeated this in 'the other choir', which presumably meant that of the lay brothers. On the assumption that the south aisle of the Chapel was the choir of the priory church, the ante-chapel had been the lay brothers' choir. Houghton had completed his process of reconciliation here, and so it seemed the appropriate place for the commemorative tablet, which was to note that it was from this place that the Carthusians went to their deaths.

Lawrence Turner was given the task of designing the memorial, but the momentum had been lost, despite Curtis's assiduous fund-raising. The deaths of Page in 1936 and Frere in 1938, the governors nervous 'desire to avoid anything likely to arouse controversy' and the charity's acute financial problems may all have been factors in the decision to postpone the scheme for the time being.[18] This was just as well, because it would have been erected in the wrong place, based upon existing interpretations of the layout of the priory buildings.

Interest in the priory's physical remains had been strong since the mid-nineteenth century. Archdeacon Hale had, characteristically, turned his attention to its fabric and layout, and he addressed a meeting of the London and Middlesex Archaeological Society on the subject at the Charterhouse in 1867. When he published his lecture, he apologised that it was not as full an account as he would have wished, blaming this on his 'want of leisure'.[19]

Others followed Hale's pioneering work, and by the 1880s there was a developing interest in the history of the priory. From the typical form of a Carthusian house and an examination of the buildings, with documentary material, an interpretation of the site emerged. Important evidence was provided by a plan-view of the priory, which formed part of a depiction of the water-supply provided in the early 1430s.[20] It could have been the need to keep a record, to assist future repairs, that prompted the preparation of the plan, some time between 1431 and 1457, which shows the line of the pipes from their source to the Charterhouse, and the distribution of water around the buildings.[21] The plan

was available to scholars after it was first shown to the Society of Antiquaries in 1746, and donated to the Charterhouse shortly afterwards.[22]

The priory church had been built in 1349 as a chapel for the adjoining Black Death burial ground, and adapted as the priory's church on its foundation by Sir Walter de Mauny in 1371. The plan shows that the chapter-house stood to the north-east of the church and so, based on the nineteenth-century interpretation, east of the present Chapel's north aisle. This placed it further east than shown on the map, a discrepancy explained by the conclusion that, in this area at least, the medieval cartographer had made 'a mistake'.[23] Moreover, allowing for the width of the chapter-house, it indicated an alignment for the cloister walk that compelled the historians of the priory to conclude that he had also made an error in the disposition of the buildings in the south-west of the great cloister, in placing Cell A, the prior's cell, south of the frater, when, according to their assessment, it should have been on its north side. The present old library was correctly identified as standing on the site of the frater, but the Great Hall was mistakenly equated with the guests' dining hall, erected during the early sixteenth century, and Master's Court was interpreted as an enlargement of the little cloister, carried out during the same period.[24]

While some authorities varied in the detailed interpretation, all accepted the basic layout and therefore mistrusted the water supply plan. They included Sir William St John Hope, whose collection of evidence from a range of documentary sources was incorporated in a book on the priory published six years after his death in 1919. He accepted that the plan was wrong in its arrangement of the buildings at the south end of the great cloister, and was later remembered as having 'scoffed' at it on his visits to the Charterhouse.[25] Little further work was done after the First World War, and interest in the priory's history came to be focused on the Carthusian martyrs, but a revision of the existing ideas was soon required, as a result of the catastrophic impact of the Second World War.

The early stages of the war were not especially disruptive, although a Brother was arrested because of his political activities and was expelled from the house. The Master decided against evacuating the Brothers on the grounds that they would be less well looked-after in the country, where staff and supplies would be harder to come by, and where there was no greater defence against high explosive bombs than in London. Moreover, moving would be costly. He also felt that, left empty, the buildings themselves would be at greater risk from fire bombs than if the staff and Brothers were on hand to help with fire watching.[26]

The main impact was upon the charity's income. The removal of the meat market from Smithfield, shortages of petrol and the decision of motorists not to renew their licences caused such a sharp fall in the numbers of cars parked in Charterhouse Square that the fees ceased to make any contribution to the revenue. More serious were the effects of the air raids in 1940, which destroyed property on the charity's Clerkenwell estate, causing loss of rental income and

cancellation of leases. In November 1940 a drastic scheme to reduce expenditure was drawn up by the Master. This involved some loss of benefits to the Brothers, principally the reduction in their pensions from £60 to £50 per annum, but most savings were to be achieved by terminating the contracts of a number of staff and reducing pensions. The Preacher, the Organist and more than ten staff were made redundant. As the Master was ordained, he could carry out the Preacher's duties, and without the Organist, Harry Stubbs, the choir was no longer needed and so was disbanded. The savings were anticipated to be £3,109 in the financial year 1941-2, but events intervened and changed the problem entirely.[27]

During heavy raids on the night of 10-11 May 1941 the Charterhouse was hit by a firebomb, which set light to the roof of the range next to the Chapel. The alarm was quickly given and the fire might have been brought under control had not the water supply failed completely. But, driven by a north-easterly wind, it spread unchecked, engulfing Master's Court and much of Wash-house Court. When the supply was restored the following morning, the flames were extinguished within an hour.[28]

By then much of the historic core of the buildings had been burnt out. Only the chapel, the north-western section of Wash-house Court and the west end of the Great Chamber and Great Hall escaped. There were no casualties, and because of the long interval between the first alarm and the fire running out of control many movable objects were rescued in advance of the flames.[29]

With the service areas put out of action by the fire, even those parts of the buildings which had been untouched, such as Preacher's and Pensioners' Courts, were no longer usable. It was decided to evacuate the buildings. Some of the Brothers went into lodgings; the remainder were moved to Godalming, initially to the Old Sanatorium at the school. When that was required soon afterwards because of an outbreak of chickenpox, they transferred to a building acquired for the purpose. This was 'Highfield', a nursing home that had been forced into closure because of a shortage of nurses, where fifteen of the Brothers could be accommodated. A second house in Godalming, 'Garth View', was bought in 1944.[30]

The fire therefore reunited the two branches of the charity, and must have revealed the contrast between them. Since the move to Godalming fewer Brothers had been housed in increasingly dowdy buildings, while the school had expanded and developed. From ten masters in 1872 the number of staff had grown more than fourfold by the 1930s, and there was no problem attracting the stipulated number of 500 boys, now grouped into eleven houses. The site was enlarged in 1888, 1897 and 1924, and buildings were steadily added, including laboratory blocks in 1882 and 1931, a swimming baths in 1883 and Brooke Hall in 1916. The practice of conducting all teaching in Big School had been brought from old Charterhouse, but was quickly superseded by instruction in separate classrooms, of which there were twenty-six by 1899, and a new block of classrooms, with

provision for the sixth form, was added in 1930. There had also been changes in the careers followed by the boys. By the early twentieth century only six out of almost 300 went into the Church, a major change since Philip Fisher's time as Master a century earlier, but almost one fifth joined the army. The South Africa cloister was built to commemorate the 500 or so old boys who fought in the Second Boer War (1899-1902) and a new chapel, designed by Sir Giles Gilbert Scott, was begun in 1922 and consecrated in 1927 as a memorial to the 687 Old Carthusians killed during the First World War, between 1914 and 1918.[31] The school also commemorated the tercentenary of Thomas Sutton's death; a statue was erected in Founder's Court and the *Charterhouse Masque* was composed by E.D. Rendall, the director of music, which dramatised aspects of the charity's history.

Such an extensive site out of London made the possibility of moving the almshouse there an attractive option, given the scale of the destruction. The damage to the buildings did, after all, provide an opportunity to carry out the intentions of the Victorian governors, either by converting the Brothers' benefits to out-pensions, or by building a new almshouse at Godalming, or perhaps in a town on the south coast. The Clerkenwell site would have been sold. The Governors were tempted by the appeal of a modern building erected in a more 'salubrious' neighbourhood. This presented a considerable dilemma. The site was undoubtedly valuable and its sale might cover the cost of new buildings within the school's grounds at Godalming, and possibly a new site and buildings if it were established elsewhere, but the property market was distorted by wartime conditions. Moreover, rebuilding those parts of the buildings that had been gutted would qualify for reimbursement by the War Damage Commission, which of course would not be the case if the charity relinquished them. Not until November 1944 did the governors finally resolve to restore the Charterhouse buildings, a decision that produced a complete restoration of the historic buildings, and a series of discoveries that revealed much of the earlier fabric and the plan of the priory.[32]

A PLACE OF LEAFY SECLUSION

The governors' delay in deciding whether the buildings should be reinstated did not hinder the process, for no work was possible during the war. The charity's finances were adversely affected, approval was required from the War Damage Commission, and the licensing system controlling building materials gave low priority to an almshouse. For several years little work could be carried out other than that which qualified as remedial and urgent. Moreover, it had to be decided exactly what should be done; although apparently a disaster, the fire provided an opportunity to modernise buildings that were old, shabby and in some ways unsuitable, while retaining their character.

Among the governors was Sir Charles Peers, an expert in the treatment of historic buildings and an important figure in the development of historical conservation. He submitted a report advising that the Jacobean and Stuart buildings be reinstated and recommended the partnership of the Hon. John Seely (from 1947 Lord Mottistone) and Paul Paget as architects to carry out the restoration. Seely and Paget had been contemporaries at Trinity College, Cambridge, and had gone into partnership in 1926. At this stage their reputation rested chiefly on the restoration of Eltham Palace and the construction of the adjoining house for Stephen and Virginia Courtauld, carried out between 1933 and 1936. They already had a connection with the charity through their remodelling in 1939 of the old Chapel at Charterhouse School as a music school. Seeley and Paget's treatment of the Charterhouse buildings did much to establish them as the foremost restoration architects of the post-war period.[1]

Peers' proposals were not restricted to the restoration of the historic buildings. A radical suggestion for modernising the Brothers' accommodation involved demolishing all the buildings in Preacher's and Pensioners' Courts, although they were undamaged, to make space for a new building – architecturally 'in keeping' with the Tudor ones – where the Brothers' rooms would be 'more compact and easier to run'. That the governors willingly accepted such a plan is indicative of how little they regarded the Charterhouse's early nineteenth-century building heritage. The Master's uncomplimentary opinion of the west side of Preacher's Court as 'by far the most inconvenient and also the ugliest' of the Brothers' quarters was doubtless a generally shared and uncontroversial view at that time.[2]

Seely and Paget's initial plans followed Peers' proposals and were approved in 1945, but a considerable delay followed before the restoration could begin. The war had brought considerable changes to the hospital's financial position. Rental income from the Clerkenwell estate did fall sharply as some properties were destroyed, but revenue for 1945-6 was ninety-six per cent of the average for 1927-46.[3] Over the same period expenses had fallen because of the lower costs of providing for the Brothers in the country and the reduction in their number, from sixty-three in the late 1930s to forty in 1942 and twenty-five in 1946. Thus, expenditure in 1945-6 was only forty-six per cent of pre-war outgoings. It continued to decrease after the war, while rental income rose as properties were rebuilt, producing a balance which stood at £9,212 for the financial year 1943-4 and £13,234 for 1947-8.[4]

By 1948 the accumulated surplus had reached £62,700, but was still well below the cost of restoration, initially estimated at £129,600, with a further £90,000 required for the new building. Even with payments from the War Damage Commission, it seemed that the charity would have to postpone the new building for some ten to fifteen years. On the other hand, the Charity Commission was insisting that the Brothers' accommodation should be reinstated as soon as possible.[5]

The governors' plans could not be implemented in isolation, and the licensing system for key materials, which was operated by the Ministry of Works and not abolished until 1954, imposed a major constraint on their timetable. Britain's involvement in the Korean War from 1950 to 1953 created further difficulties with the supply of materials required by the armaments industry. The situation was not helped by the relatively low priority given to an almshouse, compared with industrial buildings and other housing. Even after the work had begun, in 1949, licences were issued for only relatively small sections of work at a time because of shortages of finance and materials, imposing a piecemeal approach to the restoration.[6]

The availability of materials varied. Steel was often in short supply and when it was available other materials were not. In the spring of 1951 lead was obtainable, although 'terribly expensive', but not copper, yet in 1949 copper had been available and was then much cheaper than lead.[7] Although Seely and Paget were prepared to revise their designs to meet the realities of the situation, they could only go so far in that direction. The Charterhouse was not a site where 'the questionable economies of prefabrication and temporary construction' could be employed.[8] Paget later recalled that the industry had been, 'ham-strung with acute shortage of material on the one hand and the extreme restrictions imposed by the Building Licensing system on the other'.[9]

For their part, the War Damage Commission staff found the Charterhouse a difficult site to deal with, partly because the rebuilding was not a complete reinstatement. It would have been foolish to reinstate the buildings as they had been

before the fire, for they had not provided the modern accommodation required. This was accepted, but a process had to be established which took the changes into account, with replacement and 'improvement' elements distinguished and debatable costs negotiated. Thus, features such as chimney-pieces which were not replaced had nevertheless to be costed as if they were to be restored, so that the notional figures could be taken into account when determining the reinstatement costs.[10]

The delays caused by the post-war restrictions at a time of rising prices inevitably added to the steadily increasing expenditure. Indeed, one of the features of the planning during the late 1940s was that while the War Damage Commission pressed for savings, these could easily be absorbed by rising prices, and the longer the delay, the more costs rose. Between 1944 and 1950 the overall estimated costs rose by seventy-three per cent. During the period when the bulk of the rebuilding took place, from April 1949 to December 1956, costs rose by an estimated forty-six per cent.[11] Rising prices were one reason why the War Damage Commission was reluctant to commit itself to a figure for compensation until after the accounts were finalised.[12]

The most prominent casualty of rising costs and the insistence on the early provision of the Brothers' accommodation was Seely and Paget's proposed building to replace those in Preacher's and Pensioners' Courts. This was abandoned, although not before some of the Preacher's Court buildings had been demolished to obtain softwood. The other buildings there and in Pensioners' Court were reprieved. Yet the Governors were unwilling to house the Brothers in them, preferring to place all the residential and catering rooms within the 'compact' block formed by the Tudor and Jacobean buildings, so that they could all reach the communal rooms under cover.

Fewer Brothers were to be cared for than before the war because of the level of the charity's income available for their maintenance. But the number was uncertain because the financial situation after the restoration could not be predicted accurately, which added to the architects' difficulties. In 1950 the projected figure was still sixty, but within three years it had fallen to forty-four and the target was later reduced again, to forty Brothers.[13]

To create space for the Brothers within Master's Court, the Medical Officer's House, No.17 Charterhouse Square, was adapted as the Master's Lodge. All of the ranges around Master's Court could then be rebuilt to provide accommodation for the Brothers.[14] Schomberg had argued in favour of retaining the lodge, although in truth it had been, if anything, too large. He had employed five maids and one man, to carry coal and clean its 'state rooms'.[15] When the appointment of a new Master was being considered in 1907, it was pointed out that it was a disincentive to potential candidates, as it was so big that a family man would hardly be able to maintain it unless he had 'private means'.[16]

While the plans were evolving and before the main restoration programme was begun, some remedial work was carried out to the ruins. This included the removal

of the floor in the Great Hall, in 1946, which began a train of discoveries that led to the reinterpretation of the layout of the monastic buildings.[17] Excavations there uncovered one of the medieval drains, the south-west corner of the great cloister, and the remains of a monastic cell, which the fifteenth-century plan indicated was Cell A. The generally accepted interpretation placed the corner of the cloister further north, but the new discoveries made this untenable and raised the possibility that the plan was indeed accurate. Further evidence was found when the floor of Brooke Hall was lifted, revealing floor tiles, ledger slabs over monastic burials, and the footings of walls which indicated that it lay on the line of the south cloister walk.

The newly discovered alignment of the cloister walk placed it immediately to the north of the arcade between the two aisles of the Chapel and, following the cartographic evidence, left no space on the north side of the priory church for the sacrist's cell, the vestibule to the chapter-house, or the chapter-house itself, if the south aisle was indeed part of the church. Perhaps that aisle had been the chapter-house? Support for this hypothesis came from the realisation that it contained no features that would suggest a mid-fourteenth-century date. The Royal Commission on Historical Monument's investigators in 1915 had concluded that the fabric contained no feature that dated from 1349, although they did attribute the blocked doorway on the south side to the fourteenth century. In fact, the windows date from the early sixteenth century, but more convincing evidence was the fact that the tower's south wall does not have the foundations required if it had been part of the original external wall of the church. Furthermore, a window newly uncovered in the north wall of the treasury on the first floor, dated stylistically to the early fifteenth-century, appeared to be a window shown at the west end of the chapter-house on the medieval plan. But the most important clue was provided by the discovery that the circular hole in the tower's south wall, hitherto neither investigated nor explained, was a squint from the treasury above the ante-chapel. This could have served no purpose if it were part of the church's tower, although presumably it had looked down on the high altar, allowing the sacrist to participate in the mass without leaving the treasury.[18]

The possibility that the church had stood to the south of the tower and Chapel Cloister could be verified if Sir Walter de Mauny's tomb were found. According to a fifteenth-century chronicler of the priory's history, this was at the foot of the steps to the high altar, the position of which could be postulated from the alignment of the squint. Sure enough, an excavation uncovered a grave in the anticipated spot, with a lead coffin that contained a skeleton and a lead *bulla* of Pope Clement VI, assumed to have been attached to an indulgence granted by him to de Mauny in 1351, permitting him to select a confessor for a deathbed absolution. The *bulla* confirmed that this was de Mauny's grave and, therefore, that the church did indeed lie within Chapel Court.

These investigations had taken the architects eighteen months and, as there was still no likelihood of restoration work beginning in the near future, it was decided that the whole of the exposed area within the ruins should be excavated. This was an exceptional opportunity, and in 1947 the governors asked W.F. Grimes of the London Museum to carry out further excavations.[19] His findings established the plans of the monastic church and its chapels, the southern end of the great cloister and the whole of the little cloister. They also confirmed the topographical reliability of the water-supply plan.[20]

The walls exposed by the fire and restoration work revealed further evidence that contributed to the new interpretation. The removal of the plasterwork and brick skin from the fabric of the east range revealed a substantial section of the west wall of the Chapel of SS Michael and John the Baptist, built on the south side of the monastic church *c*. 1453. This had been incorporated into the face of the Tudor building of 1545-6, and is identifiable as an area of ashlar within the rubble work in Master's Court. The Chapel was endowed by Sir John Popham and contained his tomb. In the wall of the Great Hall a piece of stone carrying his arms was discovered, and is presumed to have come from his tomb. This confirms that the hall was built after the dissolution, and therefore could not have been the priory's guest hall. A part of de Mauny's tomb was also recovered from the ruins. The findings indicated that the priory church had been demolished by North, who re-used the materials in his new house. A passage in Maurice Chauncy's account contained a Latin phrase which had been taken to mean that North turned the church into his dining-room. This was now reconsidered and Paget suggested that it could equally be interpreted as meaning that he 'used the church to make a Dining Hall'.[21]

In the Norfolk Cloister, Seely and Paget uncovered a blocked doorway, largely intact beneath a brick covering, and identified it as the doorway of Cell B, not Cell A as previously thought.[22] Excavations in the south-west area of the great cloister uncovered evidence for four, possibly five, graves. The area was used by the monks as a burial ground. Guy de Burgh, who had joined the order at Beauvale in 1354 (and was one of the first monks at the London Charterhouse) was interred here. As was John Luscote, the first prior, who died in 1398 and requested to be buried at the feet of de Burgh.[23]

Work on the east side of the great cloister in 1949 uncovered cell doorways and the foundation trench of the inner wall of the cloister walk. On its north side, the cloister wall was revealed in two places, and the north-east corner of the cloister was also uncovered, before being destroyed.[24] The extent of the great cloister could now be established for the first time since it had been obscured by North's changes in the mid-1540s; it was 340ft from east to west and 300ft from north to south.

The results of the discoveries were recorded in three ways. Firstly, the lines of the principal walls were marked within the buildings by brass strips and externally by

narrow lines of stone chips set in concrete. Secondly, parts of the medieval fabric, such as the doorway and food hatches of the cells, were left exposed and the floor tiles and ledger slabs were re-set in new floors. Thirdly, Professor David Knowles was invited to write the history of the priory, with a contribution from Grimes describing the findings of the excavations. Knowles acknowledged the important role played by the architects in the discovery of the monastic plan, admitting that 'all the good ideas have come from Seely and Paget'.[25] The book was published in 1954.

In their perceptive analysis of the discoveries at the Charterhouse, Seely and Paget established the layout of one of the most important Carthusian sites in Britain. Previous interpretations had developed a momentum of their own and had gone unchallenged, perhaps partly because of the professional standing of those propounding them. The opportunity offered by the wartime damage was brilliantly exploited by Seely and Paget, following the logic of their initial findings until much of the layout had been revealed. Only after they had established the main lines of the priory's plan did professional historians and archaeologists become involved. Later work has amplified their discoveries, especially with excavations on the sites of the cells and cloister walk on the north side of the great cloister, and the west side of Preacher's Court.[26]

The findings showed that the ante-chapel was not the lay brothers' choir, and so this broke the connection between the Carthusian martyrs and the existing buildings. Knowles appreciated the alteration in atmosphere: 'It is not without regret that we now realize that henceforward we can no longer picture Prior Houghton standing at the altar in the existing chapel when he elevated the chalice at the Mass of the Holy Spirit.'[27] Undeterred, Fr Curtis revived the scheme for a memorial to the Carthusian martyrs, and in 1948 contacted Schomberg, who responded warmly, while pointing out that the proposed wording of the memorial would not now be appropriate. Although the governors were favourable, the restoration work prevented any further progress or the celebration of the foundation of the Chapel in 1349, which Schomberg had suggested.[28]

After Schomberg's death in 1952, his successor, Canon John McCleod Campbell, took up the cause. Under his supervision the prominent memorial, designed by Seely, was placed on the east wall of Chapel Court in 1957. Even though Campbell was aware that the community at Mirfield, which contributed to the cost, preferred Latin, the inscription is in English, with the names of the martyrs and, as Fr. Curtis had requested, words from the Benedicite.[29] His efforts bore further fruit when, in 2005, the Medical College of St Bartholomew's Hospital Trust commissioned from Kate Owen a commemorative stone for the former cloister garth of the priory's great cloister. It was dedicated during an ecumenical service held on the 470th anniversary of John Houghton's execution. The inscription outlines the history of the site and commemorates the martyrdom of Prior Houghton, the monks and lay brothers.

The erection of the memorial in 1957 came towards the end of the post-war restoration. The thirteen surviving Brothers had returned to Wash-house Court in April 1951, but work on the ranges around Master's Court was not completed until the middle of the decade. Only thirty-two Brothers were accommodated, with three further rooms set aside for infirmary cases.[30] In February 1958 the Queen and the Duke of Edinburgh visited the Charterhouse to officially re-open the buildings.

While the lower number of Brothers had allowed a financial surplus to be accumulated, this had been absorbed by those costs not reimbursed by the War Damage Commission. At the end of the financial year 1951-2 the investment account stood at £73,383 with an annual surplus of almost £20,000, but the capital was being drawn upon to pay for the work in progress.[31] By 1954 the hospital's share of the outstanding costs was calculated to be £63,138.[32] While this sum could be found, the consequent reduction in capital lowered the interest received to such an extent that outgoings would have to be met from current income, which limited the number of Brothers who could be maintained. This, in turn, made more extensive accommodation unnecessary, and permitted the conversion of Pensioners' and Preacher's Courts for commercial letting. When this was carried out, in 1956-7, the original crenellated parapets were removed from pensioners' Court, giving it a less collegiate appearance.[33]

The total cost of the reconstruction was approximately £465,000, of which roughly £240,000 was covered by the War Damage Commission.[34] Expenditure on such a scale would have been impossible, indeed inconceivable, before the war, or without the Commission's contribution. The work substantially changed the appearance of the hospital. Seely and Paget removed accretions of the eighteenth and nineteenth centuries, including a veritable forest of tall chimneys, to reveal the original fabric, and their approach was flexible enough to incorporate into the design features uncovered during the work. In some instances this was done as an improvement to the building, in others perhaps to help in the interpretation of the structure, or simply to give a sense of the presence of the priory and mansion in the later buildings, and the appearance of being 'antique'. The attempt to re-create the feeling of a Tudor building was taken further, some new internal timbers being left exposed and given uneven surfaces by adzing or scraping.[35]

They did not always opt for a faithful facsimile of what had been destroyed. In the case of the great staircase, although it had been completely destroyed, it had been well recorded in pre-war photographs, and Seely and Paget's stated intention was to produce 'something comparable in value, if less elaborate'.[36] In doing so, however, they changed the position of the staircase and did not attempt to reproduce the carved decoration of the original. They were inclined to follow their own inclinations and aesthetic judgements, as well as historical interpretations. The governors' preference for a Tudor appearance for the exterior

did not extend to Seely and Paget's own additions to the fabric, such as the new porch in Preacher's Court, the doorways on the south side of Master's Court and the range on the north side of Chapel Court. These, and the elevations for their proposed new buildings, were in a seventeenth-century style, perhaps intended to reflect Francis Carter's work at the almshouse, rather than that of the aristocratic mansion. The source which they most frequently used for guidance was Johannes Kip's perspective view, drawn between 1688 and 1694.

The reaction to the restoration was favourable. In 1959 an account by Arthur Oswald, of both the history of the buildings and their restoration, appeared in *Country Life*.[37] Charterhouse was 'a place of leafy seclusion and quiet', with its character enhanced by the post-war changes. Oswald described the wartime damage as 'a blessing' because of the 'most skilful and successful reconstruction' which had followed. Seely and Paget had not only preserved more than had at first seemed possible, but had revealed features previously hidden. They had also eliminated nineteenth-century 'alterations and distortions', including the 'well-meant, but not always well-judged restorations by Blore'. These, together with the polluted London atmosphere, had given the pre-war Charterhouse a dinginess that had now been removed.[38]

Other reports were equally respectful; the Ministry of Works' architect wrote that all the work he saw was 'of a high character, competently and sympathetically executed'. *The Times* quite rightly drew attention to the modern living conditions for the Brothers, which 'are fitted with all modern comforts, including central heating, and cooking in the kitchens by electricity'.[39]

By 1980 the setting had changed, especially with the building of the Barbican estate, so that Patrick O'Donovan could admire the buildings, contrasting with 'the high, shining vulgarities of London' such as the nearby 'casually agnostic tower blocks'. He found the architecture of the Charterhouse to be 'sensible' and admired the way in which the hospital had been 'richly, superbly restored' after the wartime damage. Ann Saunders was equally laudatory, describing the restoration as 'one of the most scholarly and felicitous achievements of its kind in post-war London', and praising the high standard of the workmanship.[40]

The stimulus which the architects gave to the study of the Charterhouse's history extended to the post-dissolution period. H.R. Trevor-Roper (Lord Dacre of Glantoun) published a biography of Thomas Sutton in the Charterhouse magazine, *The Carthusian*, and used evidence of Sutton's involvement in the coal trade in a study of capitalism in the north of England during the later sixteenth century.[41] An Old Carthusian, he maintained his interest in Sutton and wrote the article on his life in the *Oxford Dictionary of National Biography* (2004). The hospital's archive was also utilised for studies of Sutton's activities as a moneylender; the foundation of the almshouse and Sutton's business ventures; and a history of the school.[42] In 1991 an account of the buildings was published by Eric Harrison, the Master, incorporating the post-war interpretation and his own findings.[43]

The restored buildings provided a modern home for a community that was necessarily smaller than at any time in the past, and financial circumstances brought other changes. Because old-age pensions were now regarded as providing sufficient income, from 1956 the charity's pensions to the Brothers were phased out and in 1984 contributions by them to the charity were introduced.[44] The wearing of gowns, once regarded as an imposition, then as picturesque, was no longer required, nor was attendance at chapel compulsory.

In other ways the charity recovered steadily from the effects of the war, and the composition of the Brotherhood showed few changes, in terms of the occupations of those admitted. The admission requirements were modified; in 1962 the governors agreed that Nonconformists could be admitted as Brothers, provided that they were prepared to attend services in the Chapel, and over the years Roman Catholics, too, became Brothers.[45] In 1952 the post of Registrar was reinstated and, on the appointment of Oliver van Oss as Master, in 1973 the position of Preacher was restored, because the Master was not ordained. But not until 1998 was an organist appointed, and no choir was formed. The mixed portfolio of properties and financial investments produced an increasing income, especially from the 1970s, which allowed more Brothers to be provided for. New accommodation was provided in two buildings erected in Preacher's Court, designed by Michael Hopkins & Partners, designated the Admiral Ashmore Building and completed in 2000. These replaced the demolished buildings, and so finally completed the post-war restoration. The range between Preacher's and Pensioners' Courts was then converted into an infirmary for the Brothers.

Admiral of the Fleet Sir Edward Ashmore was a governor from 1976 until 2000 and served as chairman from 1981 to 1996. Although remaining as governors, the Archbishops of Canterbury no longer acted as chairman after 1962. From 1962 the Master was not one of the sixteen governors, who were now appointed to represent a range of professions, widening the former arrangements by which senior churchmen, politicians and lawyers had predominated. The only Prime Minister to serve as a governor during the twentieth century was Stanley Baldwin, between 1933 and 1946. But the tenure of the archiepiscopal governors, which was still regarded as a 'great tradition', had provided continuity, broken only by the interval between Laud's execution in 1645 and the Restoration in 1660. And from the Restoration, every Bishop of London served as governor of Sutton's charity, with the sole exception of Frederick Temple (bishop from 1885 until 1896), until the resignation of Henry Colville Montgomery Campbell in 1961.[46]

Following Davies's death in 1927, the post of Master was held by clergymen until 1973, when van Oss, who, like Haig Brown, had held the post of Head Master, was appointed. His successor, in 1984, was Eric Harrison, who had been Second Master, or deputy to the Head Master, a post equivalent to that of Usher, and he was its first holder to be appointed Master since Ramsden, in 1778.[47]

The next two Masters were from medical backgrounds: Professor James Malpas, Master from 1996 until 2001, and his successor, Dr James Thomson.

Thomas Sutton's choice of the Charterhouse as the home for his charity greatly influenced its character, not least because of the way that the initial governors had perceived their obligation and their successors had maintained the conventions. His notion of who should benefit from his munificence had been imprecise with respect to the qualifying requirements of the Brothers, and so was open to interpretation, which naturally changed through time. Sutton's intentions with regard to the background from which the Scholars should be drawn were clearer, but before the end of the seventeenth century were increasingly disregarded. Almost as frequently consulted as the foundation documents and Sutton's equivocal directions was Sir Francis Bacon's hostile opinion of James I on the proposed charity, which was cited and criticised by its historians and defenders for more than three-hundred years.

Growing pressure for change after the mid-nineteenth century led to the removal of the school, although the enforced absence of the Brothers between 1941 and 1951 was the only break in the charity's use of the site as an almshouse. Through changing times, successive generations of governors and officers have maintained the charity's fundamental purpose, endeavouring to establish order, harmony, administrative probity and financial soundness. And so the charity has endured as Thomas Sutton's legacy, the beneficiary of his fortune and the reason for his lasting celebrity.

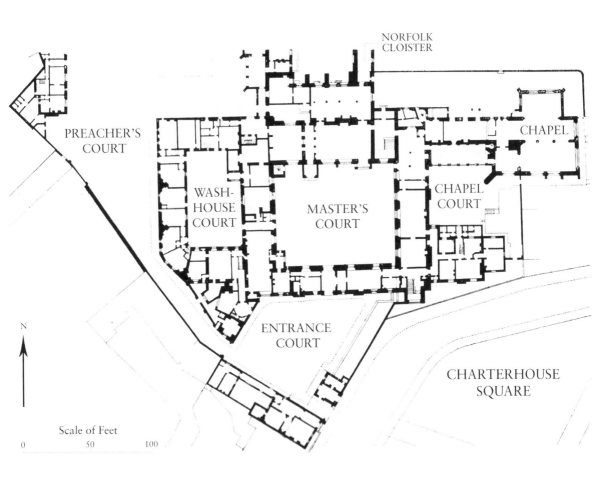

Charterhouse: the core buildings in 1910.

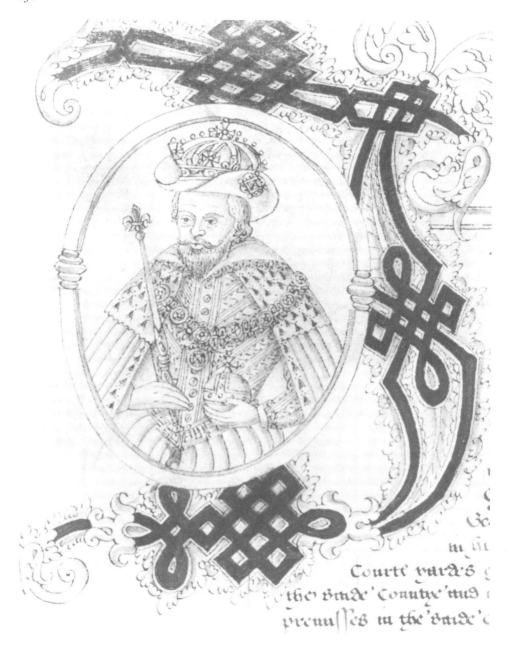

Courte yard's
the vnde' Countye' tue
premisses in the vnde'

34. Portrait of James I, at the head of the Chancery decree of 1613 ruling in favour of the governors of the charity in the case with Simon Baxter, Thomas Sutton's heir by law.

35. *Opposite:* Clerkenwell, from Richard Newcourt's plan of London, 1658. The Charterhouse buildings are incorrectly shown as standing around two rectangular courts, one north of the other.

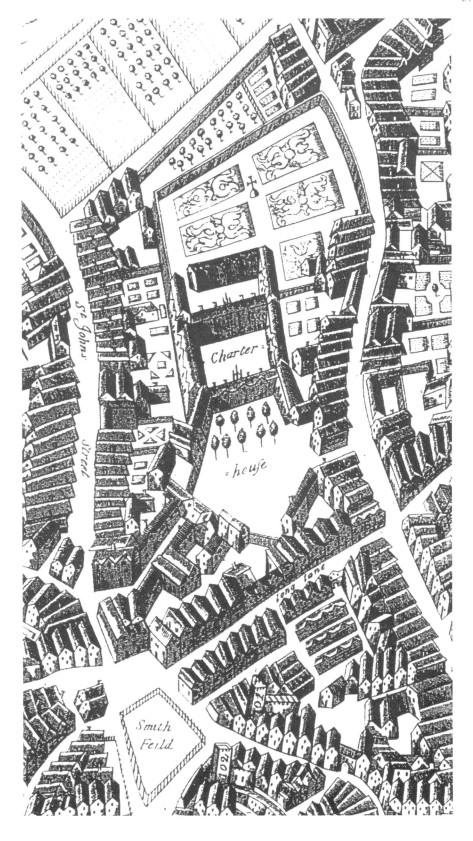

36. The gateway of the Carthusian priory from Entrance Court, by Charles Walter Radclyffe, 1844.

37. Entrance Court, with Master's Court through the archway. Undated etching.

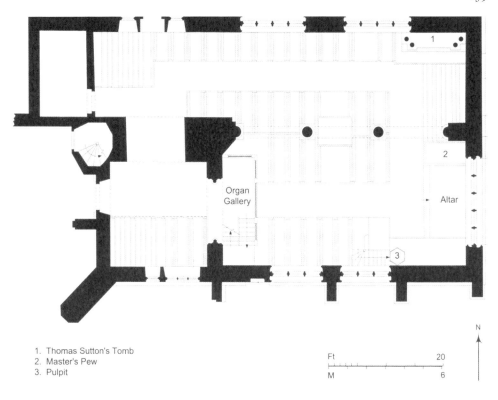

1. Thomas Sutton's Tomb
2. Master's Pew
3. Pulpit

38. Plan of Charterhouse chapel in 1805.

39. Preacher's Court, by Charles Walter Radclyffe, 1844.

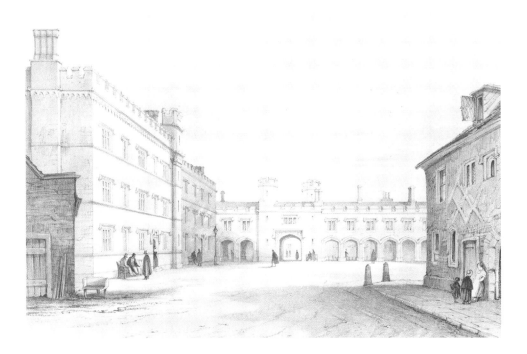

40. Preacher's Stairs, connecting the former Preacher's lodgings to the entrance hall off Master's Court.

41. The school building of 1803 viewed across Lower Green, by Charles Walter Radclyffe, 1844.

42. Bust of Thomas Sutton by J. Bromfield. Undated.

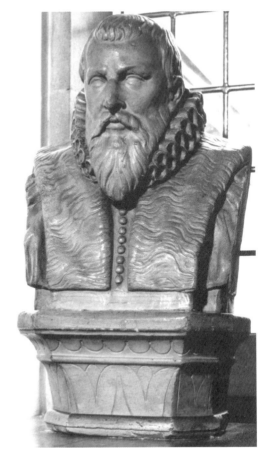

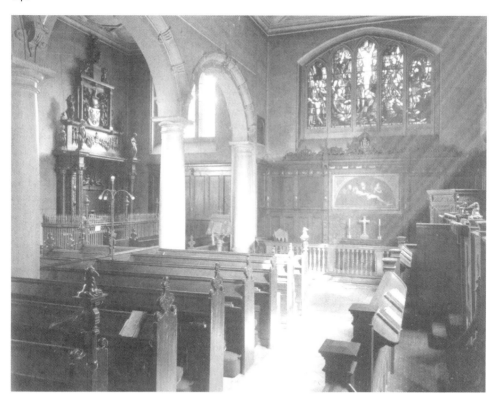

43.	Charterhouse chapel *c.* 1910. Thomas Sutton's tomb is in the north-east corner.

44.	The chapel choir in 1937. Harry Stubbs, the Organist, is second from the left.

45. The Brothers' Library, photographed before 1941. The chimneypiece is Jacobean.

46. A game of bowls in 1937, photographed by Margaret Stubbs.

47. The great staircase erected in the early seventeenth century and destroyed by the fire in 1941.

48. Post-war rebuilding: Master's Court and the Great hall *c.* 1955.

49. The Queen and the Duke of Edinburgh visited the newly restored buildings in 1958. The Queen signs a portrait photograph in the Brothers' sitting room, watched by the Master, Canon John McCleod Campbell (*d.*1961).

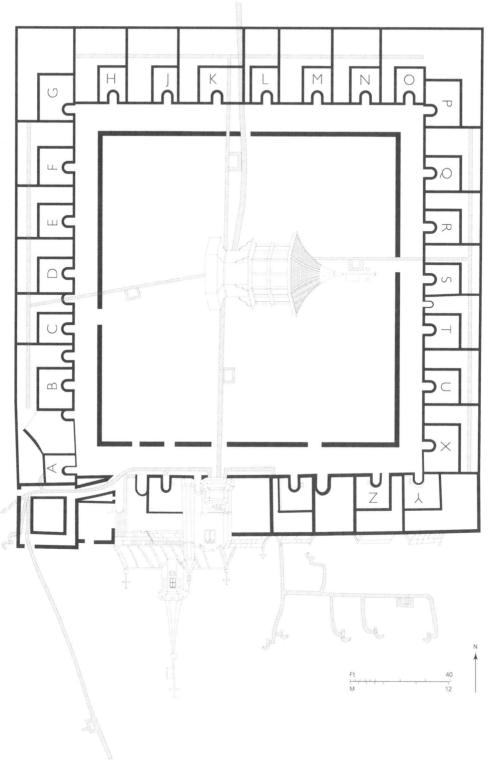

50. Mid-fifteenth century plan of the Carthusian priory and its water-supply. Redrawn by Malcolm Dickson and George Wilson.

NOTES

ABBREVIATIONS

BL – British Library
Bodl. – Bodleian Library
CJ – *Commons' Journals*
CM– Charterhouse Muniments, Sutton's Hospital
GL– Guildhall Library
HMC – Historical Manuscripts Commission
LJ – *Lords' Journals*
LMA – London Metropolitan Archives
LPL – Lambeth Palace Library
ODNB – *Oxford Dictionary of National Biography* (Oxford University Press, 2004)
PP – *Parliamentary Papers*
PRO – The National Archives, the Public Record Office
RIBA – Royal Institute of British Architects
RO – Record Office

CHAPTER 1: THIS MASTER-PIECE OF PROTESTANT CHARITY

1. Sandra Cavallo, 'The motivations of benefactors: an overview of approaches to the study of charity', in *Medicine and Charity before the Welfare State*, ed. Jonathan Barry and Colin Jones (London, Routledge, 1991), pp. 46-62.
2. *Medieval England. An Encyclopedia*, ed. Paul E. Szarmach, M. Teresa Tavormina and Joel T. Rosenthal (New York & London, Garland, 1998), p. 360. W.K. Jordan, *The Charities of London 1480-1660. The Aspirations and the Achievements of the Urban Society* (London, George Allen & Unwin, 1960), p. 146. David Cressy, *Education in Tudor and Stuart England* (London, Edward Arnold, 1975), pp. 8, 10. For general histories of English almshouses see: Walter H. Godfrey, *The English almshouse: with some account of its predecessor, the medieval hospital* (London, Faber & Faber, 1955); Brian Bailey,

Almshouses (London, Hale, 1988); Brian Howson, *Houses of Noble Poverty. A History of the English Almshouse*, (Sunbury-on-Thames, Bellevue, 1993).

3. Roy Porter, 'The gift relation: philanthropy and provincial hospitals in eighteenth-century England', in *The Hospital in History*, ed. Lindsay Granshaw and Roy Porter (London, Routledge, 1989), p. 156. Ian Archer, 'The arts and acts of memorialization in early modern London', in *Imagining Early Modern London: Perceptions and Portrayals of the City from Stow to Strype, 1598-1720*, ed. Julia Merritt (Cambridge, Cambridge University Press, 2001), pp. 89-90.

4. Paul Slack, *Poverty and Policy in Tudor and Stuart England* (London, Longman, 1988), p. 165.

5. Claire S. Schen, *Charity and Lay Piety in Reformation London, 1500-1620* (Aldershot, Ashgate, 2002), pp. 94,180. Stephen Porter, 'Order and Disorder in the Early Modern Almshouse: The Charterhouse Example', *London Journal*, 23 (1998), 1-14.

6. [William Hale Hale], *Some Account of the Early History and Foundation of the Hospital of King James, Founded in Charterhouse* (London, privately published, 1854), pp. 6-7. Hugh Trevor-Roper, 'Thomas Sutton (1532-1611)', *ODNB*, art. 26806.

7. LMA, acc/1876/F/3/3/47.

8. Neal R. Shipley, 'Thomas Sutton: Tudor-Stuart Moneylender', *Business History Review*, 50 (1976), 461,466-8. LMA, acc/1876/F/9/1, 'An inventory … '.

9. Neal R. Shipley, '"Full Hand and Worthy Purposes": the Foundation of Charterhouse, 1610-1616', *Guildhall Studies in London History*, I (1975), 241.

10. Ian W. Archer, 'The Charity of Early Modern Londoners', *Trans. Royal Historical Soc.*, sixth series, XII (2002), 225-9.

11. John Stow, *A Survey of London*, ed. C.L. Kingsford (Oxford, Clarendon Press, 1908), vol. II, p. 78, and discussed in, Margaret Healy, *Fictions of Disease in Early Modern England* (Basingstoke, Palgrave, 2001), p. 96.

12. Henry Holland, *Herωologia Anglica* (1620), pp. 128-31. *The Works of the Most Reverend Father in God; William Laud, D.D.*, vol. VI, pt I (1857), p. 3. Andrew Willet, *Synopsis Papismi* (1634 edn.), p. 1231.

13. Cited in, Philip Bearcroft, *An Historical Account of Thomas Sutton Esq.; And of His Foundation in Charterhouse* (1737), p. 162.

14. Henrie Farley, *The Complaint of Paules, to All Christian Soules* (1616), in, Pamela Tudor-Craig and Derek Whittick, '*Old St Paul's*'. *The Society of Antiquaries' Diptych, 1616*, ed. Penelope Hunting and Ann Saunders (London, London Topographical Soc., 163, 2004), p. 52.

15. BL, Lansdowne 1198, f.15.

16. James Spedding, *The Letters and the Life of Francis Bacon*, vol. IV (1868), pp. 249-54.

17. Bacon has been criticised for his advice, by those with Charterhouse connections and others. For example, Bearcroft, *Historical Account*, pp. 132-54; Robert Smythe, *Historical Account of Charter-House* (London, 1808), p. 208; E.P. Eardley Wilmot and E.C. Streatfield, *Charterhouse Old and New* (London, Nimmo, 1895), p. 303; Gerald S. Davies, *Charterhouse in London* (London, John Murray, 1921), p. 197. And see, Nieves Mathews, *Francis Bacon: The History of a Character Assassination* (New Haven and London, Yale University Press, 1996), pp. 358-60,534 nn.26-33.

18. Francis Bacon, *The Advancement of Learning*, ed. Edward Jay Gould (New York, Random House, 2001), p. 68. G.L. Hosking, *The Life and Times of Edward Alleyn* (London, Jonathan Cape, 1952), p. 237.

19. CM, G/2/1, p. 3.

20. *Charter, Acts of Parliament, and Governors' Statutes for the Foundation and Government of the Charterhouse* (1832), p. 7.

21. 43 Elizabeth I, c.4. *Stuart Royal Proclamations, Volume I, Royal Proclamations of King James I 1603-1625*, ed. James F. Larkin and Paul L. Hughes (Oxford, Clarendon Press, 1973), p. 119.

22. CM, G/2/2, f.38.

23. Francis Bacon, *Essays*, ed. Michael J. Hawkins (London, Everyman, 1994), p. 93. Archer, 'Charity of Early Modern Londoners', 227-8, 238.

24. Robert Burton, *The Anatomy of Melancholy*, ed. Thomas C. Faulkner, Nicolas K. Kiessling and Rhoda L. Blair, Vol. I (Oxford, Clarendon Press, 1989), p. 87.

25. [Charles Davenant], *An Essay upon the probable means of making a People gainers in the Ballance of Trade* (1699), quoted in Christine Stevenson, *Medicine and Magnificence. British Hospital and Asylum Architecture, 1660-1815* (New Haven and London, Yale University Press, 2000), p. 22.

26. For such architectural nostalgia see, Alice T. Friedman, 'John Evelyn and English Architecture' in *John Evelyn's "Elysium Britannicum" and European Gardening*, Dumbarton Oaks colloquium on the history of landscape architecture, XVII, ed. Therese O'Malley and Joachim Wolschke-Bulmahn (Washington DC, Dumbarton Oaks Research Library and Collection, 1998), p. 170.

27. John Newman, 'The Architectural Setting', in *The History of the University of Oxford, Volume IV Seventeenth-Century Oxford*, ed. Nicholas Tyacke (Oxford, Clarendon Press, 1997), p. 145. Owen Manning and William Bray, *The History and Antiquities of the County of Surrey*, vol. II (London, 1809), p. 553.

28. *Stuart Royal Proclamations, Volume I*, ed. Larkin and Hughes, p. 346.

29. LMA, acc/1876/F/9/1, 'Funerall Chardges'. Bearcroft, *Historical Account*, pp. 112-13.

30. The directions of Sir Thomas Richardson, 1635: PRO, PROB/11/167/35.

31. Quoted in Nigel Llewellyn, *Funeral Monuments in Post-Reformation England* (Cambridge, Cambridge University Press, 2000), p. 17, and see there, p. 349.

Archer, 'The arts and acts of memorialization', pp. 100-1.

32. *The Charterhouse, with the last Will and Testament of Thomas Sutton Esquire* (1614).

33. Henry Arthington, *Provision for the poore* (1597), unpaged.

34. [Thomas Gainsford], *The Rich Cabinet Furnished with varietie of Excellent discriptions...* (1616), p. 151.

35. Hosking, *Edward Alleyn*, p. 237.

36. J.H. Bettey, 'Matthew Chubb of Dorchester: Rapacious moneylender and benevolent philanthropist', *Dorset Natural History and Antiquarian Soc. Proceedings*, 112 (1990), 1-4.

37. Linda Levy Peck, *Northampton: Patronage and Policy at the Court of James I* (London, Allen & Unwin, 1982), p. 75.

38. W.K. Jordan, *Philanthropy in England 1480-1660* (London, Allen & Unwin, 1959), p. 262 n.1. Paul Slack, *From Reformation to Improvement. Public Welfare in Early Modern England*, (Oxford, Clarendon Press, 1998), p. 92 n.69.

39. Wallace T. MacCaffrey, *Exeter, 1540-1640. The Growth of an English County Town* (Cambridge, Mass., Harvard University Press, 1958), p. 105.

40. Hugo Soly, 'Continuity and change: attitudes towards poor relief and health care in early modern Antwerp', in *Health Care and Poor Relief in Protestant Europe 1500-1700*, ed. Ole Peter Grell and Andrew Cunningham (London, Routledge, 1997), p. 101.

41. Information kindly supplied by Dr J.E.A. Boomgaard, Amsterdam Municipal Archives.

42. BL, Lansdowne MS 1198, ff.21v-2. Knott's comments were made during an exchange between him and Christopher Potter, author of *Want of Charitie* (1633).

43. Danby Pickering, *The Statutes at Large*, vol. VII (1763), pp. 43-6. *Stuart Royal Proclamations, Volume I*, ed. Larkin and Hughes, pp. 118-21.

44. Bacon, *Essays*, ed. Hawkins, p. 93.

45. HMC, *Records of the City of Exeter* (1916), p. 97.

46. LMA, acc/1876/G/5/26.

47. J.C. Davis, *Utopia and the Ideal Society. A Study of English Utopian Writing 1516-1700* (Cambridge, Cambridge University Press, 1981), p. 316. Lisa Jardine, *On a Grander Scale: the Life and Times of Christopher Wren* (London, HarperCollins, 2002), pp. 118-19.

48. D. Lupton, *London and the Countrey Carbonadoed and Quartred into severall Characters* (1632), p. 62.

49. Peck, *Northampton*, pp. 7-10, 75. John Kimbell, *An Account of the Legacies, Gifts, Rents, Fees &c. appertaining to the Church and Poor, of the Parish of St. Alphege, Greenwich* (Greenwich, 1816), p. 46. Clive Berridge, *The Almshouses of London* (Shedfield, Ashford Press, 1987), p. 60. C. Wilfrid Scott-Giles and

Bernard V. Slater, *The History of Emanuel School 1594-1964* (London, Old Emanuel Association, 1966), pp. 29,34,35,43. Victoria County History, *County of Surrey*, vol. IV (1912), p. 228.

50. Shipley, '"Full Hand and Worthy Purposes"', 231-2. LMA, acc/1876/F/6/12.

51. LMA, acc/1876/F/6/2-10,12. *Charter, Acts of Parliament*, pp. 44-5, 52, 69. BL, Lansdowne MS 1198, ff.25v-6.

52. BL, Lansdowne MS 1198, f.6.

53. T. Cromwell, *History and Description of the Parish of Clerkenwell*, (London, Longman, Rees, Orme, Brown, and Green, 1828), p. 438.

54. Trevor-Roper, 'Thomas Sutton (1532-1611)', *ODNB*, art. 26806.

55. Bearcroft, *Historical Account*, pp. 20-4. H.R. Trevor-Roper, 'Thomas Sutton', *The Carthusian* (Oct 1948), 6-7.

56. LMA, acc/1876/F/6/8-10.

57. BL, Lansdowne MS 825, f.66.

58. Archer, 'Charity of Early Modern Londoners', 227-8. Bacon, *Essays*, ed. Hawkins, pp. 92, 107-9.

59. Nicholas Breton, *The Good and the Badde, a Description of the Worthies and Vnworthies of this Age* (London, 1616).

60. Joseph Hall, *Characters of Vices and Virtues* (1608), in, *Character Writings of the Seventeenth Century*, ed. H. Morley (London, The Carisbrooke Library, 1891), p. 131. Bearcroft, *Historical Account*, pp. 26-34.

61. LMA, acc/1876/F/3/2/5.

62. BL, Lansdowne MS 1198, f.21v.

63. Ian W. Archer, *The Pursuit of Stability: Social Relations in Elizabethan London* (Cambridge, Cambridge University Press, 1991), p. 53. Norman Jones, *God and the Moneylenders: Usury and Law in Early Modern England* (Oxford, Basil Blackwell, 1989), pp. 179-80. BL, Lansdowne MS 825, f.66.

64. Percival Burrell, *Sutton's Synagogue, or, the English Centurion: shewing the vnparrallelled bounty of Protestant piety* (1629). *Sutton's Hospitall: with the names of sixteen Mannors, ... with the rents and hereditaments thereunto belonging: ... As also the last will and testament of T. Sutton, Esq., founder of the said Hospitall, etc.* (1646).

65. Holland, *Heroologia Anglica*, pp. 128-31. Robert C. Evans, 'Thomas Sutton: Ben Jonson's Volpone?', *Philological Quarterly*, LXVIII (1989), 295-313. Margaret Hotine, 'Ben Jonson, Volpone, and Charterhouse', *Notes & Queries*, CCXXXVI (1991), 79-81. LMA, acc/1876/F/1/5. Neal R. Shipley, 'A possible source for *Volpone*', *Notes & Queries*, CCXXXVII (1992), 363-9.

66. *Memorials of Affairs of State in the reigns of Q. Elizabeth and K. James I ... from the Original Papers Of ... Sir Ralph Winwood*, vol. III (1725), p. 136.

CHAPTER 2: MAGNIFICENCE, MUNIFICENCE, AND RELIGIOUS GOVERNMENT

1. CM, PS1/5, f.9; G/2/1, p. 74.

2. *Calendar of State Papers, Domestic, 1611-1618*, p. 499. T.W. Baldwin, 'The Three Francis Beaumonts', *Modern Language Notes*, 39 (1924), 505-7. *Chaucer, The Critical Heritage*, vol. I, ed. Derek Brewer (London, Routledge, 1978), pp. 135, 140.

3. CM, G/2/1, pp. 91-2, 171.

4. Bodl., MS Tanner 161, f.48.

5. I owe the information on Tarbocke to the kindness of the late Lord Dacre. For Hadstock and Littlebury, LMA, acc/1876/D3/205,206A.

6. LMA, acc/1876/AR/1/19. CM, G/2/2, f.41. Samuel Herne, *Domus Carthusiana: or an Account of the Most Noble Foundation of Charter-House* (1677), p. 196.

7. CJ, I, 1547-1629, p.477. LMA, acc/1876/F/9/56.

8. *Charter, Acts of Parliament, and Governors' Statutes for the Foundation and Government of the Charterhouse* (1832), p. 16. BL, Lansdowne 1198, f.8v.

9. Ibid., pp. 19-20.

10. *Calendar of State Papers, Domestic, 1623-1625*, p.297. CM, G/2/1, p. 171.

11. Bacon, *Essays*, ed. Hawkins, p. 93. Spedding, *Letters and the Life of Francis Bacon*, vol. IV, p. 250.

12. Roger Lockyer, *Buckingham: The Life and Political Career of George Villiers, First Duke of Buckingham 1592-1628* (London, Longman, 1981), pp. 191-2, 206-11.

13. *The Works of the Most Reverend Father in God; William Laud, D.D.*, vol. III (1853), pp. 154-5; vol. VI, pt I (1857), pp. 1-2.

14. *The Works of ... William Laud*, vol. VI, pt I (1857), pp. 2-4. P. Heylyn, *Cyprianus Anglicus: Or, The History of the Life and Death, of The most Reverend and Renowned Prelate William ... Archbishop of Canterbury* (1671), pp. 118-19.

15. BL, Lansdowne MS 1198, f.21v.

16. PRO, PROB11/120/64.

17. Karl Josef Höltgen, 'Sir Robert Dallington (1561-1637): Author, Traveller, and Pioneer of Taste', *Huntington Library Quarterly*, vol. 47 (1984), 147-77. Roy Strong, *Henry, Prince of Wales and England's Lost Renaissance* (London, Thames & Hudson, 1986), pp. 30-1. John Hale, *England and the Italian Renaissance* (London, HarperCollins, 1996), pp. 25-6.

18. John Lough, *France Observed in the Seventeenth Century by English Travellers* (Stocksfield, Oriel Press, 1985), p. 1.

19. LMA, acc/1876/AR/½22; /F/9/40/9-13. CM, G/2/1, pp. 240-1.

20. PRO, C2/ChasI/c2/54; c51/65; c113/28. CM, G/2/1, pp. 184, 376-80.

21. CM, G/2/1, pp. 178, 179, 184.

22. LMA, acc/1876/AR/3/14A,15A,17A,19A. BL, Lansdowne 1198, f.26v.

23. LMA, acc/1876/G/1/10/1. CJ, I, p. 736.

24. *Proceedings in Parliament 1626 Volume II: House of Commons*, ed. William B. Bidwell and Maija Jannson (New Haven & London, Yale University Press, 1992), pp. 12, 20, 21, 214, 217.

25. *Charter, Acts of Parliament ...* , pp. 35, 50.

26. Ibid., pp. 69-70. CM, G/2/1, pp. 312-13.

27. CM, G/2/1, pp. 196, 207, 211, 243, 268-9. BL, Lansdowne MS 1198, f.25. Stephen Porter, 'Order and Disorder in the Early Modern Almshouse: The Charterhouse Example', *London Journal*, 23 (1998), 5-8.

28. *Alumni Carthusiani: A Record of the Foundation Scholars of Charterhouse, 1614-1872*, ed. Bower March and Frederick Arthur Crisp (1913), p. 3. BL, Lansdowne MS 1198, f.23v.

29. BL, Lansdowne MS 1198, f.25r. CM, G/1/2, p. 184.

30. CM, G/2/1, pp. 3,18. *Charter, Acts of Parliament ...* , pp. 52, 53-4.

31. *Alumni Carthusiani*, ed. March and Crisp, pp.viii,5. CM, G/2/1, pp. 173, 147. Oscar S. Straus, *Roger Williams: The Pioneer of Religious Liberty* (New York, Century, 1894).

32. CM, G/2/1, p. 353. *Charter, Acts of Parliament ...* , p. 54.

33. D. Lupton, *London and the Countrey Carbonadoed and Quartred into severall Characters* (1632), p.61. CM, G/2/1, p. 291.

34. John Aubrey, *Brief Lives*, ed. Richard Barber (London, Folio Soc., 1975), p.

44. LMA, acc/1876/G/3/2, ff.1, 39-40.

35. CM, G/2/1, pp. 238-9. LMA, acc1876/F/11/3,4.

36. Smythe, *Historical Account*, p. 236. LMA, acc/1876/AR/1/5/1; AR/1/22; AR/3/10A, Lady Day 1629.

37. LMA, acc/1876/AR/3/7A,10A.

38. LMA, acc/1876/F/9/48, bk 14; /F/9/51,53.

39. LMA, acc/1876/AR/4/23; /AR/3/8A, Lady Day 1627. Claire Gapper, Plasterers and Plasterwork in City, Court and Country *c.* 1530-*c*.1640, PhD thesis, University of London, 1998, Chap.V.

40. LMA, acc/1876/AR/1/22; AR/3/7A, 10, 12 Sept., 8 Nov 1626. Pamela Willetts, 'Benjamin Cosyn: Sources and circumstances', in *Sundry sorts of music books*, ed. Chris Banks, Arthur Searle and Malcolm Turner (London, British Library, 1993), pp. 129-45.

41. Frank Traficante, 'Tobias Hume', *ODNB*, art. 14152. CM, PS/1/5, f.12.

42. BL, Lansdowne 1198, f.23v.

43. Stephen Porter and Adam White, 'John Colt and the Charterhouse Chapel', *Architectural History*, 44 (2001), 228-36. LMA, acc/1876/AR/3/17A,18A.

44. CM, G/2/1, p. 355.

45. CM, G/2/2, ff.41r-v.

46. PRO, PROB11/176/214. CM, PS1/5, f.9.

47. *The Notebook and Account Book of Nicholas Stone*, ed. W.L. Spiers (Walpole Soc., vol. VII, 1919), p. 40.

48. Stephen Porter, 'Francis Beaumont's Monument in Charterhouse Chapel and Elizabeth, Baroness Cramond as Patroness of Memorials in Early Stuart London', *Trans. London and Middlesex Archaeological Soc.*, 54, 2003, 111-19.

49. CM, G/2/2, ff.2v-3.

50. William Knowler, *The Earl of Strafforde's Letters and Dispatches*, vol. II (1739), pp. 150, 152-3; I owe this reference to the kindness of Dr Ian Roy.

51. Knowler, *Strafforde's Letters*, vol. II, pp. 180, 351.

52. *The Diary of John Evelyn*, ed. E.S. Beer (London, Oxford University Press, 1959), p. 26.

53. Lupton, *London and the Countrey*, pp. 60-2.

CHAPTER 3: A NEST OF UNCLEAN BIRDS

1. CM, G/2/2, ff.23v,32.

2. CM, G/2/2, f.45.

3. LJ, VI, 1643-44, pp. 272, 390.

4. CM, G/2/2, ff.58v,71v-2.

5. CJ, II, 1640-42, p.475. CM, G/2/2, f.36. LMA, acc/1876/G/6/2, f.106.

6. LJ, V, 1642-3, pp.357,363,559. HMC, *Fifth Report*, App., 1876, p. 48.

7. [John White], *The First Century of Scandalous, Malignant Priests ...* (1643), p. 5.

8. CM, PS/1/5, f.9.

9. CM, G/2/1, pp. 248-9.

10. LMA, acc/1876/AR/3/25; /G/3/2, ff.48v-9; /G/3/3, p.15; AR/1/44A.

11. CM, G/2/2, ff.50r-v,59,62r-v. CJ, III, 1642-4, pp.268,568. LJ, VI, 1643-44, p. 518.

12. CM, G/2/2, f.48. CM, PS1/5, f.9.

13. CM, G/2/2, ff.62-3, 65.

14. *Walter Yonge's Diary of Proceedings in the House of Commons 1642-1645*, ed. Christopher Thompson, vol. I (1986), pp. 96, 103. CM, G/2/1, p. 3. The royalists used almshouses in Oxford for wounded soldiers in the aftermath of Edgehill. Christopher L. Scott, Alan Turton and Eric Gruber von Arni, *Edgehill. The Battle Reinterpreted* (Barnsley, Pen & Sword, 2004), pp. 153, 155.

15. CM, G/2/2, f.47v.

16. Hugh Peters, *Gods Doings, and Mans Duty* (1646), p. 44. Revelation 18, v.2. C.H. Firth, *Cromwell's Army* (London, Greenhill, 1992), pp. 265-6.

17. Stephen Porter, 'University and Society', in *The History of the University of Oxford, Volume IV Seventeenth-Century Oxford*, ed. Nicholas Tyacke (Oxford, Clarendon Press, 1997), pp. 31-3.

18. LMA, acc/1876/AR/3/23. CM, G/2/2, ff.76,81v-2.

19. CJ, III, 1642-44, pp.270,276,280,289,294. LJ, VI, 1643-44, pp. 283, 524.

20. PRO, C2/Chas.I/A3/6. CM, G/2/2, ff.74v-5.

21. CM, G/2/1, pp. 165, 207, 228. He was appointed Registrar in Feb. 1622; LMA, acc/1876/G/6/1, ff.157-8v. PRO, PROB11/176/24.

22. PRO, C2/Chas.I/A3/6.

23. CM, PS1/5, f.9.

24. CM, G/2/2, ff.48, 76v-7, 86v-7.

25. CM, G/2/2, ff.63, 66v, 92.

26. LMA, acc/1876/G/3/3, pp.25-6,46.

27. CM, G/2/2, ff.62, 70v-1.

28. LMA, acc/1876/AR/3/23. This is the only surviving rental for the years between 1640/1 and 1651/2.

29. LJ, VI, 1643-44, p. 524.

30. CM, G/2/2, f.60.

31. CM, G/2/2, f.87.

32. LMA, acc/1876/G/3/4, ff.32-3.

33. CM, G/2/3, ff.27,45.

34. LMA, acc/1876/G/3/4, f.38v.

35. PRO, C2/Chas.I/A3/6. LMA, acc/1876/AR/3/23.

36. LMA, acc/1876/G/3/4, ff.56-7.

37. PRO, C8/86/107.

38. LMA, acc/1876/G/3/2, f.44.

39. *Charter, Acts of Parliament, and Governors' Statutes for the Foundation and Government of the Charterhouse* (1832), p. 35.

40. CM, G/2/2, ff.57v-8, 65.

41. LMA, acc/1876/AM/3/1, 2.

42. *Calendar of State Papers, Venetian, 1642-43*, p.235. LMA, acc/1876/AR/3/23.

43. CM, G/2/2, ff.63, 73v.

44. CM, PS/1/5, passim.

45. LJ, VII, 1644-45, p. 520; VIII, 1645-46, pp. 236, 245. CJ, IV, 1644-46, p. 496. *Acts and Ordinances of the Interregnum, 1642-1660*, ed. C.H. Firth and R.S. Rait (3 vols, London, Stationery Office, 1911), vol. I, pp. 570-1.

46. HMC, *Sixth Report*, app. (1877), pp. 71, 128-9.

47. CM, G/2/2, ff.78, 82a, 83, 155v-6; G/2/3, f.24v.

CHAPTER 4: A COLLEGE FOR DECAYED GENTLEMEN

1. BL, Lansdowne MS 1198, ff.5v-6. Richard Carter, *The Schismatick Stigmatized* (1641), cited in David Cressy 'The Downfall of Cheapside Cross: Vandalism, Ridicule, and Iconoclasm' in *Agnes Bowker's Cat: Travesties and Transgressions in Tudor and Stuart England* (Oxford, Oxford University Press, 2000), p. 234.

2. *Calendar of State Papers, Domestic, 1649-50*, pp. 31, 130, 474; *1650*, p. 107.

3. CM, G/2/2, ff.93-116.

4. CM, G/2/2, ff.100,-1,113v,126,142r-v,190v; G/2/3, f.4v. LMA, acc/1876/G/3/3, pp.10-11,31; /4, ff.54v-5. *Oliver Cromwell's Letters and Speeches: With Elucidations* (Leipzig, Tauchnitz, 1861), III, p. 333. *Annual Register*, 1758, pp. 267-8.

6. *Gentleman's Magazine*, August 1840, p. 215.

7. CM, G/2/2, ff.105r-v,110v-11v, 165. *Biographical Dictionary of British Radicals in the Seventeenth Century*, Vol. I, ed. Richard L. Greaves and Robert Zaller (Brighton, Harvester Press, 1982), p. 190.

8. A.G. Matthews, *Calamy Revised. Being a revision of Edmund Calamy's Account of the ministers and others ejected and silenced, 1660-2* (Aldershot, Ashgate, 1999), p. 237.

9. CM, G/2/2, ff.90, 96v, 133v-4v.

10. CM, G/2/2, ff.95v-6v, 97, 103v, 108v, 109, 112r-v, 117v-18. LMA, acc/1876/G/3/2, f.69v. BL, Lansdowne MS 1198, f.24v.

11. CM, G/2/2, ff.126v-7. LMA, acc/1876/G/3/2, f.108v.

12. CM, G/2/2, ff.146v-7.

13. CM, G/2/2, ff.165r-v,168.

14. CM, G/2/2, f.161v.

15. CM, G/2/2, ff.55v-6v. LMA, acc/1987/G/3/3, pp. 10-11.

16. CM, G/2/2, f.173.

17. LMA, acc/1876/G/3/3, pp.41,43,52-3; /G/3/4, ff.59-60.

18. Anthony Quick, *Charterhouse: A History of the School* (London, James & James, 1990), p. 25.

19. CM, G/2/2, ff.174, 180, 184v.

20. CM, PS/1/5.

21. PRO, PROB11/201/197.

22. CM, PS1/5, f.30. Martin Butler 'Brome, Richard (*c*.1590-1652)', *ODNB*, art. 3503.

23. *The Travels of Peter Mundy in Europe and Asia 1608-1667*, ed. Richard Carnac Temple and Lavinia Mary Anstey (Haklyut Soc., second series, LXXVIII, 1936), p. 132. W. Herbert, *Considerations (In the behalf of Foreiners ...)*, 18 June 1662.

24. *The Diary of John Evelyn*, ed. E.S. de Beer (London, Oxford University Press, 1959), p. 378.

25. Elizabeth Jane Furdell, 'Bate, George [*pseud*. Theodorus Veridicus](1608-1668)', *ODNB*, art. 1661. John Walker, *A Selection of Curious Articles from the Gentleman's Magazine*, vol. 4 (second edn., 1811), p. 96.

26. Blair Worden, *Roundhead Reputations. The English Civil War and the Passions of Posterity* (London, Allen Lane, 2001), p. 221. Wood's account of Bate's confession is cited in, Roy Sherwood, *The Court of Oliver Cromwell* (Willingham, Willingham Press, 1989), p. 112, and is considered in, **H.F. McMains**, *The Death of Oliver Cromwell* (Lexington, University Press of Kentucky, 2000).

27. LMA, acc/1876/G/3/4, ff.56-7; /G/3/3, pp. 11-13, 30-1. Quick, *Charterhouse*, p. 21.

28. LMA, acc/1876/AR/3/25, 28.

29. CM, G/2/2,ff.165v-6; PS/1/5, f.36.

30. LMA, acc/1876/G/3/3, pp. 243, 279.

31. LMA, acc/1876/AR/1/328, 29 July 1656; /G/3/3, pp. 61, 71.

32. LMA, acc/1876/G/3/3, p. 269.

33. CM, G/2/2, ff.137,153r-v.

34. CM, G/2/2, f.176v.

35. CM, G/2/2, f.188.

36. CM, G/2/2, B, ff.178,190v; G/2/3, ff.26, 30v, 60v.

37. BL, Lansdowne MS 1198, f.26v.

38. LMA, acc/1876/G/3/3, pp.159,241; /4, f.60v.

39. LMA, acc/1876/AR/3/39/2.

40. LMA, acc/1876/G/3/3, pp. 87, 94, 110, 129.

41. LMA, acc/1876/G/3/3, p. 71.

42. LMA, acc/1876/G/3/3, p. 131.

43. Mary Edmond, *Rare Sir William Davenant: poet laureate, playwright, Civil War general, restoration theatre manager* (Manchester, Manchester University Press, 1987), pp. 116-22.

44. HMC, *Fifth Report, appendix, Duke of Sutherland Manuscripts* (1876), p. 84.

45. LMA, acc1876/G/3/3, p. 252.

46. CM, G/2/3, ff.7v-9v,11-12v,16v-17,23v,25v-6,33v-4, 38v,42v.

47. BL, Lans 1198, f.6r. Guy Miège, *The Present-State of Great-Britain and Ireland*, third edn., (London, 1716), pt 1, p. 133.

48. *Mercurius Politicus*, 29 June-6 July 1654, p. 3600.

49. CM, G/2/3, ff.21r-v.

50. LMA, G/3/3, pp. 320-2.

51. CM, G/2/3, ff.22v, 29v, 36v.

52. CM, G/2/3, f.22.

53. CM, G/2/3, f.38v.

CHAPTER 5: A HEALTHFUL, PLEASANT AND LARGE MANSION

1. CM, G/2/3, ff.19-19v, 24v.
2. CM, G/2/3, f.31.
3. *Calendar of State Papers, Domestic, 1671*, pp. 552, 564, 566. He was the younger brother of Simon Patrick, who was made a royal chaplain in that year and in 1701 became a governor, as Bishop of Ely.
4. I owe this information to the kindness of David Baldwin, Serjeant of the Vestry, HM Chapel Royal.
5. LMA, acc/1876/AR/3/30, Lady Day 1662.
6. Samuel Herne, *Domus Carthusiana; or, an Account ... of the Charter-House near Smithfield in London* (London, 1677), p. 124.
7. LMA, acc/1876/AR/3/33, Lady Day 1665.
8. LMA, acc/1876/AR/3/31-51.
9. Peter Holman, *Henry Purcell* (Oxford, Oxford University Press, 1994), p. 11.
10. Nigel Fortune, 'Purcell: The Domestic Sacred Music', in *Essays on Opera and English Music*, ed. F.W. Sternfeld, Nigel Fortune and Edward Olleson (Oxford, Basil Blackwell, 1975), pp. 63-4.
11. Stephen Porter, 'Composer in residence: Henry Purcell and the Charterhouse', *Musical Times*, 139 (1998), 14-17.
12. *Calendar of State Papers, Domestic, 1671*, pp. 552, 564. CM, G/2/3, f.106.
13. Anthony Wood, *Athenae Oxonienses*, ed. Philip Bliss, vol. III (1817), col.999; vol. IV (1820), col.209.
14. W.A. Thorpe, *History of English and Irish Glass*, 2 vols. (London, Medici Soc., 1929), p. 104; I owe this reference to the kindness of Harriet Richardson.
15. James Anderson Winn, *John Dryden and His World* (New Haven & London, Yale University Press, 1987), pp. 44, 230-1, 236, 572, 579.
16. Giovanni Tarantino, *Martin Clifford 1624-1677. Deismo e Tolleranza Nell'Inghilterra della Restaurazione* (Firenze, Studi e testi per la storia della tolleranza in Europa nei secoli XVI-XVIII, 2000), p. 286.
17. Tarantino, *Martin Clifford*, pp. 280, 332. Anthony Quick, *Charterhouse: A History of the School* (London, James & James, 1990), p. 24.
18. Tarantino, *Martin Clifford*, pp. 36, 363. Charterhouse School, MS 170/2/4.
19. BL, Lansdowne MS 1198, The Life and Death of Thomas Sutton.
20. Herne, *Domus Carthusiana*, p. 197.
21. LPL, Sheldon's Register, f.204v. *The Correspondence of John Cosin, D.D. Lord Bishop of Durham*, pt II, ed. George Ornsby (Surtees Soc., LV, 1872), p. 110.
22. Herne, *Domus Carthusiana*, pp. 108-9. *The Journal of William Schellinks' Travels in England 1661-1663*, ed. Maurice Exwood and H.L. Lehmann (Camden Soc., fifth series, vol. I, 1993), p. 71.

23. LMA, G/3/3, p. 293. *The Oxinden and Peyton Letters 1642-1670*, ed. Dorothy Gardiner (London, Sheldon Press, 1937), pp. 303, 306. BL, Lansdowne MS 1198, f.23.

24. LMA, acc/1876/AR/1/328, p. 2.

25. LMA, acc/1876/G/3/3, f.361v.

26. CM, G/2/3, ff.99v-100.

27. LMA, acc/1876/AR/3/37/3.

28. Bodl., MS Gough London 11.

29. Herne, *Domus Carthusiana*, p. 197. LMA, acc/1876/AR/3/37/1-2; / AR/1/261.

30. CM, G/2/3, f.100.

31. CM, G/2/3, ff.88v-9, 161v, 163, 169.

32. CM, AR/1/241, 245, 248, 253.

33. LMA, acc/1876/M/2/2.

34. Bodl., MS Tanner 161, ff.55-60. CM, G/2/3, f.142.

35. CM, G/2/3, f.163r-v.

36. CM, G/2/3, f.69v. LMA, acc/1876/MP/1/171.

37. LMA, acc/1876/D1/198, 201, 212.

38. CM, AR/1/373.

39. CM, AR/1/261, 264.

40. CM, G/3/3a, pp.9-10. Bodl., MS Tanner 161, ff.51-3.

41. CM, G/2/3, ff.171v-2; G/3/3a, pp. 18-19. LMA acc/1876/G/3/4, f.100.

42. CM, G/2/3, ff.98v,171v,176v.

43. CM, AR 1/363-73; G/2/4, p. 99.

44. LMA, acc/1876/AR/½261.

45. CM, G/2/3, f.145; AR/1/242. LMA, acc/1876/M/2/2.

46. CM, G/2/3, ff.36v-7, 79, 81. LMA, acc/1876/G/3/3, pp. 283-4.

47. CM, G/2/3, ff.97, 103v.

48. CM, G/2/3, f.183.

49. Bodl., MS Tanner 161, f.76.

50. Bodl., MS Tanner 161, ff.55v-6.

51. CM, G/2/3, ff.161v, 169v, 195v.

52. CM, G/2/4, pp. 171-2, 177-9, 294-5; G/3/3a, pp. 113, 117-19, 123, 126. LMA, acc/1876/M/1.

53. CM, G/2/4, p. 283; G/3/3a, p. 130. East Sussex RO, FRE/650.

54. PRO, C7/322/9.

55. Matthew Nathan, *The Annals of West Coker* (Cambridge, Cambridge University Press, 1957), p. 316.

56. *Alumni Carthusiani: A Record of the Foundation Scholars of Charterhouse, 1614-1872*, ed. Bower March and Frederick Arthur Crisp (London, privately published, 1913), pp. vii, 27-59.

57. Bodl., MS Tanner 161, f.55. *The Diary of John Evelyn*, ed. E.S. de Beer

(London, Oxford University Press, 1959), p. 846.

58. CM, G/2/3, f.145.

59. CM, G/2/3, f.156. Quick, *Charterhouse*, p. 25.

60. Edward Chamberlayne, *The Second Part of the Present State of England* (1682), p. 320.

61. *Diary of John Evelyn*, ed. de Beer, p. 715.

62. Those of Charles II; George Villiers, second Duke of Buckingham; Gilbert Sheldon, Archbishop of Canterbury; James Scott, Duke of Monmouth; and Charles Talbot, Duke of Shrewsbury are copies of portraits by Sir Peter Lely, and that of William Earl of Craven is by Gerrit Honthorst.

63. CM, G/2/3, ff.172-3.

64. This account is based upon, [Thomas Burnet], *A Relation of the Proceedings at Charter-House, upon Occasion of King James the II. His presenting a Papist To be admitted into that Hospital* (London, 1689).

65. CM, G/2/3, f.183v.

66. House of Lords RO, Main Papers, 2 Nov. 1689, no.154, p. ii; reference kindly supplied by David Johnson.

67. Thomas Babington Macaulay, *The History of England from the Accession of James II*, vol. 2, Chap. VIII.

68. CM, G/2/3, ff.172, 181.

69. CM, G/2/3, ff.183-184v.

70. CM, G/2/3, f.184.

71. CM, G/2/3, ff.185v, 187v-8.

72. Winn, *John Dryden*, pp. 123, 415, 601 n.65.

73. John Fendy, 'Martin Benson, Bishop of Gloucester', *Trans. Bristol and Gloucestershire Archaeological Soc.*, 119 (2001), 155.

74. *The Carthusian*, XX (1949), 140.

CHAPTER 6: A SCENE OF HORROR AND WRETCHEDNESS

1. Staffordshire RO, DW1778/I/ii/513. Cambridge University Library, Ch(H), 80, 95. East Sussex RO, SAS/A379/1/5.

2. PRO, SP36/19, Dorset to Newcastle, 30 June 1730; /20, ff.203,223.

3. CM, G/2/4, pp. 330, 332.

4. CM, G/2/5, pp. 299, 329.

5. CM, G/2/4, pp. 357-8.

6. H.R. Woudhuysen, 'A maker of curious books', *Times Literary Supplement*, 21 May 2004.

7. CM, G/2/4, pp. 160, 268, 278.

8. CM, G/2/4, p. 198.

9. CM, G/2/4, pp. 181-2, 194, 198-9, 205-6; G/3/3a, p. 100. LMA, acc/1876/

M/1.

10. CM, G/2/3, pp. 194-5.

11. CM, G/2/4, p. 211.

12. 8 Geo.I, c.29. CM, G/2/4, p. 221.

13. CM, G/2/5, p. 6.

14. LMA, acc/1876/M1/19.

15. CM, G/2/5, p. 236. *The Agrarian History of England and Wales, V 1640-1750, pt ii, Agrarian Change*, ed. Joan Thirsk (Cambridge, Cambridge University Press, 1985), p. 849.

16. CM, G/2/4, pp. 161, 163; G/3/3a, pp. 103-5. LMA, acc/1876/D/1/23A.

17. CM, G/2/4, pp. 260-1.

18. CM, G/3/3a, p. 174.

19. CM, G/3/3a, pp. 174-5, 186-7; G/2/4, p. 264. LMA, acc/1876/AR/3/91, Michaelmas 1727; AR/7/8, Midsummer, Michaelmas 1727; /AR/3/90, Lady Day 1727.

20. Basil F.L. Clarke, *The Building of the Eighteenth-Century Church* (London, Batsford, 1963), pp. 174-6. Stephen Porter, 'Planning for a Monument: Dr John King and Charterhouse Chapel', *Trans the Ancient Monuments Soc*, 47, 2003, 33-46.

21. CM, G/2/4, pp. 274-7.

22. *Alumni Carthusiani: A Record of the Foundation Scholars of Charterhouse, 1614-1872*, ed. Bower March and Frederick Arthur Crisp (London, privately published, 1913), p. viii.

23. PRO, PROB11/805/322.

24. BL, Add MS 1198, f.25.

25. *Alumni Carthusiani*, ed. March and Crisp, frontispiece, p. ii. John Sheffield, son of the second Earl of Mulgrave, was appointed a governor in 1685 and was created Duke of Buckingham and Normanby in 1703.

26. PRO, SP34/36/163.

27. CM, G/2/4, p. 26.

28. LMA, acc/1876/AG/4/2/3,4.

29. LMA, acc/1876/G/2/60/28.

30. LMA, acc/1876/G/2/60/37.

31. LMA, acc/1876/AG/4/2/4.

32. LMA, PS/2/18/2.

33. LMA, acc/1876/M1/8.

34. LMA, acc/1876/G/2/60/38.

35. LMA, acc/1876/M1/8.

36. Edgar Wesley Thompson, *Wesley at Charterhouse* (London, Epworth Press, 1938), pp. 5-7.

37. LMA, acc/1876/AM/3/15.

38. CM, G/2/4, pp. 186-7, 202, 240; /5, p.102. Christ Church, vol. CCLX, Wake

Letters, 27, no.236. LPL, MS 1742.

39. LMA, PS/2/18/2.

40. CM, G/2/4, pp. 146-8, 162.

41. CM, G/2/4, p. 202.

42. CM, G/2/4, pp. 240-1, 365.

43. LMA, acc/1876/G/3/3, p. 230. CM, G/2/3, ff.74, 77, 103.

44. CM, G/2/4, p. 308.

45. CM, G/2/4, pp. 294-5, 306-7. Christ Church, vol. CCLX, Wake Letters, 27, no.237.

46. CM, G/3/3a, p. 185.

47. CM, G/2/4, pp.305, 307-8, 360-1, 369, 373.

48. CM, G/2/5, pp. 209-10, 226. *A True Narrative Of certain Circumstances Relating to Zachariah Williams ... in Sutton's Royal Hospital, The Charter-House* (London, 1749). Robert Smythe, *Historical Account of Charter-House* (London, 1808), pp. 259-60.

49. CM, PS1/6, 24 September 1694, 24 June 1706.

50. Thompson, *Wesley at Charterhouse*, p. 7.

51. CM, G/3/3a, p. 153.

52. LMA, acc/1876/G/5/105/1.

53. Thompson, *Wesley at Charterhouse*, p. 5.

54. *Alumni Carthusiani*, ed. March and Crisp, p. 75.

55. *Alumni Carthusiani*, ed. March and Crisp, p. 95.

56. R.L. Arrowsmith, *A Charterhouse Miscellany* (London, Gentry, 1982), pp.41-5. CM, PS/2/19/A-D; G/2/4, pp. 383-4; G/2/5, pp. 41-4.

57. CM, G/2/5, 57-8, 72, 86-7.

58. Staffordshire RO, DW1778/I/ii/739.

59. CM, G/2/4, p. 386; G/2/5, pp. 228-9, 243-4.

60. Anthony Quick, *Charterhouse: A History of the School* (London, James & James, 1990), pp. 30-1. CM, G/2/5, pp. 364-5.

61. LMA, acc/1876/AR/7/20/2.

62. Quick, *Charterhouse*, pp. 32-3.

63. CM, M/10/5/1.

64. CM, G/2/3, f.188.

65. CM, G/2/4, pp. 20, 115.

66. CM, G/2/4, p. 134.

67. William Coxe, *Anecdotes of George Frederick Handel and John Christopher Smith* (London, 1799), pp. 40-1. I owe this reference to the kindness of John Greenacombe. *The New Grove Dictionary of Music and Musicians*, second edn., ed. Stanley Sadie (London, Macmillan, 2001), vol. 19, pp. 324-7.

68. CM, G/2/6, p. 128. LMA, acc/1876/G/5/105/3.

69. Thompson, *Wesley at Charterhouse*, p. 11.

70. Bernard Mandeville, *The Fable of the Bees: Or, Private Vices, Publick Benefits*

(second edn, London, 1723), pp. 294, 302.

71. Daniel Defoe, *A Tour through the Whole Island of Great Britain*, ed. Pat Rogers (Harmondsworth, Penguin, 1971), p. 334.

72. Guy Miège, *The New State of England* (London, 1691), p. 302.

73. Ned Ward, *The London Spy* (London, Folio Soc., 1955), pp. 206-7. CM, G/3/3a, p. 61.

74. Philip Bearcroft, *An Historical Account of Thomas Sutton Esq.; And of His Foundation in Charter-House* (London, 1737), pp. 145-54.

75. Bearcroft, *Historical Account*, p. 147.

CHAPTER 7: THE APPEARANCE OF MELANCHOLY POVERTY

1. Monumental Inscription, Chapel Cloister, Charterhouse.

2. CM, G/2/5, pp. 284-5.

3. CM, G/2/9, pp. 172-5.

4. CM, AR/1/392-4.

5. CM, G/2/7, pp. 72-78, 85-7.

6. CM, G/2/7, pp. 216-21, 258.

7. 30 Geo. III, c.46 private. CM, G/2/5, pp. 380-1, 392-3, 399, 418-19; /6, pp. 21-2; D6/431.

8. CM, AR/5/13, p. 149.

9. CM, G/2/8, p. 287.

10. CM, G/2/7, pp. 21-2, 27.

11. CM, G/2/8, p. 232; /AR/5/13, p. 17; /AR/3/462-5.

12. CM, AR/3/455, 1 Aug 1780.

13. CM, G/2/5, pp. 373, 394.

14. *The Commissions for Building Fifty New Churches, The Minute Books, 1711-27, A Calendar*, ed. M.H. Port (London Record Soc., 23, 1986), pp.13, 28, 29, 34, 151, 161. LPL, MSS 2705, f.6; 2713, f.71; 2750/39.

15. CM, G/2/4, pp. 137,143.

16. LMA, acc/1876/D1/210.

17. CM, G/2/8, p.171; AR/3/457, Michaelmas 1789; AR/3/462, 465.

18. LMA, acc/1876/M2/5, letter 8 May 1771.

19. CM, G/2/7, p. 4. LMA, acc/1876/G/5/22; G/2/8, pp. 208-11.

20. CM, G/2/8, pp. 405-6.

21. LMA, acc/1876/M2/5.

22. LMA, acc/1876/G/2/60/40. CM, G/2/8, p.412; AR/3/458, ff.40-1.

23. CM, G/2/8, p. 317.

24. CM, G/2/8, pp. 124-5, 200.

25. CM, G/2/7, pp. 143-4.

26. *The New Grove Dictionary of Music and Musicians*, second edn., ed. Stanley

Sadie (London, Macmillan, 2001), vol. 24, pp. 376-7. LPL, Beilby Porteus Papers, vol. 3, f.132. *Recollections of R.J.S. Stevens: An Organist in Georgian London*, ed. Mark Argent (London, Macmillan, 1992), pp. 193-4.

27. CM, G/2/8, p. 206.

28. CM, AR/5/15.

29. *Alumni Carthusiani: A Record of the Foundation Scholars of Charterhouse, 1614-1872*, ed. Bower March and Frederick Arthur Crisp (London, privately published, 1913), p. ix.

30. CM, G/2/8, pp. 325-7.

31. CM, G/2/7, pp. 6-7.

32. CM, G/2/5, pp. 381-2; G/2/8, pp. 147-8, 248, 335-6, 471, 475.

33. I am very grateful to Brian Smith for drawing my attention to the Doharty papers, which I consulted with the kind permission of Christopher Powell-Cotton of Quex Park, Kent.

34. CM, G/2/8, p. 216.

35. I am very grateful to Alan Frederick Smith, Brother of Charterhouse, for drawing my attention to Blake's poem.

36. James Peller Malcolm, *Londinium Redivivum*, I (London, 1802), pp. 413-14.

37. Smythe, *Historical Account*, pp. 254-7. *The Registers and Monumental Inscriptions of Charterhouse Chapel*, ed. Francis Collins, Harleian Soc., Registers, vol. 18 (1892).

38. Smythe, *Historical Account*, pp. 257-60.

39. LMA, acc/1876/PS/3/17.

40. CM, G/2/9, p. 237.

41. LPL, Beilby Porteus Papers, vol. 3, ff.143-4.

42. *A Commemoration Sermon, preached at the Chapel of Charterhouse, on Thursday, December 12, 1811 ... By Philip Fisher, D.D. Master of Charterhouse* (London, 1811), p. 13.

43. CM, G/2/8, pp. 10-20.

44. R.L. Arrowsmith, *A Charterhouse Miscellany* (London, Gentry, 1982), p. 52.

45. CM, G/2/5, pp. 411-12.

46. CM, G/2/8, p. 16.

47. LMA, acc/1876/G/2/60/154.

48. CM, G/2/8, p. 472.

49. LPL, Beilby Porteus papers, vol. 3, ff.131-2.

50. [William Hale Hale], *Some Account of the Early History and Foundation of the Hospital of King James, Founded in Charterhouse* (London, 1854), pp. 17-18.

51. H.W. Donner, *The Browning Box* (Oxford, Oxford University Press, 1935), p.56. *Recollections of R.J.S. Stevens*, p. 138.

52. CM, G/3/3a, p. 204.

53. *Commemoration Sermon … By Philip Fisher*, pp. 6-9.

54. Ibid., pp. 12, 21.

CHAPTER 8: THAT EXCELLENT HOSPITAL

1. Adam Sisman, *Boswell's Presumptious Task* (London, Penguin, 2001), p. 178

2. *A Commemoration Sermon, preached at the Chapel of Charterhouse, on Thursday, December 12, 1811 … By Philip Fisher, D.D. Master of Charterhouse* (London, 1811), pp. 14-17.

3. W.M. Jacob, 'Sutton, Charles Manners (1755-1828)', *ODNB*, art. 17964. The anecdote concerning his appointment as Archbishop is related in Andrew Barrow, *The Flesh is Weak. An Intimate History of the Church of England* (London, Hamish Hamilton, 1980), p. 126.

4. CM, G/2/8, pp. 458-9.

5. LMA, acc/1876/MP/1/22(H). Smythe, *Historical Account*, pp. 262-3. CM, G/2/9, p. 174; AR/3/465,467.

6. CM, AR/3/464.

7. Smythe, *Historical Account*, p. 269.

8. Gerald S. Davies, *Charterhouse in London* (London, John Murray, 1921), p. 269. E.P. Eardley Wilmot and E.C. Streatfield, *Charterhouse Old and New* (London, John C. Nimmo, 1895), pp. 174-6. Information kindly supplied by Bob Noble.

9. Smythe, *Historical Account*, pp. 261-2.

10. Davies, *Charterhouse*, p. 270. *The Carthusian*, vol. XX, no.8 (April 1950), 182.

11. LMA, acc/1876/G/2/60/259.

12. LMA, acc/1876/AR/7/14/3. CM, AR/3/455. Anthony Highmore, *Pietas Londinensis* (London, 1810), p. 654.

13. Davies, *Charterhouse*, pp. 295-6. E.M.J., 'The Cloister Game', *The Carthusian*, vol. XX, no. 4 (June 1949), 90-1. Wilmot and Streatfield, *Charterhouse Old and New*, pp. 74-9.

14. Wilmot and Streatfield, *Charterhouse Old and New*, pp. 96-8.

15. Based upon an account kindly supplied by Bob Noble. See also, Percy M. Young, *A History of British Football* (London, Arrow, 1968), pp. 100, 101, 115n.11, 133n.1, 147.

16. CM, G/2/8, pp. 380-1.

17. CM, G/2/9, pp. 273-4, 277-8.

18. William Cowper, *Tirocinium; Or, A Review of Schools* (1784).

19. LPL, Beilby Porteus Papers, vol. 3, f.133.

20. CM, G/2/9, p. 313.

21. William Haig Brown, *Charterhouse Past and Present* (Godalming, Stedman, 1879), pp. 128, 150-1. Davies, *Charterhouse*, p. 265 n.

22. Wilmot and Streatfield, *Charterhouse Old and New*, pp. 163, 173.

23. Haig Brown, *Charterhouse*, p. 154. H.W. Donner, *The Browning Box* (Oxford, Oxford University Press, 1935), p. 57. Articles by Harriet Richardson and Ian Thomson in, *Thomas Lovell Beddoes Soc. Newsletter*, 6 (2000).

24. Frank B. Chancellor and Henry S. Eeles, *Celebrated Carthusians* (London, Philip Allan, 1936), p. 14, 15, 239.

25. Chancellor and Eeles, *Celebrated Carthusians*, pp. 226-7. D.J. Taylor, *Thackeray* (London, Chatto & Windus, 1999), pp. 32-42, 80, 159, 430-1.

26. Cited in Ann Robey, "All asmear with filth and fat and blood and foam'. The social and architectural reformation of Smithfield Market during the nineteenth century', *Trans Ancient Monuments Soc.*, 42 (1998), 4.

27. CM, AR/3/473, p. 192.

28. Haig Brown, *Charterhouse*, p. 151. Anthony Quick, *Charterhouse: A History of the School* (London, James & James, 1990), pp. 43-8.

29. Arthur Burns, 'From 1830 to the present', in *St Paul's: The Cathedral Church of London*, ed. Derek Keene, Arthur Burns and Andrew Saint (London and New Haven, Yale University Press, 2004), pp. 85-6. *The Times*, 28 Nov. 1870, p. 10a. Julian Lock, 'William Hale Hale, 1795-1870', *ODNB*, art. 11908.

30. CM, G/2/11, p. 176.

31. CM, G/2/10, pp. 218-19.

32. [William Hale Hale], *Some Account of the Early History and Foundation of the Hospital of King James, Founded in Charterhouse* (London, privately published, 1854), p. 21.

33. CM, G/2/10, pp.520-1. G/3/5, f.139.

34. CM, G/2/10, p. 516. Hale, *Some Account*, p. 21.

35. CM, G/2/10, pp. 425-8.

36. CM, G/2/10, pp. 307-8.

37. CM, G/2/10, pp. 431-3, 435-6, 438-42.

38. Hale, *Some Account*, pp. 19, 22.

39. CM, G/2/10, p. 342. *Recollections of R.J.S. Stevens* ... , ed. Argent, p. 137.

40. CM, G/3/6, p. 34.

41. Hale, *Some Account*, p. 23.

42. Cited in, Kathryn Morrison, *The Workhouse. A Study of Poor-Law Building in England* (Swindon, Royal Commission on the Historical Monuments of England, 1999), p. 30.

43. Hale, *Some Account*, pp. 23-4. CM, G/2/10, p. 477.

44. *Charter-House, Its Foundation and History* (London, M. Sewell, 1849), pp. 70-6.

CHAPTER 9: A FITTING ASYLUM FOR ANY MAN

1. Brian Howson, *Houses of Noble Poverty. A History of the English Almshouse* (Sunbury-on-Thames, Bellevue Books, 1993), p. 141. Anthony Trollope, *The Warden*, ed. David Skilton (Oxford, Oxford University Press, 1981 edn.), pp. xiii-xv.

2. Moncrieff was paid £5 for his contribution to the article. Eric Harrison, 'When Dickens attacked Charterhouse …', *The Carthusian* (1995), 4-7, and information kindly supplied by Harriet Richardson.

3. *Household Words*, 12 June 1852, p. 288.

4. *Household Words*, 12 June 1852, pp. 288-91.

5. [William Hale Hale], *Some Account of the Early History and Foundation of the Hospital of King James, Founded in Charterhouse* (London, privately published, 1854), pp. 33-40.

6. CM, G/2/12, p. 349.

7. Hale, *Some Account*, p. 23.

8. CM, G/2/10, pp. 128-9; G/2/11, pp. 117, 266-7.

9. Hale, *Some Account*, p. 28.

10. Hale, *Some Account*, p. 28.

11. CM, Poor Brothers' Admissions, pp. 10-18.

12. CM, G/2/12, pp. 12, 221-2.

13. Hale, *Some Account*, p. 29.

14. Hale, *Some Account*, pp. 29-32.

15. PP, 1857-8 (9) XLVI, A Copy of the Report of an Inquiry … into the state and Management of the Estates and Property of the Charterhouse, and into the general Affairs of that Charity, 7 Dec. 1857.

16. *The Letters of Charles Dickens*, ed. Madeline House, Graham Storey and Kathleen Tillotson (London, British Academy, 1993), vol. 7, p. 711 n5.

17. Ann Monsarrat, *An Uneasy Victorian. Thackeray the Man 1811-1863* (London, Cassell, 1980), pp. 340-1. Wilmot and Streatfield, *Charterhouse*, pp.150-1.

18. *Letters of Charles Dickens*, ed. House, Storey and Tillotson, Vol.7, p.710. *Household Words*, 1 Dec. 1855, pp. 409-14.

19. PP, 1864 XXI.I, p. 560.

20. R.L. Arrowsmith, *Charterhouse Register 1769-1872* (London & Chichester, Phillimore, 1974), sampling of initial letters, A, B, L-N, S-Y.

21. PRO, RG9/188, pp. 56-60.

22. LMA, acc/1876/AR/1/242.

23. CM, G/3/6, pp. 95-7; G/2/13, p. 332.

24. CM, G/2/13, pp. 353-4; G/2/14, pp. 4, 38.

25. PP, 1864 XXI.I, p. 540.

26. PP, 1864 XXI.I, pp. 553, 582.

27. PP, 1864 XX, pp. 196-7.

28. E.M. Jameson, *Charterhouse* (London & Glasgow, Blackie & Son, 1937), p. 23.

29. Haig Brown, *Charterhouse*, p. 133. PP, 1864 XXI.I, p. 589; 1864 XX, pp. 60, 196.

30. CM, G/2/14, pp. 178-9, 238, 312-13. Haig Brown, *Charterhouse*, pp. 172-4. Quick, *Charterhouse*, p. 62.

31. CM, G/2/14, p. 252. Davies, *Charterhouse*, pp. 276-8.

32. CM, G/2/15, pp. 130-1. In 1905 the school was constituted as a separate charity.

33. LPL, Benson Papers, vol. 21, f.24.

34. CM, G/2/15, pp. 76-7,82,116.

35. CM, G/2/16, p. 75.

36. LPL, Benson Papers, vol. 21, f.32. *Scheme for the regulation of Sutton's Hospital in Charterhouse approved by the Charity Commissioners 3 Dec. 1872*, p. 23.

37. LPL, Benson Papers, vol. 21, ff.28-9.

38. Haig Brown, *Charterhouse*, pp. 167-8.

39. LPL, Benson Papers, vol. 21, ff.24-6.

40. LMA, G/4/19. W.W. Hutchings, *London Town Past and Present* (London, Cassell, 1909), I, p. 452.

41. Basil Champneys, 'Old Charterhouse', *Magazine of Art*, XII, 1886, 309.

42. Hansard, *Commons Debates*, vol. 305, third series, 7 May 1886, cc. 510, 514.

43. Champneys, 'Old Charterhouse', 309. *English Illustrated Magazine*, vol. 3 (April 1886), pp. 496-7.

44. Hansard, *Commons Debates*, vol. 305, third series, 7 May 1886, col. 503.

45. LMA, acc/1876/AR/1/244-5.

46. *The Daily Graphic*, 23 Feb. 1893.

47. Walter Thornbury, *Old and New London* (London, Cassell, 1897), II, pp. 398-9.

48. *Dickens's Dictionary of London 1888* (Moretonhampstead, Old House Books, 1993), p.65. *The Daily Telegraph*, 22 Feb. 1908. CM, G/3/8, p. 17.

49. CM, G/2/17, pp. 297-8, 302, 307.

50. Gerald S. Davies, *Charterhouse London. Monastery, Mansion, Hospital. A Historical Sketch* (London, John Murray, 1911).

51. The whereabouts of Hale's window is unknown. CM, AG/4/22/6, unpaged.

52. Haig Brown, *Charterhouse*, p. 95.

53. Davies, *Charterhouse*, pp. 32-3.

CHAPTER 10: PRAISED BE THE LORD AND THOMAS SUTTON

1. CM, G/2/17, p. 304.

2. CM, G/2/17, pp. 397, 446; G/2/18, pp. 15, 22.

3. CM, AG/6/2-12.

4. CM, AD/1/12.

5. Anne Ritchie, Introduction to *The Newcomes*, Biographical Edition, vol. VIII (London, Smith, Elder, & Co., 1898), p. xxii. Gerald S. Davies, *Charterhouse London: Monastery, Mansion, Hospital* (London, John Murray, 1911), p. 33. Charles Morley, *Travels in London* (London, Smith, Elder & Co., 1916), pp. 177-213. And see G.S. Davies, 'Thackeray as Carthusian', *The Greyfriar*, II (1890-5), 61-7, and Anne Barter, *Stories of Pendennis and the Charterhouse from Thackeray* (London, Harrap, 1912).

6. W. Teignmouth Shore, *Touring London* (London, Batsford, 1930), p. 29. The *Evening News*, 4 Dec. 1933. CM, G/2/17, p. 275.

7. *The Times*, 10 April 1951, p. 4f.

8. *Scheme for the Regulation of Sutton's Hospital in Charterhouse approved by the Charity Commissioners 3 Dec. 1872*, p. 19.

9. CM, G/3/6, pp. 206-11.

10. CM, PS/3/40, 41, 42, 43.

11. *Charter-House, Its Foundation and History* (London, M. Sewell, 1849), p. 6.

12. *A Pictorial and Descriptive Guide to London and its Environs* (London, Ward, Lock & Co., 1923 edn.), pp.213-4. E. Montizambert, *Unnoticed London* (London & Toronto, J.M. Dent, 1923), pp. 148-9.

13. *The Builder*, 19 Nov. 1864, p. 850. *Building News*, 12 Oct. 1866, p. 685; 15 Feb. 1867, p. 136.

14. Frank B. Chancellor and Henry S. Eeles, *Celebrated Carthusians* (London, Philip Allan, 1936).

15. Samuel R. Gardiner, *History of the Great Civil War 1642-1649*, I (London, Longman, 1886), pp. 287-9. Oscar S. Straus, *Roger Williams: The Pioneer of Religious Liberty* (New York, Century, 1894), pp. ix-xii.

16. CM, AD/2/16.

17. CM, G/2/18, pp. 142,146, 154, 159-60, 167.

18. CM, AD/2/16.

19. William Hale, 'The Carthusian Monastery of London', *Trans. London and Middlesex Archaeological Soc.*, III (1869), 309-31.

20. CM, MP/1/14a. William St.John Hope, *The History of the London Charterhouse* (London, SPCK, 1925), pp.132-3. *Local Maps and Plans from Medieval England*, ed. R.A. Skelton and P.D.A. Harvey (Oxford, Clarendon Press, 1986), p. 228. The three later derivatives, one from the early sixteenth century and two from the early seventeenth, do not show the layout of the priory.

21. W.StJ. Hope, 'The London Charterhouse and its old water supply',

Archaeologia, LVIII (1902), 293-312.

22. CM, AD/2/16.

23. Hope, *Charterhouse*, p. 164. Gerald S. Davies, *Charterhouse in London* (London, John Murray, 1921), pp.80-2. Lawrence Hendriks, *The London Charterhouse* (London, Kegan Paul, Trench & Co., 1889), pp. 268-76, preferred the late fifteenth century as the period of these changes.

24. CM, AD/1/13, C. McNee to J. McLeod Campbell, 26 Oct. 1961.

25. CM, G/2/18, pp. 240, 259-61; AG/6/14.

26. CM, G/2/18, pp. 273-81.

27. CM, G/2/18, pp. 289-93; AD/2/8, letter of D.W.H. Kirkaldy, 10 June 1984; E/1/79, Crawhall-Wilson to Upcott, 4 July 1941.

28. CM, G/2/18, pp. 289-93; AD/2/8, letter of D.W.H. Kirkaldy, 10 June 1984.

29. CM, E/1/79, Crawhall-Wilson to Upcott, 4 July 1941.

30. CM, G/2/18, p.307; G/3/8, pp. 134, 139-40, 173.

31. Anthony Quick, *Charterhouse: A History of the School* (London, James & James, 1990), pp. 74-7, 92-3, 95.

32. PRO, IR37/102, pt i, A. Burnett Brown to War Damage Commission, 28 Sept. 1944; memo 12 Oct. 1944. CM, G/2/18, p. 396.

CHAPTER 11: A PLACE OF LEAFY SECLUSION

1. Seely and Paget's other restoration work included Lambeth Palace; the Deanery and Little Cloister at Westminster Abbey; Eton College; the restoration of All Hallows by the Tower, St Andrew's Holborn, St Bartholomew-the-Less and St John's Clerkenwell.

2. CM, G/2/18, p. 382.

3. CM, AG/6/2-12, 15.

4. CM, AG/6/15-22.

5. CM, AG/6/21; B/1/2, Notes of meetings, 20 April 1951, pp. 4-5; 4 May 1951, p. 3; B/1/4, Long-Brown to Paget, 25 June 1952.

6. PRO, IR37/102, pt iv, S&P to War Damage Commission, 13 Sept. 1955.

7. CM, B/1/2, Notes of meeting, 20 April 1951, p. 3.

8. CM, G/2/19, p.74. RIBA, S&P, AE, box 47, S&P to Freeborn, 4 Jan. 1949; box 36, report to Governors, 14 July 1947.

9. RIBA, S&P, AE, box 34, S&P to Whinney, 13 July 1971.

10. PRO, IR37/102, pt iii, Estimate by H.H. Martyn, 20 April 1954.

11. CM, G/2/19, p. 216; these figures include professional fees. PRO, IR37/102, pt ii, S&P to War Damage Commission, 23 May 1957.

12. CM, B/1/2, Notes of meeting, 20 April 1951.

13. CM, AG/6/23; B/1/5, Long-Brown to Weeks, 2 Dec. 1953.

14. CM, G/3/8, pp. 279-80; B/1/5, Notes at a meeting, 1 Dec 1953; Long-Brown

to Weeks, 2 Dec. 1953.

15. CM, AD/1/12, letter 3 June 1938. CM, G/3/8, pp. 279-80; B/1/5, notes, 1
 Dec 1953.

16. LPL, Davidson MSS, vol. 125, f.139.

17. This and the following paragraphs are based upon David Knowles and W.F.
 Grimes, *Charterhouse: The Medieval Foundation in the light of recent
 discoveries* (London, Longmans, Green & Co., 1954), pp. 41-50, and RIBA,
 Seely & Paget archive, box 36, 'Sequence of events ... ', 20 June 1950.

18. Knowles and Grimes, *Charterhouse*, pp. 47-8. Lord Mottistone, 'The Ancient
 Buildings of the London Charterhouse', *Journal of the London Soc.* (1951),
 101-2.

19. CM, G/2/19, p.22. Museum of London, W.F. Grimes archive, Paget to Grimes,
 6 Nov. 1947.

20. RIBA, Seely & Paget archive, box 33, Clerk of Works reports, week 3, 11 Aug
 1951; week 17, 17 Nov. 1951.

21. RIBA, Seely & Paget archive, box 36, Seely & Paget to Knowles, 16 Oct.
 1950.

22. CM, G/2/20, pp. 19, 34.

23. Knowles and Grimes, *Charterhouse*, p. 66.

24. RIBA, Seely & Paget archive, box 47, Seely & Paget to William Golding, 10
 Jan. 1949; to A.P. Humby, 24 Feb. 1949. Knowles and Grimes, *Charterhouse*,
 p l. VIIIB-D.

25. RIBA, Seely & Paget archive, box 36, letter, Knowles to Mottistone, 17 Oct.
 1950.

26. Bruno Barber and Christopher Thomas, *The London Charterhouse* (London,
 Museum of London Archaeology Service, Monograph 10, 2002).

27. CM, AD/2/16.

28. CM, G/2/19, pp. 14-15.

29. CM, G/2/19, pp.325, 337-8, 407; G/3/8, pp. 387-8.

30. CM, List of Brothers, *c.* 1957. *The Times*, 8 Dec. 1956, pp. 8, 14.

31. CM, G/2/19, p. 120; AG/6/24,25.

32. CM, G/2/19, pp. 249-50.

33. CM, G/2/19, p. 352.

34. CM, G/2/19, p. 309; /20, p. 47.

35. RIBA, S&P, AE, box 28, Seely & Paget to Costains, 18 Aug. 1949.

36. RIBA, S&P, AE, box 47, diary note 23 May 1949.

37. Arthur Oswald, 'The London Charterhouse Restored', *Country Life*, 1959,
 pp. 418-21, 478-81, 538-41.

38. Oswald, 'Charterhouse Restored', p. 418.

39. PRO, HLG126/1115/32-3. *The Times*, 10 April 1951, p.4f.

40. *Catholic Herald*, 11 July 1980, p. 10. Ann Saunders, *The Art and Architecture
 of London. An Illustrated Guide* (Oxford, Phaidon, 1984), p. 295.

41. H.R. Trevor-Roper, 'Thomas Sutton', *The Carthusian* (Oct. 1948), 2-8; 'The Bishopric of Durham and the Capitalist Reformation', *Durham Research Review* vol. 18 (1967), 103-16.

42. Lawrence Stone, *The Crisis of the Aristocracy, 1558-1641* (Oxford, Clarendon Press, 1965), pp. 102-3, 526, 534-5, 595-6. Neal R. Shipley, '"Full Hand and Worthy Purposes": the Foundation of Charterhouse, 1610-1616', *Guildhall Studies in London History*, I (1975), 229-49; 'Thomas Sutton: Tudor-Stuart Moneylender', *Business History Review*, 50 (1976), 456-76; 'The History of a Manor: Castle Campes, 1580-1629', *Bulletin of the Institute of Historical Research*, XLVIII (1975), 162-81. Anthony Quick, *Charterhouse: A History of the School* (London, James & James, 1990).

43. E.E. Harrison, 'The History of Charterhouse and its Buildings', *Trans. of the Ancient Monuments Soc.*, 35(1991), 1-28; reprinted in booklet form with the same title.

44. CM, G/2/19, pp. 334-5; G/2/20, pp. 422, 439-40.

45. CM, G/2/20, pp. 149-50.

46. CM, G/2/20, p. 387.

47. Quick, *Charterhouse*, p. 145.

BIBLIOGRAPHY

CONTEMPORARY SOURCES

Anon., *A True Narrative Of Certain Circumstances Relating to Zachariah Williams ... in Sutton's Royal Hospital, The Charter-House*, London, 1749.

Anon., *Charterhouse : a brief record of Sutton's Hospital compiled for the members of the Lodge of Freemasons*, 1906.

Anon., *Charters, Acts of Parliament and Governors' Statutes of the Charterhouse*, 1832.

Anon., *Some Account of the Hospital of King James*, 1854.

Anon., *Sutton's Hospitall: with the names of sixteen Mannors ... with the rents and hereditaments thereunto belonging: ... As also the last will and testament of T. Sutton, Esq., founder of the said Hospitall, etc.*, 1646.

Arthington, Henry, *Provision for the poore*, 1597.

Aubrey, John, *Brief Lives*, ed. Richard Barber, London, Folio Soc., 1975.

Bacon, Francis, *The Letters and the Life of Francis Bacon*, ed. James Spedding, vol. IV, 1868

—, *Essays*, ed. Michael J. Hawkins, London, Everyman, 1994.

Bacon, Francis, *The Advancement of Learning*, ed. Edward Jay Gould, New York, Random House, 2001.

Barrett, C.R.B., and Smythe, G.E., *Charterhouse 1611-1895 in pen and ink*, Bliss Sans & Foster, 1895.

Bearcroft, Philip, *An Historical Account of Thomas Sutton, Esq.: and of his Foundation in Charter-House*, 1737.

Breton, Nicholas, *The Good and the Badde, a Description of the Worthies and Vnworthies of this Age*, London, 1616.

Brown, Harold E.H. Haig, *William Haig Brown of Charterhouse*, Macmillan, 1908.

Brown, W. Haig, *Charterhouse Past and Present*, Stedman, Godalming, 1879.

—,*Carthusian Memories*, Longmans, Green, 1905.

Burnet, Thomas, *A Relation of the Proceedings at Charter-House, upon Occasion of King James the II. His presenting a Papist To be admitted into that Hospital*, London, 1689.

Burrell, Percival, *Sutton's Synagogue, or, the English Centurion: shewing the vnparrallelled bounty of Protestant piety*, 1629.

Burton, Robert, *The Anatomy of Melancholy*, ed. Faulkner, Thomas C., Kiessling, Nicolas K., and Blair, Rhoda L., Vol. I, Oxford, Clarendon Press, 1989.

The Carthusian: A Miscellany in Prose and Verse, 2 vols., 1839.

Chamberlayne, Edward, *The Second Part of the Present State of England*, 1682.

Collins, F., ed., *Registers and Monumental Inscriptions of Charterhouse Chapel*, Harleian Soc., 1892

Cowper, William, *Tirocinium; Or, A Review of Schools*, 1784.

Coxe, William, *Anecdotes of George Frederick Handel and John Christopher Smith*, London, 1799.

Cromwell, T., *History and Description of the Parish of Clerkenwell*, London, Longman, Rees, Orme, Brown, and Green, 1828.

Defoe, Daniel, *A Tour through the Whole Island of Great Britain*, ed. Rogers, Pat, Harmondsworth, Penguin, 1971.

Dickens, Charles, snr., *The Letters of Charles Dickens*, vol.7, ed. Madeline House, Graham Storey, and Kathleen Tillotson, London, British Academy, 1993.

Dickens, Charles, jnr., *Dickens's Dictionary of London 1888*, Moretonhampstead, Old House Books, 1993.

Evelyn: *The Diary of John Evelyn*, ed. E.S. De Beer, London, Oxford University Press, 1959.

Fisher, Philip, *A Commemoration Sermon, preached at the Chapel of Charterhouse, on Thursday, December 12, 1811 ... By Philip Fisher, D.D. Master of Charterhouse*, London, 1811.

Fletcher, Frank, *After Many Days. A Schoolmaster's Memories*, Robert Hale & Co., 1937.

—, *Brethren and Companions – Charterhouse Chapel Addresses*, R. Hale, 1936.

Gainsford, Thomas, *The Rich Cabinet Furnished with varietie of Excellent discriptions ...* , 1616

Greyfriars, The, vols. 1-5, 1884-1906.

—, *Papers from the Greyfriars*, S. Walker, 1861.

Hall, Joseph, *Characters of Vices and Virtues* (1608) in, *Character Writings of the Seventeenth Century*, ed. H. Morley, London, The Carisbrooke Library, 1891.

Herbert, W., *Considerations (In the behalf of Foreiners ...)*, 1662.

Herne, Samuel, *Domus Carthusiana: or an account of the Most Noble Foundation of the Charter-House ... with the life ... of Thomas Sutton the founder thereof ...* , 1677.

Heylyn, P., *Cyprianus Anglicus: Or, The History of the Life and Death, of the Most Reverend and Renowned Prelate William ... Archbishop of Canterbury* 1671.

Highmore, Anthony, *Pietas Londinensis*, London, 1810.

Holland, Henry, *Herwologia Anglica*, 1620.

Irving, Washington, *The Sketch Book of Geoffrey Crayon, Gent* (1819-20).

Lupton, D., *London and the Countrey Carbonadoed and Quartred into severall Characters*, 1632.

Malcolm, James Peller, *Londinium Redivivum*, I, London, 1802.

Mandeville, Bernard, *The Fable of the Bees: Or, Private Vices, Publick Benefits*, second edn., London, 1723.

Miège, Guy, *The Present-State of Great-Britain and Ireland*, third edn., London, 1716.

Mundy: *The Travels of Peter Mundy in Europe and Asia 1608-1667*, ed. Temple, Richard Carnac, and Anstey, Lavinia Mary, Haklyut Society, second series, LXXVIII, 1936.

Peter, Hugh, *Gods Doings, and Mans Duty*, 1646.

Radclyffe, C.W., *Memorials of Charterhouse*, James Moore, 1844.

[Ryder, W.J.D.], *Chronicles of Charter-House*, Bell, 1847.

Schellinks: *The Journal of William Schellinks' Travels in England 1661-1663*, ed. Maurice Exwood, and H.L. Lehmann, Camden Soc., fifth series, vol. I, 1993.

[Sewell, M.], *Charter-House, Its Foundation and History* Sewell, 1849.

Smythe, Robert, *Historical Account of the Charter-House; compiled from the works of Herne and Bearcroft*, W.M Dowall, 1813.

Stow, John, *A Survey of London*, ed. C.L. Kingsford (Oxford, Clarendon Press, 1908).

Strafford: Knowler, William, *The Earl of Strafforde's Letters and Dispatches*, vol. II, 1739.

Thackeray, William Makepeace, *The Newcomes*, Complete Works, III, 1870.

Thornbury, Walter, *Old and New London*, London, Cassell, 1897.

Walker, John, *A Selection of Curious Articles from the Gentleman's Magazine*, vol.4, second edn., 1811

Ward, Ned, *The London Spy*, London, Folio Soc., 1955.

White, John, *The First Century of Scandalous, Malignant Priests ...* (1643).

Willet, Andrew, *Synopsis Papismi*, 1634.

Winwood, T., *Memorials of Affairs of State in the reigns of Q. Elizabeth and K. James I ...* from *the Original Papers* Of ... Sir *Ralph Winwood*, vol. III, 1725.

Wood, Anthony, *Athenae Oxonienses*, ed. Philip Bliss, vol. III, 1817; vol. IV, 1820.

SECONDARY SOURCES

Archer, Ian W., *The Pursuit of Stability: Social Relations in Elizabethan London*, Cambridge, Cambridge University Press, 1991.

—, 'The arts and acts of memorialization in early modern London', in *Imagining Early Modern London: Perceptions and Portrayals of the City from Stow to*

Strype, 1598-1720, ed. Merritt, Julia, Cambridge, Cambridge University Press, 2001.

—, 'The Charity of Early Modern Londoners', *Transactions of the Royal Historical Society*, sixth series, XII, 2002, 223-44.

Argent, Mark, ed., *Recollections of R.J.S. Stevens: An Organist in Georgian London*, Macmillan, 1992.

Arrowsmith, R.L., *A Charterhouse Miscellany*, Gentry Books, 1982.

—, *Charterhouse Register 1769-1872*, Phillimore, 1974.

Bailey, Brian, *Almshouses*, London, Hale, 1988.

Baldwin, T.W., 'The Three Francis Beaumonts', *Modern Language Notes*, 39 (1924), 505-7.

Banks, Chris, Arthur Searle and Malcolm Turner, *Sundry sorts of music books*, British Library, 1993.

Barber, Bruno, and Thomas, Christopher, *The London Charterhouse*, Museum of London Archaeology Service, Monograph 10, 2002.

Barratt, Mark and Thomas, Chris, 'The London Charterhouse', *The London Archaeologist*, vol. 6, 1991.

Barrow, Andrew, *The Flesh is Weak. An Intimate History of the Church of England*, London, Hamish Hamilton, 1980.

Berridge, Clive, *The Almshouses of London*, Shedfield, Ashford Press, 1987.

Bettey, J.H., 'Matthew Chubb of Dorchester: Rapacious moneylender and benevolent philanthropist', *Dorset Natural History and Antiquarian Society Proceedings*, 112, 1990, 1-4.

Brewer, Derek, ed., *Chaucer, The Critical Heritage*, vol. I, London, Routledge, 1978.

Butler, Martin, 'Brome, Richard (*c.*1590-1652)', *Oxford Dictionary of National Biography*, 2004.

Cavallo, Sandra, 'The motivations of benefactors: An overview of approaches to the study of charity', in *Medicine and Charity before the Welfare State*, ed. Barry, Jonathan, and Jones, Colin, London, Routledge, 1991.

Champneys, Basil, 'Old Charterhouse', *Magazine of Art*, XII, 1886, 309-15.

—, *Charterhouse. 1, The monastery. 2, Spoilation : North, Howard, and Sutton*, 1902.

Chancellor, Frank B. and Eeles, Henry S., *Celebrated Carthusians*, Philip Allan, 1936.

Clarke, Basil F.L., *The Building of the Eighteenth-Century Church*, London, Batsford, 1963.

Corke, Shirley, *Charterhouse-in-Southwark, 1884-2000: A Short History*, 2001.

Cressy, David, *Education in Tudor and Stuart England*, London, Edward Arnold, 1975.

—, *Agnes Bowker's Cat: Travesties and Transgressions in Tudor and Stuart England*, Oxford, Oxford University Press, 2000.

Davies, Gerald S., *Charterhouse, London: A Historical Sketch*, London, John Murray, 1911.

—, *Charterhouse in London*, London, John Murray, 1921.

Davis, J.C., *Utopia and the ideal society. A Study of English utopian writing 1516-1700*, Cambridge, Cambridge University Press, 1981.

Donner, H.W., *The Browning Box*, Oxford, Oxford University Press, 1935.

Edmond, Mary, *Rare Sir William Davenant: poet laureate, playwright, Civil War general, restoration theatre manager*, Manchester, Manchester University Press, 1987.

Evans, Robert C., 'Thomas Sutton: Ben Jonson's Volpone?', *Philological Quarterly*, LXVIII (1989), 295-313.

Fendy, John, 'Martin Benson, Bishop of Gloucester', *Transactions of the Bristol and Gloucestershire Archaeological Society*, 119, 2001, 155-76.

Firth, C.H., *Cromwell's Army*, London, Greenhill, 1992.

Firth, C.H., and Rait, R.S., eds., *Acts and Ordinances of the Interregnum, 1642-1660*, 3 vols., London, Stationery Office, 1911.

Fletcher, Hanslip, *Bombed London*, Cassell, 1957.

Friedmen, Alice T., 'John Evelyn and English Architecture' in *John Evelyn's "Elysium Britannicum" and European Gardening*, Dumbarton Oaks colloquium on the history of landscape architecture, XVII, ed. Theresa O'Malley, and Joachim Wolschke-Bulmahn, Washington DC, Dumbarton Oaks Research Library and Collection, 1998.

Furdell, Elizabeth Jane, 'Bate, George [*pseud*. Theodorus Veridicus] (1608-1668)', *Oxford Dictionary of National Biography*, 2004.

Gapper, Claire, Plasterers and Plasterwork in City, Court and Country *c.* 1530-*c.*1640, PhD thesis, University of London, 1998.

Gardiner, Dorothy, ed., *The Oxinden and Peyton Letters 1642-1670*, London, Sheldon Press, 1937.

Gardiner, Samuel R., *History of the Great Civil War 1642-1649*, London, Longman, 1886.

Gibson, E.C.S., *Thackeray and Charterhouse, with sidelights on the life of a public school a hundred years ago*, 1922.

Girdlestone, F.K.W., Hardman, E.T and Tod, A.H., eds., *Charterhouse Register 1872-1900*, 1904. Charterhouse Register, 3 *vols.*: *1872-1891; 1892-1910; 1911-193*.

Godfrey, Walter H., *The English almshouse: with some account of its predecessor, the medieval hospital*, London, Faber & Faber, 1955.

Greaves, Richard L., and Zaller, Robert, eds., *Biographical Dictionary of British Radicals in the Seventeenth Century*, Vol. I, Brighton, Harvester Press, 1982.

Hale, John, *England and the Italian Renaissance*, London, HarperCollins, 1996.

Hale, William Hale, *Some Account of the Early History and Foundation of the Hospital of King James, Founded in Charterhouse*, privately published, 1854.

—, 'The Carthusian Monastery of London', *Transactions of the London and Middlesex Archaeological Society*, III (1869), 309-31.

Harrison, E.E., *The history of Charterhouse and its buildings*, 1991, reprint of 'The History of Charterhouse and its Buildings', *Transactions of the Ancient Monuments Society*, 35, 1991, 1-28.

—, 'When Dickens attacked Charterhouse …', *The Carthusian*, 1995, 4-7.

Healy, Margaret, *Fictions of Disease in Early Modern England*, Basingstoke, Palgrave, 2001.

Hendriks, L, *The London Charterhouse, its monks and its martyrs*, Kegan Paul, Trench, 1889.

Holden, W.H., ed., *The Charterhouse we knew*, British Technical and General Press, 1950.

Holman, Peter, *Henry Purcell*, Oxford, Oxford University Press, 1994.

Höltgen, Karl Josef, 'Sir Robert Dallington (1561-1637): Author, Traveller, and Pioneer of Taste', *Huntington Library Quarterly*, vol.47, 1984, 147-77.

Hope, William StJohn, *The History of the London Charterhouse from its foundation until the Suppression of the Monastery*, SPCK, 1925.

—, *The London Charterhouse and its Water Supply*, Archaeologia, vol. LVIII, 1902, 293-312.

—, *The History of the London Charterhouse*, London, SPCK, 1925.

Hosking, G.L., *The Life and Times of Edward Alleyn*, London, Jonathan Cape, 1952.

Hotine, Margaret, 'Ben Jonson, Volpone, and Charterhouse', *Notes & Queries*, new series, CCXXXVI (1991), 79-81.

Howson, Brian, *Houses of Noble Poverty. A History of the English Almshouse*, Sunbury-on-Thames, Bellevue, 1993.

Hutchings, W.W., *London Town Past and Present*, London, Cassell, 1909.

Huxley, L, (contributor) *Great Public Schools* Arnold, n.d.

Irvine, A.L., *Sixty Years at School*, P&G Wells, 1958.

Jacob, W.M., 'Sutton, Charles Manners (1755-1828)', *Oxford Dictionary of National Biography*, 2004

Jameson, E.M., *Charterhouse*, Blackie, 1937.

Jardine, Lisa, *On a grander scale: the life and times of Christopher Wren*, London, HarperCollins, 2002

Jones, Norman, *God and the Moneylenders: Usury and Law in Early Modern England*, Oxford, Basil Blackwell, 1989.

Jordan, W.K., *Philanthropy in England 1480-1660*, London, Allen & Unwin, 1959.

—, *The Charities of London 1480-1660. The Aspirations and the Achievements of the Urban Society*, London, George Allen & Unwin, 1960.

Keene, Derek, Burns, Arthur, and Saint, Andrew, eds., *St Paul's: The Cathedral Church of London*, London and New Haven, Yale University Press, 2004.

Knowles, D. and Grimes, W.F., *Charterhouse. The Medieval Foundation in the Light of Recent Discoveries*, Longman, Green, 1954.

Larkin, James F., and Hughes, Paul L., eds., *Stuart Royal Proclamations, Volume I, Royal Proclamations of King James I 1603-1625*, Oxford, Clarendon Press, 1973.

Laud, William, *The Works of the Most Reverend Father in God; William Laud, D.D.*, vol. III, 1853; vol. VI, pt I, 1857.

Llewellyn, Nigel, *Funeral Monuments in Post-Reformation England*, Cambridge, Cambridge University Press, 2000.

Lock, Julian, 'Hale, William Hale, 1795-1870', *Oxford Dictionary of National Biography*, 2004.

Lockyer, Roger, *Buckingham: The Life and Political Career of George Villiers, First Duke of Buckingham 1592-1628*, London, Longman, 1981.

Lough, John, *France Observed in the Seventeenth Century by English Travellers*, Stocksfield, Oriel Press, 1985.

Macaulay, Thomas Babington, *The History of England from the Accession of James II*, 1848-55.

MacCaffrey, Wallace T., *Exeter, 1540-1640. The Growth of an English County Town*, Cambridge, Mass., Harvard University Press, 1958.

Manning, Owen, and Bray, William, *The History and Antiquities of the County of Surrey*, vol. II, London, 1809.

March, Bower, and Crisp, Frederick Arthur, eds., *Alumni Carthusiani: A Record of the Foundation Scholars of Charterhouse, 1614-1872*, privately published, 1913.

Mathews, Nieves, *Francis Bacon: The History of a Character Assassination*, New Haven and London, Yale University Press, 1996.

Matthews, A.G., *Calamy Revised. Being a revision of Edmund Calamy's Account of the ministers and others ejected and silenced, 1660-2*, Aldershot, Ashgate, 1999.

Monsarrat, Ann, *An Uneasy Victorian. Thackeray the Man 1811-1863*, London, Cassell, 1980

Montizambert, E., *Unnoticed London*, London & Toronto, J.M. Dent, 1923.

Morley, Charles, *Travels in London*, London, Smith, Elder & Co., 1916.

Morrison, Kathryn, *The Workhouse. A Study of Poor-Law Building in England*, Swindon, Royal Commission on the Historical Monuments of England, 1999.

Nathan, Matthew, *The Annals of West Coker*, Cambridge, Cambridge University Press, 1957.

Newman, John, 'The Architectural Setting', in *The History of the University of Oxford, Volume IV Seventeenth-Century Oxford*, ed. Nicholas Tyacke, Oxford, Clarendon Press, 1997.

Ornsby, George, ed. *The Correspondence of John Cosin, D.D. Lord Bishop of Durham*, pt II, Surtees Society, LV, 1872.

Oswald, Arthur, *The London Charterhouse Restored*, 1959, reprinted from, *Country Life*, 1959, 418-21, 478-81, 538-41.

Patrick, George, *The history and architecture of the Charterhouse*, 1897.

Peck, Linda Levy, *Northampton: Patronage and Policy at the Court of James I*, London, Allen & Unwin, 1982.

Port, M.H., ed., *The Commissions for Building Fifty New Churches, The Minute Books, 1711-27, A Calendar*, London Record Society, 23, 1986.

Porter, Roy, 'The gift relation: philanthropy and provincial hospitals in eighteenth-century England', in *The Hospital in History*, ed. Lindsay Granshaw and Roy Porter, London, Routledge, 1989.

Porter, Stephen, 'Order and Disorder in the Early Modern Almshouse: The Charterhouse Example', *London Journal*, 23, 1998, 1-14.

—, 'Composer in Residence: Henry Purcell and the Charterhouse', *Musical Times*, vol. 139, 1998, 14-17.

—, 'Planning for a Monument: Dr John King and Charterhouse Chapel', *Transactions of the Ancient Monuments Society*, 47, 2003, 33-46.

—, 'Francis Beaumont's monument in Charterhouse Chapel and Elizabeth, Baroness Cramond as patroness of memorials in early Stuart London', *Transactions of the London and Middlesex Archaeological Society*, 54, 2003, 111-19.

Porter, Stephen, and White, Adam, 'John Colt and the Charterhouse Chapel', *Architectural History*, 44, 2001, 228-36.

Quick, Anthony, *Charterhouse: A History of the School*, James & James, 1990.

Robey, Ann, "All asmear with filth and fat and blood and foam'. The social and architectural reformation of Smithfield Market during the nineteenth century', *Transactions of the Ancient Monuments Society*, 42, 1998, 1-12.

Royal Commission on the Historical Monuments of England, *London, II: West London*, 1925.

Saunders, Ann, *The Art and Architecture of London. An illustrated guide*, Oxford, Phaidon, 1984.

Schen, Claire S., *Charity and Lay Piety in Reformation London, 1500-1620*, Aldershot, Ashgate, 2002.

Scott-Giles, C. Wilfrid, and Slater, Bernard V., *The History of Emanuel School 1594-1964*, London, Old Emanuel Association, 1966.

Seely, Henry J.A., Baron Mottistone, *The ancient buildings of the London Charterhouse*, 1951, reprinted from *Journal of the London Society*, 1951.

Shepherd, T.B., *John Wesley and Charterhouse*, 1937.

Sherwood, Roy, *The Court of Oliver Cromwell*, Willingham, Willingham Press, 1989.

Shipley, Neal R., '"Full Hand and Worthy Purposes": the Foundation of Charterhouse, 1610-1616', *Guildhall Studies in London History*, I, 1975, 229-49.

—, 'Thomas Sutton: Tudor-Stuart Moneylender', *Business History Review*, 50, 1976, 456-76.

—, 'The History of a Manor: Castle Campes, 1580-1629', *Bulletin of the Institute of Historical Research*, XLVIII, 1975, 162-81.

—, 'A possible source for *Volpone*', *Notes & Queries*, CCXXXVII (1992), 363-9.

Shore, W. Teignmouth, *Touring London*, London, Batsford, 1930.

Sisman, Adam, *Boswell's Presumptious Task*, London, Penguin, 2001.

Skelton, R.A., and Harvey, P.D.A., eds., *Local Maps and Plans from Medieval England*, Oxford, Clarendon Press, 1986.

Slack, Paul, *Poverty and Policy in Tudor and Stuart England*, London, Longman, 1988.

—, *From Reformation to Improvement. Public Welfare in Early Modern England*, Oxford, Clarendon Press, 1998.

Soly, Hugo, 'Continuity and change: attitudes towards poor relief and health care in early modern Antwerp', in *Health Care and Poor Relief in Protestant Europe 1500-1700*, ed. Grell, Ole Peter, and Cunningham, Andrew, London, Routledge, 1997.

Spiers, W.L., ed., *The Notebook and Account Book of Nicholas Stone*, Walpole Society, vol. VII, 1919.

Stone, Lawrence *The Crisis of the Aristocracy, 1558-1641*, Oxford, Clarendon Press, 1965.

Sternfeld, F.W., Fortune, Nigel, and Olleson, Edward, eds., *Essays on Opera and English Music*, Oxford, Basil Blackwell, 1975.

Stevenson, Christine, *Medicine and Magnificence. British Hospital and Asylum Architecture, 1660-1815*, New Haven and London, Yale University Press, 2000.

Straus, Oscar S., *Roger Williams: The Pioneer of Religious Liberty*, New York, Century, 1894.

Strong, Roy, *Henry, Prince of Wales and England's Lost Renaissance*, London, Thames & Hudson, 1986.

Tarantino, Giovanni, *Martin Clifford 1624-1677. Deismo e Tolleranza Nell'Inghilterra della Restaurazione*, Firenze, Studi e testi per la storia della tolleranza in Europa nei secoli XVI-XVIII, 2000.

Taylor, D.J., *Thackeray*, London, Chatto & Windus, 1999.

Taylor, William F., *The Charterhouse of London, Monastery, Palace and Thomas Sutton's Foundation*, Dent, 1912.

Thompson, Christopher, ed., *Walter Yonge's Diary of Proceedings in the House of Commons 1642-1645*, vol. I 1986.

Thompson, Edgar Wesley, *Wesley at Charterhouse*, London, Epworth Press, 1938.

Thompson, E. Margaret, *The Carthusian Order in England*, SPCK, 1930.

Thorpe, W.A., *History of English and Irish Glass*, 2 vols., London, Medici Society, 1929.

Tod, A.H., *Charterhouse*, London, Bell, 1919.

Traficante, Frank, 'Hume, Tobias (*b.* in or before 1569, *d.* 1645), *Oxford Dictionary of National Biography*, 2004.

Trevor-Roper, H.R., 'Thomas Sutton', *The Carthusian*, Oct 1948, 2-8.

— , 'The Bishopric of Durham and the Capitalist Reformation', *Durham Research Review* vol. 18 (1967), 103-16.

— , 'Sutton, Thomas (1532-1611)', *Oxford Dictionary of National Biography*, 2004.

Tudor-Craig, Pamela, and Whittick, Derek, 'Old St Paul's'. *The Society of Antiquaries' Diptych, 1616*, ed. Penelope Hunting, and Ann Saunders, London Topographical Soc., 163, 2004.

Tyacke, Nicholas, ed., *The History of the University of Oxford, Volume IV Seventeenth-Century Oxford*, Oxford, Clarendon Press, 1997.

Veale, W., *From a New Angle – Charterhouse 1880-1945* P&G Wells, 1957.

Wilkins, Harold T., *Great English Schools*, Noel Douglas, 1925.

Willetts, Pamela, 'Benjamin Cosyn: Sources and circumstances', in *Sundry sorts of music books*, ed. Chris Banks, Arthur Searle, and Malcolm Turner, London, British Library, 1993.

Wilmot, E.P. Eardley, and Streatfield, E.C., *Charterhouse Old and New*, 1895.

Winn, James Anderson, *John Dryden and His World*, New Haven & London, Yale University Press, 1987.

Worden, Blair, *Roundhead Reputations. The English Civil War and the Passions of Posterity*, London, Allen Lane, 2001.

ACKNOWLEDGEMENTS

My interest in Thomas Sutton's charity began while I was on the staff of the Survey of London, when I was fortunate to be assigned to research the history of the Charterhouse buildings, which the charity has occupied for almost four hundred years. I am grateful to the former General Editor, John Greenacombe, for allocating me to the project, and to Harriet Richardson and the late Catherine Steeves, for being such helpful colleagues. I am especially grateful to Harriet for introducing me to many aspects of the charity's history in the late eighteenth and nineteenth centuries, and for many informative discussions.

The staff and the Brothers of Sutton's Hospital have been encouraging and helpful hosts, maintaining the long tradition of warm hospitality, and I am especially grateful to the three Masters who have held that post since my first visit, Eric Harrison, Dr James Malpas and Dr James Thomson, for their kindness and co-operation. The governors generously allowed me unrestricted access to the archive and the buildings. Many of the Brothers have gently guided me towards investigating various aspects of the charity's history. I have benefited especially from thought-provoking questions from the late Lawrence French on several topics; the late Thomas Wells on Thomas Sutton; Graham Matthews on the Charterhouse's musicians; Stanley Underhill on its art; Alan Scrivener on Thackeray; and Jack Bowles, editor of the Charterhouse Magazine, for commissioning articles, the material from a number of which is incorporated in this book. Peter Day kindly read the text and saved me from several errors. Donna Birkwood and Dawn Woodford helped with assembling the illustrations, which owe much to the photographic skills of Derek Kendall of English Heritage and Brother Brian Newble.

Others whose research has led them to the Charterhouse have provided help and information, including Adam White on sculpture; Michael Rossi on Tobias Hume; Steffi Dippold on Roger Williams; Dr Clare Gapper on the plasterwork; Dr Ian Roy on the militaria on the organ screen; Heather Cannan-Braniff on John Wesley; Giovanni Tarantino on Martin Clifford; Carol Galvin on Sutton's tomb; Bob Noble on sport; and Dr Michael Turner on Seely and Paget.

Having shared civil war, fire and plague with me, my wife Carolyn was well prepared for what quickly became an absorbing interest in the Charterhouse and its many aspects. As always, she has provided the help, advice, encouragement and stimulation needed for me to write this history.

LIST OF ILLUSTRATIONS

INDEX

Numbers in italics refer to the illustrations and the illustration number